MY NAME IS

LOVE

MY NAME IS
LOVE

DARLENE LOVE

with Rob Hoerburger

wm

WILLIAM MORROW
An Imprint of HarperCollins*Publishers*

Grateful acknowledgment is made to reprint the following: "He's Sure the Boy I Love," words and music by Barry Mann and Cynthia Weil. © 1962, 1963 (renewed 1990, 1991) Screen Gems-EMI Music, Inc. All rights reserved. International copyright secured. Used by permission. "He's a Rebel," by Gene Pitney. Copyright © 1962 (renewed) Unichappell Music, Inc. (BMI). All rights reserved. Lyrics reprinted by permission of Warner Bros. Publications U.S., Miami, FL 33014. "Stoney End," words and music by Laura Nyro. © 1966, 1968 (renewed 1994, 1996) EMI-Blackwood Music, Inc. All rights reserved. International copyright secured. Used by permission. "Lord, If You're a Woman," words and music by Barry Mann and Cynthia Weil. © 1977 Screen Gems-EMI Music, Inc., and Summerhill Songs, Inc. All rights controlled and administered by Screen Gems-EMI Music, Inc. All rights reserved. International copyright secured. Used by permission. "The Age of Miracles," by Bette Sussman and Tina Shafer. © 1997. All rights reserved. Lyrics reprinted by permission of the writers.

Billboard chart data from Joel Whitburn's Record Research books, reprinted courtesy of Joel Whitburn/Record Research, Inc., P.O. Box 200, Menomonee Falls, WI 53052.

A hardcover edition of this book was published in 1998 by William Morrow, an imprint of HarperCollins Publishers.

FIRST WILLIAM MORROW PAPERBACK EDITION PUBLISHED 2013.

The Library of Congress has cataloged the hardcover edition as follows:
Love, Darlene.
 My name is love : the Darlene Love story / by Darlene Love with Rob Hoerburger.
 p. cm.
 ISBN 0-688-15657-6
 I. Love, Darlene. 2. Singers-United States-Biography.
 I. Hoerburger, Rob. II. Title.
 ML420.L885A3 1998
 782.42164'092-dc21
 [B] 98-19242
 CIP
 MN

ISBN 978-0-06-229554-5 (pbk.)

13 14 15 16 17 DIX/RRD 10 9 8 7 6 5 4 3 2 1

For Marcus, Chawn, and Jason, my blessed (and patient) sons

For G.H., V.H., and E.B., the music supply

CONTENTS

Lean on, trust in and be confident in the Lord
with all your heart and mind and do not rely on
your own insight or understanding.
In all your ways know, recognize and acknowledge Him, and
He will direct and make straight and plain your paths.

<div align="right">—Proverbs 3:5–6</div>

MY NAME IS

LOVE

INTRODUCTION

he gas tank was full. My clothes were laid out.
The alarm clock was set. I was determined
to be on time, even if it was going to be for
the hardest ride of my life. It would last
only twenty-five minutes, about fifteen miles,
the distance between my small apartment in
West Los Angeles and the Hollywood Hills,
where I was due at 9:00 A.M. sharp. That's when
the tour would begin.

I've always been on time: for a business
meeting, a recording session, a date, church.
Punctuality should be the fifth virtue. It's good
practice for keeping promises. If you don't
keep somebody waiting, they'll be more likely
to smile on you. And if they keep you waiting,
then you have an advantage. But Lord, if there

was anything I ever wanted to be late for, it was this. During the ride across town, I felt as if everything I'd ever built up in my life was doing a slow burn out of existence, like the fuel in my tank. As I passed each exit I felt as if I were missing another chance to escape, to find a road back to my former life. Take this cup, Lord, please, I don't want to go. But God's directional signals didn't suddenly change, and there I was, half an hour later, on time again, doing what I'd learned in church as a child, keeping my head down and my mouth shut.

My destination was one of those hilltop Hollywood dream houses that you couldn't see from the bottom of the driveway. The lawns had the square footage of some shopping malls. I tried to be politely impressed, humbled by the topography of success—"Would you just look at these pillars?" I'd say, or "What a fine Hockney," but in reality I had been in homes like this hundreds of times because I had dozens of friends who lived in these Hollywood palaces. Now wasn't the time to go tit for tat with the woman giving the tour, usually the live-in housekeeper. This was where I would learn to be an actress.

The tour started in the foyer, large enough to hold a small recital, and then on to the library/study, with a carpet so thick it would swallow your feet, and shelves with more books than could ever be read in a lifetime. Next was the sitting room, bright and cheery and lacy, where the lady of the house might receive her guests or have afternoon tea. As a room, it had perfect posture. The kitchen was next door, bigger than my own apartment. The stove was like a small vessel, and the pantry and refrigerators were walk-ins. You'd think they were stocking for Armageddon, with the quantities of cereal and flour and sugar

and dog and cat food. (This was about ten years before Price Club–like warehouses came on the scene.) Extending beyond the side door of the kitchen, like another wing, was the formal dining room, with a mahogany table that could seat thirty and had carved pedestals for legs. On the wall was a mirror trimmed with gold leaf, so heavy it could have taken the entire defensive line of a football team to hang. It wasn't the kind of room that stimulated the appetite, especially the carpet, which was bright white.

"I'd be afraid to eat in here, with this carpet," I said. Even the most careful eater was sure to leave telltale crumbs and spots.

"Oh, it's not a problem," said the woman giving the tour. "The carpet gets cleaned every day."

Finally we made our way upstairs, my hand brushing against the polished mahogany banisters, which were almost as smooth as leather. There were at least five bedrooms, each with its own bathroom. The kids' rooms—there would always be kids in these houses, usually two or three—looked like kids' rooms, maybe with a football banner or rock-star poster on the walls. There might be an audio room, loaded with the latest in high-tech finery. These were the kinds of houses that had VCRs while most people were getting their first color TVs. The centerpiece, though, was the master bedroom, which was really like two bedrooms with a wall knocked out between them, one side for the man, one for the woman. The man's side had a king-size bed, all dark wood and masculine, while the woman's side had its own bed and a bathroom that was mirrored all around. Push a button and one of these mirrors opened up to reveal a steam room. And every bathroom had a bidet. From the window you could see the trellised garden and the man-made waterfall. You

could always tell if the husband, usually a stockbroker, and wife were fighting, because both beds had been slept in.

We finally wound our way back downstairs for the final stop, a walk-in closet near the kitchen. Yes, I knew this room well. "And here is where you'll change," said my tour guide. Newly pressed uniforms hung near an array of cleansers, solvents, and disinfectants that were waiting to do battle with the forces of grease, grime, and dust. There was a lot of house to clean. And that was what I had come to do.

This was 1982, and I was forty years old. It had been almost twenty years since my records were hits. Many of the intervening years, when I worked as a backup singer, had been good ones; I had a nice home, a marriage, and all the lovely extras that come along with a show-business career: clothes, furs, jewels. Once or twice I was making enough money to be given this same tour, by a real-estate agent.

But not too long before my fortieth birthday I started hearing God's whisper: "You're wasting your talent." Not that the people I was singing behind—Dionne Warwick, Aretha Franklin, Tom Jones—were anything to be ashamed of. But how many more chances was I going to have to resume my own recording career? The year or so when my records were hits, 1962–1963, was now my generation's nostalgia. I was beginning to feel like that hapless rube in the Bible who buries his master's capital and suffers later for not making the most of it.

So I gave up the comfortable confines of backup singing and made a go of a solo career, only to find that nobody outside the business remembered who I was. It was already the era of MTV, and record executives were looking for the next Talking Heads, not for someone who hadn't been on the charts for twenty years.

(And when the records were mine, as opposed to other artists' songs that I sang backup on, most of them were under group names like the Crystals and Bob B. Soxx and the Blue Jeans.) So one by one, like pearls rolling off a severed strand, everything that I had built up over a twenty-year career started to slip away. First my house, then my jewels, then eventually my husband, who wasn't interested in life without the lovely extras my income brought in. While I tried to scrape together a gig here and there, I held firm to my promise not to return to backup singing, even when that meant working at a friend's cleaners, sleeping on friends' sofas, and now, cleaning other people's houses.

"Start with the master bathrooms, Miss Mitchell." The live-in housekeeper and the lady of the house knew me as Darlene Mitchell (my married name), and I didn't want to take the chance that anyone might remember me. Once I arrived, I found it easy to throw myself into the "day work," as it's called; as I said, there was an awful lot of house to clean, and some of those gold faucets in the bathrooms could take the better part of a day to restore to their natural luster. I tried to avoid any real contact with anyone else in the house, especially if there were teenagers, who might recognize me. Once or twice the people I was working for tried to get friendly, and even accused me of being standoffish.

"The lady of the house wants to get to know you better," said the live-in housekeeper.

"Tell her I appreciate it," I said, "but I'll just do my work and go."

As strange as it felt cleaning someone else's piss off the toilet rim—when only a couple of years ago I wasn't even cleaning my own piss off my own toilet rim—it was honorable work. I was

making fifty to seventy-five dollars a day, I wasn't doing anything illegal, and my mother had done the same kind of work when she was raising her kids. The hardest part, as I said, wasn't the work itself but the drive over every morning. I still had the Mercedes I bought—and paid for—in 1975, and I clung to it as the last reminder that I had once been the singer Darlene Love. The only problem was that I couldn't drive it all the way to the job. If the people I was working for had seen me pull up in that car, they would have asked too many questions. They were perfectly nice people, but they just wouldn't have understood a maid with a Mercedes. It would have upset the apple cart of class expectations. So I parked it down the road and walked the rest of the way up the hill. A maid with a Mercedes would be the same as a butler with a Rolex, a toll taker in a tuxedo. A maid with a Mercedes just wouldn't know her place.

The scary part was that I *didn't* know my place anymore. I'd had a No. 1 record. I'd been on television and in the movies. I'd sung with everyone from Frank Sinatra to Roy Rogers, from Elvis Presley to Doris Day. I'd performed all over the world. I'd made—and lost—a couple of small fortunes. True, I'd had most of these experiences as a backup singer. But I always said, when you're a singer on the side, sometimes you have the best view.

Now my only view was of dirty sinks and toilet rims. As I made that drive every morning to the Hollywood Hills, I began to wonder, for the first time in my life, if God had given me the wrong directions. How had He led me to this place? I needed every ounce of faith I had to get through those times, especially on the days when I would crash into one of my old songs on the radio. Once, around Christmas, I even thought I heard my own

voice coming down the hall of the house I was cleaning, singing "Christmas (Baby Please Come Home)." I wanted to throw my dust rags up in the air and shout, "Hey, that's me." But I couldn't. Because in so many ways, it wasn't me anymore. "And I forget all of my dreams," I sang in "He's Sure the Boy I Love," in 1963. That now seemed like a lifetime ago. How prophetic those words turned out to be. On those days, I would need God to wipe away my tears. . . .

CHAPTER I

An Early Baptism

In the beginning, there almost wasn't a beginning. At least there wouldn't have been if my mama had had her way.

Ellen and Joe Wright, each barely twenty years old, had married in 1939 and piled themselves, their belongings, and their dreams into a single room in a boardinghouse on the east side of Los Angeles. Ellen's high school graduation dress still hung in the closet when she found out she was pregnant with their first child. When their son, whom they named Johnny, arrived on May 22, 1940, he filled up the last corner of that tiny room in a house where everyone shared a bath. And then, a few weeks before Christmas, with Johnny not even crawling yet, Ellen got an early present.

"Lord, how could I be pregnant again?" she remembers thinking. "I didn't know a lot in those days, but I knew I didn't want to have another baby so soon." The days when birth control was just down the hall in the medicine cabinet or around the corner at the pharmacy hadn't reached the corner of Compton and Thirty-third streets. "We didn't know about that stuff," Ellen says.

Abortion, of course, wasn't an option, either. Ellen wasn't about to trust her life to some back-alley entrepreneur with a dirty knife looking to make a few extra dollars off the misfortune of young, mostly poor girls. But through the wife of a friend, she thought she might know of a safer, cleaner way.

"They were a couple, Johnnie May and Eldridge," Ellen says. She had dated Eldridge when she was in high school and stayed friendly after they were both married to different people. "They said they knew of a foolproof way to cause a miscarriage. We got home one day and they ran the hot water in the tub." According to these "experts," the fetus, only a month or so along, wouldn't be able to stand this scorching, unholy whirlpool. But no matter how many times Johnnie May dunked Ellen—while Joe and Eldridge waited in the front room—the baby wouldn't budge. Maybe the water wasn't hot enough. Or maybe on that day God had other plans.

After that, my parents decided to stop challenging God's will, and on July 26, 1941, I was born, seven pounds fourteen ounces, none the worse for my early baptism.

"I didn't know it was you when I tried to lose you," Mama says. "But then you turned out to be a girl, and you were beautiful." There would be three more children: Joseph Jr., born in 1943, Edna in 1944, and Alan in 1946, plus one stillbirth.

And then my parents discovered the rhythm method, and at age twenty-five, Mama was through with being pregnant. It took her almost fifty-five years to tell me this story. It's easy for us to joke about it now: "I tried to get rid of you, hah, hah, hah," and "We didn't get the job done, hah, hah, hah." By now, the pedestal I had put my mother and father on was set in stone. If she had told me earlier, though, I might not be laughing quite so much.

My father was sixteen years old when he left Port Arthur, Texas, for the more temperate climes of Southern California. He wanted to be a doctor, but there was no money anywhere for him to go to college, and there were no jobs, even for a man as strong as he was. He had dark olive skin that would turn bloodred in the summer, and though he barely topped five-eight, he was athletic and powerful, with taut, bulging muscles on his arms like a row of baseballs. The best that Texas had to offer him was a freight train headed west, where his aunt Emma had already moved. He was running from trouble. "He didn't leave because he got into any," says his sister-in-law Melissa. He was running from what almost certainly lay in store for a smart, athletic black man in a place where no one cared to recognize him as either.

The line between memory and wishful thinking blurs and sometimes dissolves altogether when parents remember their glory days. The world is populated with brilliant brain surgeons, dancers, architects, and other climbers of life's highest peaks whose ascents were halted "when you kids came along." But my father really did want to be a doctor; he enrolled in Jefferson High School in 1936 when he got to California, and knew that

to better his chances for getting into a pre-med program, he would have to learn not just higher mathematics and science but also Latin, a subject he immediately failed. Undeterred, he took it again the next term and got an A. The dream, at least until he graduated in 1937, was still alive.

He was living with Aunt Emma then, scrabbling together any money he could, working on the roads with a jackhammer for the county and shining shoes on the side. He made enough to live but not anything to save for college. And then there was another distraction living right across the street, a high school girl named Ellen Maddox.

Ellen's family had wound its way from Little Rock, Arkansas, to Detroit to Los Angeles, her father, Leroy, following his brothers wherever they went and found work. Not that *he* ever worked a day in his life; he managed somehow to be both a chauvinist pig and a liberated male, in that he insisted on setting the rules as the man of the house but let the women in the family go out and earn a living. My grandmother, Edna Maddox, a granite-built woman with a pot-boiling mix of Spanish, Irish, and African ancestry, put up with him through four children: Ellen, Leona, Melissa, and Leroy. They lived on Compton Street amid the working poor, my grandmother bringing home the bacon, my grandfather supplying all the emotional sustenance. He came equipped with copious amounts of affection and anger: One minute he would slobber over his kids, the next he was whipping his belt out of its loops and laying on the leather. Once he slapped my aunt Melissa across the room when she was long past her teens, and she grabbed a bottle, broke it, and came right back at him. "We were the best of friends after that," she says. "I don't think he ever hit anyone ever again."

My grandmother was a cool customer, though; she loved her children, no doubt, but there were no extravagant kisses, hugs, hosannas, or gushes of affirmation coming from her lips. (My mother would get this trait, too.) Ellen, her oldest daughter, was beautiful, not like a movie star but more like a Rose Bowl queen, an almost-knockout. She had light skin, what is called a high yellow. (I got this from her, and apparently we both got it from our Spanish and Irish ancestors.) She always knew how to put herself together, whether she was in ponytails or a beehive. Her nose was thin and long—we called it the family curse. Lord, I was happy I didn't get *that* from her, but she also had long, gorgeous pinup legs, which I also didn't get. The girls in the court where she lived were all jealous of her looks, not necessarily because she was a natural beauty but because she knew how to make the best of the goods she had.

Ellen didn't have a lot of self-confidence then, but she had enough to be unimpressed by the young man who was suddenly turning up everywhere when she was going to high school: Joe Wright. In those days, Ellen attended Los Angeles High School, along with maybe ten other black kids. It was in the neighborhood where her mother cleaned houses, and the people she worked for let her use their address. That meant Ellen had to take three buses to school, rising at dawn and getting home after dark. But Joe was persistent. No matter how late Ellen got home, he was waiting for her every day in a grown-up "can I carry your books" kind of way. She basically ignored him those first weeks, but he was undeterred, trailing her on the weekends when he wasn't working or when she was going to church. For every cold shoulder he got, he came back with a bigger bouquet of roses or, if he couldn't afford that, a smile that seemed to

feed on my mother's rejection. It took almost a year, but he wore her down. A few months after they officially started keeping company, they were engaged.

Her parents weren't too happy to get this news. They had big plans for her to go to college back east. That was the whole reason my grandmother insisted that Ellen attend Los Angeles High School—its academic credentials were better (which I guess meant whiter). But my mama made no bones about her own ambitions, despite the fancy high school she was attending. "I didn't want to be a nurse or teacher," she says. "I just wanted to be married, period." It was, she figured, the easiest way out of the house, and a lesson that I would, regrettably, learn only too well from her twenty years later.

But before they could get married, Joe had to convince Ellen's father that he had enough money to provide for her. "I think he had about three dollars in the bank," Mama said. "So he just took a straight pin"—that's the way bankbooks were stamped in those days, with a punch that made holes when a transaction was done—"and added a few zeroes." Her father saw the bankbook, and not long after that a date was set. A month after Ellen graduated from Los Angeles High School, they were married. And a few weeks after that, she turned eighteen.

Joe, meanwhile, was a ripe old man of twenty, and as my aunt Melissa remembers, he was "a bit of a shady character." I guess she was referring to the business about the bankbook, or maybe the scar that he had on his cheek, and the brief stint he did in prison while my mother was pregnant with my brother Johnny. It was my father's athleticism that got him into trouble; he was a great tennis player, but had no racquet in Los Angeles, and so one night decided to help himself to a five-dollar model

at a sporting goods store a few blocks away from the house. He wasn't counting on running into the owner, though—or the owner's shotgun. The man fired, and almost simultaneously my father felt his head do a sudden quarter-turn away. "Lord, he always said that bullet was headed right for his brains," Mama says, until God turned his head away and it just grazed him. He did his time and came out ready for his new life as a saved man. Advantage: God.

While he was in prison, my father kept feeling God's hand on his shoulder. And sometime soon after he got out, the tap became a tug and the tug a magnet, drawing him toward salvation. My whole life I have never known anyone closer to the Lord than my father. My mother says that on the day he was saved, my father stayed after services until the whole church had emptied out and everyone had gone home, and he walked up to the altar, where the heavens opened up and he saw the Lord. That's when he was told to go out and preach. He never did tell her, or me, what the Lord looked like.

Los Angeles in the thirties and forties was a city that existed mostly in people's imaginations. On the one hand, you had Hollywood and the era of MGM extravaganzas, of *The Wizard of Oz* and *Gone With the Wind*; on the other, you had the dark and mysterious worlds of Nathanael West and Raymond Chandler. But for us Los Angeles had nothing to do with movie stars or stubbly, hard-drinking gumshoes trying to piece together broken dreams after hours. For us Los Angeles was contained in about twenty blocks, bookended on one side by our projects and play-grounds and on the other by church. And in our minds, church

was more than just a bookend. It was the border and the whole perimeter. As for the rest of it, it might as well have been New York, that's how close we felt to it. My parents bounced around this grid from boardinghouse to boardinghouse until they finally settled in, with all of us, at 887 1/2 42nd Street, three and a half rooms that, had they been located near the beach, might have made a nice bungalow for a swinging single. However, for a family of seven, it was a little tight. There were six houses in this court, three that stood one behind the other, and behind that, three in a row across like the top of a "T." The narrow alleys behind these houses were our own personal playground, because there were no other kids in this court. The units were so small, no one in his right mind would try to raise kids there. But for my parents, the price—eleven dollars a month—was right. They took the bedroom, and we five kids squeezed in on the couch in the living room. We burned our trash out behind the house. These were the days when people could still do that, before the freeways ushered in the age of smog.

After my father was saved, he rose quickly through the storefront churches in the neighborhood, from parishioner to junior elder to assistant pastor at Pentecostal Assemblies of the World, near Compton Street. Daddy was truly on "God's payroll," which meant that his only compensation was the riches his soul was gathering. Assistant pastors didn't get paid. Though the members of the congregation tithed, they were still dirt poor. Ten percent of nothing still adds up to nothing. The few pennies from the weekly collection plate went toward the maintenance of the church, a little white building that fit maybe one hundred people, and for church dinners and programs. Whatever was left went to the pastor.

So Daddy had to keep a full-time job in addition to his church duties. He worked the roads until he hurt his back using a jackhammer when I was still a baby. Today he'd get a nice worker's compensation settlement, but in those days the best offer the county made was to give him a night job cleaning buildings. My father wasn't too proud to take any work, as long as it was honest labor. When he wasn't cleaning buildings he was shining shoes on Saturday mornings in front of the Sears Roebuck building. He would read his Bible and write his sermons and prepare the church programs early in the mornings or late into the night. We'd often wonder when he slept. "No rest like rest in the Lord," he'd say.

My mother, though she attended church regularly, wasn't saved until a couple of years later. "And what were you doin' all that time, finger-poppin'?" I asked her recently.

"Oh, you know, I was just doing whatever young married girls did." Right, young married girls who had five kids before they were twenty-five. My daddy used to joke that he got down on his knees and asked the Lord to save Mama, praying these words: "Look, you either save her or I'm going back out there with her." I can understand her reluctance; the PAW, as my father's church was known, was one of the stricter Pentecostal churches, especially for women. You couldn't wear jewelry, or makeup, or shoes with toes or heels showing. I think my mother finally opened herself up to God initially as a way to be with her husband more, because when he wasn't out working he was at church. She was saved in her mid-twenties, and not long after that became Sunday school superintendent, which meant that there was no escaping Mama's eye, because she sat all five of us in the front row. "You were the best-behaved children there,"

she says. We didn't have a choice in the matter. Then there was afternoon service and "youth activities." Sometimes my parents would even take us home, put us to bed, and drive back in my father's 1932 dark blue Pontiac with a rumble seat. Five children under ten left alone on Sunday night. "We just prayed over you before we left, and you were safe," Mama says. Lord, the state would call it neglect. My parents called it faith.

It wasn't easy being a PK (preacher's kid). There were so many rules—besides the prohibitions on appearance, there was supposed to be no dancing, no real fun of any kind. Baptists had it so much easier than Pentecostals: They were allowed to be out in the world a little more, and to show a little more of themselves to it. Baptists could even smoke cigarettes! But my father knew that if we were going to make our way, we needed some balance, so he did let us go to the movies and let us whoop it up at home and in the courts. Thankfully my parents didn't completely forget their "former lives." My daddy still loved sports, and kept up with his teams, and always had his nose in a book or a crossword puzzle. Even a man as devout as he was needed a coffee break from religion.

My earliest memories include Saturday afternoon walks with Daddy over to Central Avenue, where many of the black entertainers performed and had offices. Mama would doll me up—my nickname was always Dolly—and Daddy would take me out for his special time with him. But we weren't looking for Lena Horne. Daddy took me to the barber and the grocer and the cleaners: "This is my Dolly," he would say, showing me off. In these early days I formed a closeness with Daddy that would last until the day he died, long after I'd become a mother and a singer. Even when he was at the park playing baseball with my

brothers, he'd include me, because he knew how much I wanted to play, even though I was small. (I could hit the ball, though.) Daddy was gone so much, between his regular job and his duties at church, that we had to make the most of the time when he was around, and I think because I was his oldest daughter he never lost that special place for me in his heart. The affection between us never swerved from the days of those walks on Central Avenue. As I got older, Johnny and I would pair off and go for walks, too. "I liked having her around," he remembers, "because she never said much. Dolly was always humble. She'd answer you if you asked her something, but otherwise she'd let you do the talking. My father wanted me to go around with her because even at that age, young boys were noticing her, boys who were about three or four years older than we were."

Mama, strangely enough, was more of a mystery to me, even though we saw her more. This was partly because she inherited her own mother's cool-heartedness, and partly because she had to manage the care and feeding of five children without much help from my father, who was always out working. So she kept her distance. She wasn't very quick to praise us, but Lord, step out of line and there was no loss for words. We knew we had stretched our limits when she got to "Are you children trying to drive me crazy?"—the next step over the line meant feeling the back of her hand. Still, I remember that as a child I admired her from afar: how beautiful I thought she was; how her clothes, what few she had, were spotless; and what a great cook she was. I appreciate this even more now, because she didn't have much raw material to work with. Give my mother some cornmeal and beans and she'd turn it into a week of feasts.

There's an old cliché that goes, "We didn't know we were

poor," and in our case that was true enough. Even in a house—more of an address, really—where all the kids slept in the living room and we ate corn bread and beans most nights, we still managed to have birthday parties, some with fifteen children in attendance. We also went to big dinners at church on Sundays and often spent Saturday afternoons at the movies. I don't know where the money for these treats came from—though my mother started taking day work when we were old enough to be left alone. Just as when she was a student at Los Angeles High School, she had to take two buses and a streetcar to clean the houses of rich women on the other side of town. She never resented this work; her mother had done it, and, moreover, my mother was proud because she was good at it.

I'm astounded now to think how often we were left unsupervised in those days. The same method my parents used when they left us alone to go to church on Sunday nights helped to keep us healthy—we simply couldn't afford to get sick, so they'd pray over us, and basically it worked. The only doctor bills we had were for Edna, who was born with eczema, which was so severe that at one point my parents had to tie her hands down in bed so that she wouldn't scratch her skin off in her sleep. This ailment gave Edna admission to the one sympathetic corner of my mother's heart (and also got her out of a lot of chores as the years went on).

And if we didn't know we were poor, we certainly didn't "know" we were black, either. There were whites in our development, there were whites in our school, and there were even whites in our church. Los Angeles wasn't as populous in those days, and white, blacks, and Mexicans mixed peacefully for the most part. "I had a white girlfriend around the corner," Johnny

remembers, "and I never even thought about it. I went over to her house and her family was always happy to see me." Our school was about 70 percent white, and we were never made to feel unwelcome. All the parks had open access. My daddy was a great golfer, at a time when blacks were never seen on golf courses except maybe as caddies. Daddy, in fact, started playing golf long before Tiger Woods's daddy was a gleam in *his* daddy's eye. He would think nothing of rising at five A.M. and getting on the course before most of the other golfers arrived. "There's no law that says I can't," Daddy said. "Call the cops." He raised a few eyebrows, but no one bothered him. In California, we did a lot of things that black folks "wouldn't do" elsewhere simply because we never learned the racial divide.

CHAPTER 2

"Y'all Can Pass"

*I*n 1951, when I was ten years old, there was a mild scandal at the PAW. One of the assistant pastors got caught with his hand in the till. Not that there was all that much to steal, but the man was removed, and because he was a friend of my father's, there were mutterings that my father was involved, too. It wasn't true, but it left a bad taste in my father's mouth about the PAW, and he started telling my mother that it might be time for him to find another church. As chance would have it, around this time we were visited by Bishop Robert Lawson, a Pentecostal legend who headed the Church of Our Lord Jesus Christ, in New York. Bishop Lawson, before he was saved, played piano in nightclubs, and that's where he saw the Lord,

in a whirlwind on the stage, telling him to go out and preach. Who says the Lord doesn't swing?

Bishop Lawson had just been evangelizing in Texas and had a group of believers who needed a church in San Antonio. He offered it to my father, and soon we were packing up and heading east. Our excitement about the train ride we'd be taking—our first ever—was tempered by the fact that we had to leave almost everything behind because we couldn't afford to ship it. The parsonage we were promised was furnished, and everything else we'd have to save for all over again. This meant leaving behind the few toys we had, including my roller skates and the beloved Schwinn bicycle I'd won by selling newspaper subscriptions. Only Edna got to bring her dolls—she just cried so loud that my parents gave in.

Little did we know what kind of life awaited us in Texas. In fact, we had a taste of it on the train, which had segregated dining cars. We had almost no experience with prejudice to this point, so we looked upon this cordoned-off area almost as a novelty. This was just the beginning, though, of the "new" places we'd soon be visiting. These places had names like the back of the bus, the back of the line, the coloreds-only section. Daddy, of course, had experienced all of this when he was growing up in Texas, but the integrated life we lived in California had dulled his memory, or else he figured that there must have been some improvement in the fifteen years he'd been gone.

The excitement of the trip wore off quickly when we got to the house and saw just how shabby it was. It was a brown wood frame with linoleum floors throughout and flowered wallpaper that was yellowed and ugly. Some of our coloring books—the ones we left behind—had more intricate designs. Thank God

Daddy knew how to paint, but it took him almost a year to peel all that hideous paper off the walls. Everything in the house was in various states of disrepair—the faucets, the toilets, the bunk beds. In some places on the floor, you could see clear through to the foundation. The furniture was borderline Goodwill—in other words, a few sticks pasted together here and there. Welcome to the Promised Land, Pastor Wright.

At least there were lots of pecan trees in the backyard, which meant pecan pies, cheap. Daddy's job was supposed to have a salary, my father's first as a church official. But of course it wasn't enough to support us, so for a few years he had to get a job with a printer. We had no hot water, and in the summer it was hotter than hell, which made everyone's hay fever unbearable. Edna's eczema got so bad that she became a regular at the emergency room. Only when Bishop Lawson came to stay with us a few years later did they decide to take up a collection so that a hot-water heater could be put in our house.

Once my daddy had his own church, he really came into his own as a preacher. You've heard of fire and brimstone? Lord, the Devil himself never saw this much fire. Daddy was such a commanding presence, jumping all around the altar like a pogo stick, up, down, sideways, always seeming to veer out of control and then when you weren't looking landing smack in the middle of your face, locking your eyes with his. And his voice, Lord, it was like an ocean roar. Daddy didn't need any microphone. With that much projection, he could have been a featured voice in the choir (except he couldn't sing a lick). The man felt like an ocean, too; if you sat in the front row, you weren't showered just with my father's wisdom on the Word, you were showered period. The man could sweat.

The first sermons I remember him preaching were about Joshua and Jericho, and Moses and the burning bush, and he was so demonstrative you felt as if you were in the middle of a Charlton Heston movie. His arms would windmill and his body would quake and blaze. But it wasn't all just pyrotechnics; the message got through, too, even to my antsy ten-year-old self. This was where I remember Daddy preaching that the Devil couldn't read your mind. He might put some temptation there, but he never knew what you were going to do until you did it. When Daddy spoke from the pulpit, you got something from it, no matter how old you were.

Early on my father faced his first big challenge with Sister Ruby Dukes, one of the missionaries. In all my years in Pentecostal churches, I never met one of these black-robed battle-axes that I liked. They were always so full of themselves, marching up to the altar with the eucharistic wine, as if it had been placed in their hands by the Lord himself. As far as I was concerned, though, the chalices might as well have been filled with bile. These women were so nasty, they were enough to drive anyone to Buddhism.

No one remembers just what she did, but Sister Dukes crossed some line that required my father to silence her. This was akin to temporary excommunication, though Sister Dukes was still required to attend services and suffer her punishment publicly. My father was thirty-two years old and raised a lot of the elders' eyebrows: "Who does this young whippersnapper think he is, coming in here and disciplining one of the missionaries?" But their rumblings went no farther than the church socials, and no one would ever challenge my father's authority. From the beginning, he let them know who was boss.

My daddy wasn't all business, even when the business was God. We eventually saved enough money to buy a TV, and we watched *Kukla, Fran & Ollie* and Milton Berle. And on Saturday nights, if we had enough money, we all piled into the car and headed for the drive-in. This was where we had our first really sour taste of segregation. There was an entrance for whites and one about a mile around the corner for blacks. The concession stands were separate, too: the whites had to walk a stone's throw to their fancy, modern refreshment kiosk, while ours was an old shed half a mile away, where the soda was flat and the popcorn was left over from the Depression. Finally, after our third or fourth time, Daddy sent Mama and Edna to the whites-only stand. They had both inherited the complexions of Mama's Irish and Spanish relatives. In the dark, Daddy said, "Y'all can pass." And so they did. Daddy had always asked his congregations to pray for equality, but after we lived in Texas it became a local as well as a global prayer. After living in California, we really did have to learn to be second-class. Here were the nice things (for the whites) and here were the ugly things (for the blacks). The whole idea of making us feel that we weren't as good as white people was a joke to me, since I had lived in California long enough to know better.

Just as my daddy found his voice in the pulpit in Texas, so I was assuming a new role in the house: acting head of the family. Mama went to work cleaning houses almost as soon as we got to Texas, and now that I was ten she started making me responsible for the cooking, cleaning, and baby-sitting at home. I was the one who made sure everyone got off to school and who had to mind the house until Mama got home in the evenings. If I wasn't cooking or washing dishes or ironing my brothers' and

sister's clothes, I was playing referee. After a couple of years I started being the counselor, as everyone came to me with the problems they were having in school or with girlfriends. I don't remember Mama ever thanking me for essentially doing her job. The only occasions she did comment were when I didn't finish all the household chores. One day I forgot to iron my brother Johnny's pants—I had been talking to my friend Peggy Boyd—and Mama didn't even stop to rant. She grabbed a metal ruler and rapped me across the mouth. I still had the impression on my face when Daddy got home that night, and when he found out what happened, he took Mama into their bedroom and wrung her out. Johnny remembers hearing Daddy say: "Ellen, stop and think about what you're doing. You've got to stop acting on impulse." It wouldn't be the last time Daddy came to my defense. Edna remembers another occasion when Mama was hauling off on me and Daddy dragged her away and said, "You are not to lay hands on my children." These incidents polarized the family, at least in my mind, drawing me ever closer to Daddy and further away from Mama.

Daddy may have stayed Mama's hand in those days, but that didn't stop her from pressing me into service or offering me to relatives who needed some housework done. About a year after we got to Texas, Mama and Daddy were having such a hard time making ends meet that they farmed all us kids out to different relatives. Edna and I were sent to my father's sister Dorothy, who lived in Port Arthur, where my life became a nightmare out of Dickens. When I wasn't going to school, I was scrubbing stoves, cleaning blinds, mopping floors. As usual, I did whatever I was told. Edna, of course, was always too young and too cute and too sick to help. But it was she who finally wrote to my fa-

ther and told him what my life had become. "You have to come and get us," she said. "They're treating Dolly like a slave." My parents did come and retrieve us, several months earlier than expected. I still had to do all the cleaning at home, but now at least it was my own house.

Whenever I did get to escape from household chores, I usually spent time with Peggy, who was my best friend and whom I met because her father worked with mine in the print shop. I liked her because she was unusual-looking: eyes too big for their sockets, it seemed, always a little overweight, and kind of an outcast at school. I thought of myself as an underdog, too, mostly because I was the one catching most of Mama's wrath at home, and so I sensed a kindred spirit in Peggy. Most of what was good in Texas happened when I was with her, even when we got into trouble. Peggy was a Baptist, and as I've said, they were allowed to indulge in some more worldly pleasures than the Pentecostals were (that is, they weren't afraid to let the Devil get a little closer). And in the mid-fifties, this meant that when I went to Peggy's house I heard some of the new rhythm-and-blues sounds that my parents would never let in our house. The artists—the Robins, Johnny Ace, Jesse Belvin—were making what were still called "race" records, a potent blend of country and urban blues and Southern gospel, and the precursors to rock and roll. And the lyrics! You never heard anything like them in church! The music was sweaty and thrilling and a little licentious. Some of the lyrics on these records were so bawdy, we felt as if we were learning about sex. Peggy had two in particular—"Work with Me Annie" and "Annie Had a Baby," by Hank Ballard and the Midnighters—that should have been sold in plain brown wrappers with girlie magazines. We sneaked one

of these records into my house when my mother wasn't home and told Joseph and Edna to be on the lookout in case they saw her coming down the street. And we played the record over and over again, whirling around the room while Hank Ballard was throwing down about his knocked-up girlfriend. What we didn't know was that our lookouts had fallen asleep on their watch (which meant they were probably playing in the backyard) and that Mama was in the kitchen listening all the way through to "Annie Had a Baby." She stormed into the living room, ripped the record off the phonograph, and threw it against the wall, where it smashed into a few dozen pieces. "But, Mama, that's Peggy's record . . . ," I cried. "I don't care!" she yelled. "I cannot believe you have brought that filth into this house." I expected another beating from Mama, but I think she got so tired from screaming that she just let my father take care of it.

But all that I got from Daddy was a stern warning about the ways the Devil could tempt young people, all dressed up in a swinging bass line. Johnny remembers that Daddy would threaten us calmly when we got out of line by telling us he was saving a lot of our misbehavior up and then he was going to whip us for everything bad we'd done, "starting from Day One." "I think this actually scared us more because we were afraid we were going to get the beating of our lives," Johnny says. In fact, in my whole life Daddy hit me only once, not too long after this incident, when he caught me in a lie. Peggy and I had gone to the movies alone one Saturday—which was forbidden for both of us—and decided to tell our parents that each of us had been at the other's house. Little did we know that our parents had been looking for us and had spoken on the telephone. When Peggy got home, she caved almost immediately, but I kept my

end of the mendacious bargain. "Where have you been, young lady?" my father asked.

"Oh, with Peggy," I said.

"Mmm-hmm, and where were you?"

"Over at her house."

"And what were you doing?"

"The usual, talking, listening to records."

Daddy just kept letting me dig a deeper and deeper hole for myself, and finally told me he knew I had been lying all along and whipped me with his belt. It wasn't so much the first lie that bothered him, but the fact that I kept on lying. Unlike the irrational beatings I would get from Mama, though, this one was deserved, and I never resented Daddy for it.

Texas became a little more bearable as the years went on, not because the prejudice eased up, but because I started to love the people at church. Now that I was a teenager, I could participate in more activities, and our youth group took trips to the Alamo and was very involved in the weekly church programs. This church was even smaller than the one in California—with no more than fifty members at any one time—but it felt like my extended family. We went to the malt shop on Sundays after church, just like a lot of teenagers in the fifties, even though it was the "black" malt shop in town.

I was also feeling the stirrings of sex during those hot Texas summers, and Lord, almost as soon as I realized I was interested, I had not just a boyfriend but a bona fide gentleman caller, a church member named Cliff who lived three doors down from us. On the surface, he was a clean-cut all-American type, a great athlete who played tennis with my father. (My father was as ahead of his time in tennis as he had been in golf—there weren't

many well-known black tennis players yet. Althea Gibson was still a few years before her first Wimbledon crown, and Arthur Ashe was still in grammar school.) Cliff was twenty-four, almost as close to my father's age (thirty-six), as to mine (fourteen), and despite the surface virtue, we always said he had a little "world" in him. He smoked cigarettes and drank beer and ate cloves to cover the smell of his breath. Whenever somebody would question this behavior, he'd say, "Do as I say, not as I do." And though he was a friend of the whole family, he started paying more and more attention to me. First he bought me sodas at the community pool. (This, too, was a "coloreds" pool, one that we had to walk three miles to early in the hot summer mornings. If we didn't leave by ten o'clock, it would be too hot to go.) Then he taught me how to swim, and even in my fourteen-year-old naïveté I knew that I was excited by more than just mastering the backstroke. Cliff would swim through my legs or throw me in the pool, and one day I was so carried away that I got up the nerve to kiss him, a quick swipe across the mouth.

"What do you think you're doing?" Cliff said, pretending to be scandalized.

"I . . . I thought I was kissing you," I said.

"No, no, that's not a kiss. *This* is a kiss." And he pulled me close to him in a clinch that I thought would last forever (because I was sure the heavens would fall on us). After we locked lips that day, there was no reason to be coy. Cliff started walking me home, and the second or third time he invited me into his house. Even though I knew I was probably letting myself in for trouble, it was all so unreal to me. How could I have gone from getting my first kiss to being in a man's house alone in so short a time? Lord, was I nervous.

Cliff put on some music and offered me a soda, and then we just sat on opposite ends of the couch, and I remember thinking I could really leave any time I wanted. Cliff had other ideas, though. Slowly he inched his way down the couch and said, "Let's kiss again." So I let him kiss me some more, and liked it, and then he started rubbing his hands all over my body. I pushed him away, but I didn't move off the couch. After a few more minutes he took my hand and led me into the bedroom, where he took off my pants and then his own, and when I looked at his naked lower half I screamed. Lord, there was a lot of him there. He tried to calm me down, and we made an effort to have sex, but Cliff was just a little more man than my fourteen-year-old body could handle. Sister just couldn't hold it.

I started crying, and Cliff begged me not to tell my father. Nothing to worry about there. These proceedings might have been too hard a test of even Daddy's patience and understanding. Cliff didn't come around as much anymore after that, and I never mentioned him. One day, out of the blue, Daddy said, "You know, Cliff used to talk about how he wished he could marry you. Maybe we should just leave you here if we ever decide to go back to California." I was scared, and angry, and tempted to tell Daddy just how close I'd come to losing my virtue to that very man. But I held my tongue, and turned on my best fourteen-year-old charm, saying something like, "Oh, Daddy, what would I do with so *old* a man?" Of course I couldn't tell Daddy that it wasn't Cliff's age that concerned me most.

I got over this incident, and my preoccupation with sex and boys, pretty quick, because there was another discovery I was

making during those miserable Texas summers, right in our living room. I found out I had a voice.

I had always sung in the youth choir at church, but the elixir of modesty, imbibed from earliest childhood, kept me from ever really hearing myself. It wasn't until I was about thirteen years old that I got hold of a stack of Mama's Marian Anderson records—God's greatest hits like "He's Got the Whole World in His Hands" and "Twelve Gates to the City." The power of this music was so overwhelming that I was able to shake the warnings in my head telling me not to stand out and not to be proud. I began to shake loose the reins on my imagination, too. I started imitating Miss Anderson, that low, rumbling alto, that voice that called angels to attention. Standing there flat-footed next to the Victrola in the living room, I was shocked, embarrassed, and secretly in thrall to what was coming out of my mouth.

I started joining glee clubs at school—Wheatley Junior High in San Antonio—and a group called the Wailers, who sang at school assemblies. But God was always my most dependable audience, and I continued to sing at church, with a new confidence that led me to audition for some solos. Mama was so surprised because she didn't even know I'd been listening to her records.

You hear stories of so many of our great singers who experienced some kind of transfiguration when they started to sing, a wide column of God's light shining down on them and changing them from just another teenager into a gravity-defying Voice. I wish I could say the same. But after these concerts in the living room, even after I started getting some solo spots in

Daddy's church at Christmas and Easter services, I went back to being Dolly Wright, a churchgoing, smart-mouthed fourteen-year-old who occasionally sneaked a smoke at my friend Peggy Boyd's house, where we did the Seven Step to the latest pop and R&B hits. Peggy was always proud of my voice, but for all the time we spent together just talking and gossiping, so few of these conversations were about singing. I always said I was glad I wasn't on the stage at three years old. Even after I started making a living as a singer, I never thought of myself as a Singer.

Singing *did* do a lot to improve my relationship with Mama, though. Up to this time she still, at least outwardly, had only fillips of affection to pass out, and most of them went to Edna, who had started singing herself by this time, also at church, though she was only about ten. I thought that Mama was jealous of my relationship with Daddy, and that singing would only make it worse. But instead she became my greatest champion, and even encouraged me to sing outside of church and school, at tea parties and the like. The material didn't stray very far: songs like "He's Got the Whole World in His Hands" and "Trees." But it wasn't long before Mama started hearing the stage whispers at church. "Look at her up there, the preacher's daughter and her proud self." "If you don't like what you're seeing," Mama cut back, in no particular direction, "why don't you close your eyes?" She never told me who these people were, but I would have bet the week's collection plate they were missionaries.

After five years in Texas, Daddy had had enough. The heat was unbearable, the prejudice even more stifling, and the church

kept making him do too much for too little. He was given total responsibility for running the church but not a living wage. By 1956, he was still working an extra job to make ends meet. He was also struggling with the Pentecostal doctrine that frowned on other faiths. He started "mixing" with Baptist ministers, attending some of their services and inviting them to his church. This was against the rules, but Daddy realized that there were Catholics and Baptists and Muslims who would be in heaven, and probably a lot of Pentecostals who wouldn't make the cut.

Early in 1956, he started talking about heading back to California and made some inquiries with the "home office" in New York about finding a new church there, but they told him they wanted him to stay in Texas. Daddy decided to take his chances, though. We packed up in the summer and headed back to L.A., without the blessing of Bishop Lawson's organization.

We moved into a house on Flower Street, the house that my mother lives in to this day. It cost eleven thousand dollars in 1956. With every house we stepped up another bedroom—this one had three—and I loved the cherry-red door and the huge palm tree in front. After the desert in Texas, California was like an oasis, and a real one, not a mirage. Years after we moved there we were going out to dinner, and my father got out of the car at the end of the driveway and just stood in front of the house with his arms raised. "What are you doing, Daddy?" came the chorus of hungry voices from the car. "Just stationing my ministering angels," he said. When Mama had bars put in the windows a few years after he died, I could almost hear Daddy saying, "Where's y'all's faith?"

When we got back in '56 we were greeted by two new structures that would change the face of Los Angeles, as well

as the whole country: freeways and rock and roll. When we left in '51, the freeways were just getting started, and we used to roller-skate and ride our bicycles up the unfinished ramps. To my ten-year-old eyes, they were like a concrete amusement park. They were finished when we got back (and the smog had already started to settle in). Soon Los Angeles was saying good-bye to the streetcars and hello to traffic jams. To us the city would never again be confined to a twenty-block swing.

By the time we moved back, the roles in our family had pretty much become set. My brother Johnny was the loner. He'd go off for hours playing basketball and we'd never see him until late at night. Sometimes you never knew where he was going or what he was doing. But whenever somebody started giving us trouble, he always seemed to be around to protect us. All my brothers were built like my father, small but sinewy, leopards ready to spring if anyone messed with us. One Saturday at South Park I suddenly found myself surrounded by a pack of young she-wolves—bad girls in jeans and sneakers and halter tops. Look at these girls the wrong way and the switchblades were popping out of their ratty bouffants. Edna was with me, and she went running for Johnny, who got between me and the approaching disaster. "If any one of y'all wants to fight my sister, that's okay. But you sure aren't going to gang up on her." They slithered away, muttering about having another chance, but with Johnny around, they knew better than to pick on me again. Another time at South Park my younger brother Joseph was the one getting whipped, and I came to the rescue. I broke a bottle and started cutting up the guy on him.

Joseph was the pretty boy, and he was always primping. He'd never let anyone touch his face, which he always, always had

in front of a mirror, going the extra mile—with the comb. It worked with the ladies, though, because he had a lot of girl-friends, most of them white. My sister, Edna, was always beauti-ful. As a baby she had a pumpkin-shaped face and blond hair and light blue eyes. She really did look white, so much that my parents almost gave her up for adoption to a white couple from church, who became her godparents. As she got older, she dark-ened a few shades, and her hair turned a sandy-red color. And everyone still felt sorry for her, because of her terrible eczema, which afflicted her long into adulthood. And Lord, her eczema still got her out of more housework! Edna was the only one whom I ever heard give my mother lip. Once Mama asked Edna to clean the house and she said, "Who do you think I am, your slave, like Dolly?" Alan, our baby brother, was a spoiled brat and a slob.

I was still the big cheese, and even though I was fifteen and pleasing Mama with my singing, I often felt like the repository of her rage. You haven't known the wrath of God until you've seen my mama come home from work on Saturday afternoon and discover that the house didn't pass her white-glove test. If she found one speck of dust, we had to do it all over again, which meant there'd be no Saturday night movie.

When we were kids Mama was the source of regular spank-ings and more thou-shalt-nots than Moses could have carried on the Commandment tablets. Being so young herself, and with my father away ministering so much of the time, I think she felt she had the right to be a harsh disciplinarian. She never spared the rod. Even when we were too old to spank, Mama was still as tough as nails, and we crossed her at our own risk.

The car culture that had sprung up in L.A. had an unex-

pected effect on our churchgoing. Daddy didn't have his own church, so he bounced around from Sunday to Sunday. The kids went to St. Paul Baptist Church, where instead of the two hundred parishioners they once had, there were now about two thousand. They also had junior and senior choirs that occasionally brought in guest stars to sing at the church or at some bigger auditoriums. During these years I saw Aretha Franklin, who was a few months younger but already years ahead of me; Sam Cooke, the gorgeous Sam Cooke; and the Davis Sisters and their caravan.

We became official members of St. Paul Baptist Church shortly after my sixteenth birthday—Daddy had become so progressive that he was allowing us not just to attend Baptist churches but to sing there—and I was still just another voice in the choir. It was just a lucky accident that brought my voice to the attention of our choir director, Cora Martin. She caught me giggling and talking with another member of the choir during practice and told me I had to sing the whole song—maybe it was "Oh, What a Beautiful City." My dander overwhelmed my shyness, and I let it rip. I thought she'd tell me to stop, but I got through the whole song, and she didn't say anything until practice ended. Then I got ready for the other shoe to drop.

"Darlene, I want you to stay for a minute."

I could only foresee big trouble. I knew I had sung the song well, but pride had no place in church, and so I thought I would be punished for the sin of shining just a little too brightly. But instead she asked if I could come down to the Music Mart, a kind of Christian bookstore where they did some broadcasts, and sing a few songs. I guess that was when my "career" started.

My three closest friends in those days were Shirley Mat-

thews, Wanda Dabbs, and Frankie Anderson, and we did everything together, from singing in choir to strutting our stuff in felt skirts and sweaters and black-and-white oxfords. My mother always made me take Edna with us because she thought we'd stay out of trouble that way. But we went to some wild beach parties anyway. Edna remembers, "There were guys drinking and kids having sex in the car. I finally told my mother I didn't want to go anymore."

We were still good girls, though. We never got into those backseats at the beach. The highlight of our years together was not the party scene but a contest the church choir won to sing with Nat "King" Cole at the Hollywood Bowl. He came down to the church to rehearse, and we thought we'd gone to heaven. Here was this suave, debonair, well-dressed, soft-spoken black ambassador coming down into our neighborhood, and Lord, he was the real deal. We were all too shy to talk to him, but just having him in our presence stirred the spirit in us. Then we took the hour-long trip to the Hollywood Bowl, past Sunset and Vine, and we had our first look at the world that movie stars lived in. Homes that were as big as our own blocks. Limousines. And white faces as far as we could see, even in the Hollywood Bowl, to see a black man sing. Though we had to return to our mostly black neighborhood in East Los Angeles, I think we all walked out of the ampitheater inspired by the great Mr. Cole. He had that mostly white crowd at his feet. And for the few minutes that we were singing "Oh, What a Beautiful City," we felt that we did, too.

A few weeks later, a girl I knew at the church, Delores Ferguson, asked me to sing at her wedding. What I didn't know was that the wedding was also an audition: Delores's bridal party

included her friends Gloria Jones, Fanita Barrett, and Nanette and Annette Williams, who had a singing group called the Blossoms. They were all a couple of years older than I was, and they were real city girls. Annette just happened to be pregnant, so they were looking for someone to replace her. As the girls were walking down the aisle, they were also scouting me. Later I'd realize that Baptist and Pentecostal choirs were something of a farm system for the popmusic big leagues: Aretha, Patti LaBelle, Gladys Knight, and Merry Clayton all cut their teeth in the choir loft.

After the ceremony, I was introduced to the girls, who complimented me on my song, which now I can't remember, and invited me to an audition for their group at their manager's office. I was thrilled that these girls who looked so grown-up and professional wanted me to sing with them. I had sung with a pop group called the Echoes long enough to make one record before the group broke up. It lasted all of a week! Now I felt as if I had just been asked to join the most exclusive sorority on campus, and enjoyed every minute of it—or, I should say, the only minute of it. Then I landed back on earth, where my father the preacher and my mother the Sunday schoolteacher weren't likely to allow me to enjoy this most secular of dreams. To them, singing pop music was like praying to the Devil. (The Echoes hadn't lasted long enough for them to get upset.) As for joining the Blossoms, my parents just wouldn't hear of it.

The girls kept asking me to sing with them, so I did the unthinkable. Somehow I made it down to an office on Selma where they were recording, and I conveniently forgot the Fourth Commandment, the one about honoring thy mother and father. The girls had a manager and vocal coach named Eddie Bill, who had

already got them a recording contract with Capitol and some session work. I just watched and listened for a while, slowly sipping my first long, cool drink in the music business. I loved it. Eddie Bill was teaching four-part harmony, on songs like "I Got It Bad and That Ain't Good" and "Mood Indigo," and since that day, harmony has always been my favorite kind of singing, finding your part and staying there. It's like knowing how to solve jigsaw puzzles or opening the hood to a car and knowing what every valve, point, and plug does and what it connects to. Anybody who can carry a tune can sing melody, but singing harmony is like having the keys to the kingdom.

I knew my mother and father thought that singing with the Blossoms would take me right down the path to perdition, but the minute I heard these neatly dressed, perfectly pitched girls I knew that they weren't going to turn me into an alcoholic or a drug addict. Coca-Cola was the strongest thing that touched these girls' lips, and though they were free spirits, they were also very family-oriented. Gloria was an only child and already had her own car. She seemed to run the group with a kind of cool, well-pressed, college-girl grace. Fanita was the lazy one, always looking as if she had just rolled out of bed. Her parents were divorced, but her mother spoiled her, and everything was always a bit of a tussle with her, whether we were picking a song or learning a part. But they had dreamy voices, and I immediately loved them all, and no matter what it took, I was going to be a part of this group. It took a few weeks, though, for Mama and Daddy to break down and give their official sanction, if not their blessing. I had the girls over to the house, and they came back to St. Paul Baptist Church, and it finally dawned on my parents that they weren't juvenile delinquents. Soon I was rush-

ing off after school to sing with them. But I still couldn't imagine why they wanted me.

That's an easy one, Gloria says. "We sounded too pop, like the Four Freshmen. We wanted a lead singer with more of an R&B sound." In those days there were no black female groups: The Chantels and the Shirelles were still gestating back east, and the Cookies, a New York group, weren't known outside of the recording studio culture, where they did a lot of backup work for Atlantic's early R&B sessions. Even the Bobbettes and their great song "Mr. Lee" were just another mutation of the Andrews Sisters. So the Blossoms got in on the ground floor of rock and roll, around the Year Two, A.P. "after Presley"; in other words, 1957, the year after Elvis rattled the fault line of pop music and American culture. The Blossoms didn't sound white, but we didn't sound black, either. The magic of the Blossoms was that we could sound whatever way we wanted.

And that was because of Elvis's revolution. He didn't sound black and he didn't sound white, but from song to song and measure to measure he could sound like either. One minute you heard the church in his voice, the next you heard the Grand Ole Opry, and after that there was even a little bit of Dean Martin. The Blossoms got lucky in that we came along just after Elvis had opened America's ears—or at least the ears of American kids.

Eddie Bill wasn't the kind of guy who advertised what was interesting about him. He didn't wear flashy clothes and didn't have a handful of rings or an accordion of business contacts in his wallet. He was a short man with a bushy mustache and a slight

lisp that he never tried to hide. He was smart, but he wasn't a slave to his intelligence or his desire to make a name for himself in the business. He just taught us what he knew, which was mostly harmonies. We rehearsed in a building at 3555 Selma, which was the hub of black pop, a kind of Brill Building West. Of course, in the land of earthquakes, everyone was on the same floor, because most of the buildings were just one story high. After we had been singing together for a few months, Eddie told us that he had gotten us a background session at Capitol recording studios. But after we got through jumping and screaming, he told us that the session was not with the Platters or Sam Cooke or any of the other black-pop elite who worked out of 3555 Selma, or even with Nat Cole, Frank Sinatra, Peggy Lee, or any of the other legends who passed through the echo chambers of the Capitol building on Vine. No, the Blossoms' first session would be with the teen idol James Darren, who was then the star of *Hawaiian Eye* and then later, in the movies, Gidget's boyfriend.

Well, this was still all right with us. Gloria remembers that Jimmy was "drop-dead gorgeous." And so were we on the day Eddie drove us to Capitol, all of us dressed in our best church clothes, high heels, and stockings. I swear we spent more time getting ready than we did singing. And we sure felt like fools when we got there and everybody else was wearing blue jeans and tennis shoes. We were scared to death, unsure of our talent, and feeling more like fans and sycophants than musicians. (We kept checking the halls for Mr. Cole. After all, Capitol was known as the tower that Nat built.) We were like mice being let out of a cage. Eddie had already warned us not to act out of place, and we knew that this was his way of telling us that we were going into the white world and that we were going to be

scrutinized for any "inappropriate" behavior. Essentially, that meant we were to speak when spoken to and do as we were told. We were a mess.

This was back when rock and roll was still so new that it seemed as if anyone could sing it—at least that's what the people signing all the checks thought. If the Hollywood moguls found out that any of their teen idols could carry a tune, they got recording contracts. Ricky Nelson was a good example of this, I guess. He was no fluke, which you can tell by how good his records still sound today. But for every Ricky Nelson, you had Tommy Sands and Hayley Mills and Shelley Fabares and Paul Petersen corralled into recording studios and appearing on *American Bandstand*, in some cases their voices hanging on for dear life by the thinnest of vocal cords (and almost always augmented by studio singers).

But Jimmy Darren helped us relax. "He was scared to death, too," Gloria says. He did have a decent voice, and the songs were cute. But they certainly weren't anything like what we sang in church: There were no whoops, no hollers, no melisma, no shouts. All we had to do was echo the lead, with prim wahs and proper whoa-whoas. And yet because we were black, I guess we gave his records a depth of sound, even though it wasn't gospel or raw R&B. This sound is what made a name for us on the L.A. studio scene. We didn't get paid much for those sessions, maybe union scale, but it was enough to keep gas in Gloria's car. For me, especially, it was a way of avoiding homework, since I was still in high school.

Our next big gig was a result of Gloria's "legwork." One night she was listening to Sam Cooke giving an interview on the radio, and she called to dedicate a song to him from "the

Blossoms." Sam never met a sexy voice he didn't like (much to his detriment, as the world would tragically learn several years later), and Gloria must have poured it on with her deep, smooth alto. Sam told the deejay to ask Gloria to call back. Before they hung up the phone, the Blossoms had a date to meet at Sam's place to go over some material for his next session.

We were practically three Jell-O molds when we went over to the Knickerbocker Hotel, where Sam was staying. He was eating his breakfast, wearing only a silk robe and cute little briefs. We put on our best poker faces and tried to act as if we weren't looking, but there was no escaping the man's beauty. Even *he* couldn't get around it. "Lord, he spent so much time in front of that mirror," Gloria says. "But you know what? It didn't make me like him less."

Gloria and I remember what happened next differently. I swear that Sam came to pick us up for the session. By then I was a senior at Fremont High School, which in those days was like a college campus, with rolling lawns and twenty front doors in a row. It almost looked like an old castle. In my version of the story, Sam picked me up there and drove me to the session. And that's how it was—a true Cinderella story, in which the finest black prince on earth came to get me, in front of all my friends, on his steed, which in this case happened to be a green Cadillac convertible. The other Blossoms were already in the car and there I was, followed by my train of giggling girlfriends, ready for the ball, and playing it to the hilt.

"Excuse me, but I was driving the car," Gloria says. She claims that Sam drove to Eddie Bill's office, and Gloria begged to drive the car all around town to show off. She says *she* was the one who came to pick me up. Since Gloria and I couldn't agree

about this, it was up to Fanita to cast the deciding memory: "Oh, I know Sam came to pick Darlene up, because Sam had a little thing for Miss Darlene."

Working in the studio with Sam was my first experience of seeing what real genius could do. There was a full-size orchestra there and maybe six other singers, who all were white except one, Gwen Johnson, sister of the great saxophonist Plas Johnson. We were still pretty nervous, but we had a little more confidence (and this time we didn't dress up). If Sam Cooke thought we were good enough, then we must have had something. The first song we did was "Everybody Likes to Cha Cha Cha," and then a couple of others that weren't hits, and then we did "Chain Gang." It was so exciting, because we got to see music changing in front of our eyes, like that day when you catch the first whiff of spring in the air. Most studio musicians were white in those days (except for jazz players), but Sam didn't want to use an all-white orchestra or all white singers, and so there were blacks playing horns and percussion. But the musician who amazed me the most was Sam himself. I'd heard him sing gospel before, and though he was now singing pop, he did it with the same feeling and the same charisma. Only the words were different. And he was so fine that he was actually a distraction sometimes; it was all Gloria and I could do to concentrate on the music. He had this way of biting his lower lip that made the walls come tumbling down. Gloria saw it, too, and we got to the point where we could anticipate that glorious overbite. "Look, look," Gloria would whisper, "he's gonna do it again. Lord save us."

Luckily for Gloria and Fanita, they weren't preachers' daughters, so they didn't have to put up with the "communion klatch" at church on Sundays. For about the first year or so, nobody at

church really knew that I was singing pop music, especially because we weren't working that much. But once the Sam Cooke session went down, everybody in town knew. "She's singing what?" the holier-than-thous would say to my father. But whatever reservations Daddy expressed to me in private, he always defended me in public. "Just using her gift" was his response. Even so, we tried not to broadcast our work with Sam Cooke too much. The real holy rollers were blasting him for going pop, and a precious song like "You Send Me" became a cause for damnation. I wonder what they would have said about "Work with Me Annie."

CHAPTER 3

On the Side

espite our tastes of the big time with Jimmy
Darren and Sam Cooke, the Blossoms were
still working mostly sock hops and parties,
and so there was plenty of room for me to
have a "normal" teenage life: malts and movies
and football games and house parties. (The
drive-ins were still off-limits. Respectable,
churchgoing young girls did not go to the
drive-ins without their parents yet.) And the
big news at Fremont High was that Darlene
Wright was dating Leonard Peete. I had landed
the big one.

Leonard Peete was a football hero, three
years older than I was and already out of
school and working as an assistant manager at
a grocery store. He was built like my father,

compact like a tight end, 170 pounds of hydraulic power. Every girl in twelfth grade had her eyes on Leonard, but when he asked after me, I pretended not to care. Oldest trick in the book, right? It worked. Soon we were double-dating with our friends Arlene Brackeen and Duke Covington.

Daddy wasn't too fond of Leonard at first. Maybe he didn't like the fact that Leonard was older, or maybe Leonard reminded Daddy too much of himself in his wilder days, but whatever the reason, whenever Leonard took me home, it wasn't but five minutes before Daddy's sonorous baritone was flooding the front porch. "I think it's time your company went home now, Dolly."

"I thought your father was about seven feet tall," Leonard told me. "I couldn't believe that that voice could come out of such a little man." Daddy and Leonard, though, after circling each other with the suspicion of two people seeing themselves at twenty years farther down or farther back on the road, ended up getting along famously. I wasn't driving yet, and Daddy expressly forbade me to drive Leonard's car, a '57 Ford. So, of course, it took us only a couple of blocks—out of Daddy's immediate line of vision—before Leonard was giving me driving lessons. Life for teenagers in 1959, and probably for every year since, has been the art of running red lights and not getting caught.

For a few months we had the kind of existence that teenagers would only later know from Beach Boys songs, except with black people. The car, the football hero, the beach. Much to my regret, though, the combination of my singing and then my romance with Leonard made me think I could just cruise through school. I got A's in music and was a star of all the school assemblies and concerts, but I just marked my other classes, pass-

ing with C's and not making much effort. I should have taken a
lesson from my father, who always had his nose in a book. We
used to kid Daddy about the two pairs of glasses he had on his
forehead, one for watching TV and the other for doing cross-
word puzzles. (This was Daddy's lone submission to vanity. He
refused to wear bifocals.) But Daddy could tell you a little bit of
something about anything. In all my teenage wisdom, I thought
I already knew everything I needed to know.

Soon Leonard was picking me up at lunch and we were going
back to his parents' house (they both worked) and having sex.
Now that I was a little older, it was more enjoyable than my
clumsy forays with Cliff in Texas, and even though I was break-
ing one of the church's strictest rules, I was in love and knew
Leonard loved me. About a month before high school gradu-
ation, he surprised me with an engagement ring and said he
wanted to ask my father for my hand in marriage. I didn't know
whether I should feel elated or petrified, because I had a feeling
it wouldn't go over well with Daddy.

I called that one slightly wrong. The firestorm came not
from Daddy but from Mama. "You are not getting married,"
she screamed, and grabbed my hand, whisked the ring off my
finger, and threw it across the room. I could tell my father wasn't
happy, either, but he tried to play the mediator, trying to stay
my mother's hand again. "You can't throw the child's ring across
the room," he said.

The child. Hmm. I guess I was, but I didn't think so then,
and Mama's reaction made me want to get married even more,
because I was still under her thumb, cooking and cleaning, and
the closest target for the jagged projectiles of her temper. I knew
that I didn't want to live like that much longer, and in those days

the only way for a girl to get out of her family's house was to get married.

Daddy couldn't still Mama's raging waters. "If you marry this man, your children are gonna be dark, little nappy hairs," she screamed. "Why do you want to marry so black a man?" I knew Mama could be tough, but Lord, I never thought that some of the worst racism I've ever experienced would come from within my own house. Mama, somewhere, had my best intentions at heart; she didn't want me to do what she did— get married so young—and she knew the disadvantages black people faced from the day they were born, and how her own children's light skin had given them a dispensation from some of the world's ignorance. But now I was determined—just as determined as I had been to join the Blossoms—that I was going to marry Leonard no matter what my parents thought.

And suddenly our lives became a *Peyton Place* melodrama. I got pregnant. If not entirely intentional, my pregnancy wasn't exactly unplanned, either. I was desperate to get out of the house.

I didn't tell Mama right away, but she knew when I stopped having my period and my bust size went up one. I finally broke the news when I was about four months along. At first Mama didn't want me to leave. My sister, Edna, remembers, "She wasn't just losing a daughter, she was losing a maid." But Mama finally turned and said, "Okay, go ahead, get out then," in a brief, one-way hissy fit. I ran up to my bedroom crying, and an hour later she came up to my room, apologizing, telling me she didn't mean it and that if I didn't want to have the baby, we would find a way to work it out. "We'll talk about it tomorrow," she said, and left me there too stunned to cry anymore. I got on

the phone right away to Leonard. "Pick me up as soon as you can," I said. "Mama's lost her mind. She wants me to get rid of the baby." She could have meant adoption, too, but I wanted this baby. It was my ticket out.

So in grand B-movie style, Leonard came over at two or three in the morning, and we "ran away." All that was missing was the ladder against the house. We stayed in a hotel for a few nights, and then with Fanita, but we couldn't get married until Leonard got permission from his mother, because he wasn't twenty-one yet. (Women could get married at eighteen.) She was a little more generous with her compassion than my mother had been and she gave him permission. That very day we got blood tests and were married at City Hall.

When I married Leonard, I realized for the first time that even when you think that you're doing the right thing, you can feel incredibly alone. You can be with the person you love most in the world and still feel lonely. Here I was, a preacher's daughter, getting married at City Hall, with nobody there to share and enjoy and rejoice with me. I wondered why, for all the happiness that Leonard and the baby were bringing to me, I had to sneak off to get it.

When my parents found out that I was gone, they tracked me down and asked me to wait, but once they heard it was already done, they said they would give me a big wedding reception. To their credit, I never heard another word from them about it. I'll say this for my parents, when it came to carting around the baggage of the past, they traveled lightly, living and loving in the present.

With the baby due in five months, Leonard and I didn't have much time to set up house. We got an apartment on Ninety-

fourth Street, not far from Watts. It wasn't a great neighbor-hood, but we needed to get a place in a hurry. Though I didn't really realize it then, I was well on my way to becoming my mother. Here I was, a few months past my eighteenth birthday, three months from high school graduation, married and getting ready to give birth. Singing faded a bit to the periphery then. Right now, about the only singing I would be doing was to my unborn child, who was due in March.

Leonard and I still had a pretty regular sex life, but it wasn't long after I got pregnant that he started wandering. Now, al-most forty years later, I have a calmer perspective on this. He was only twenty years old, and still a local hero, and once he got promoted to manager of the Mayfair supermarket, plenty of young women were passing under his nose. I'm sure there were times when he thought that he'd tied himself down too soon, that he still had a lot of world—or at least a lot of backseats—to see. Eventually he started coming home later and later, and the night I went into labor, a month early, he was nowhere to be found.

I started calling everywhere looking for him—work, his par-ents, our friends, until he finally came in the door at two A.M. and found me almost hysterical. He took me out to the car, and as I got in, I felt myself sitting in some sand in the front seat. Right away I knew he had been down at the beach, screwing his latest squeeze. I screamed at him, almost forgetting for a minute about the baby. I guess he didn't think I was going to be in the car so soon. Just then the pains got so bad that I thought I was going to have my baby right there in the car, on the blanket fresh with the smell of Leonard's cheating all over it. He just kept telling me to calm down, and then there were no more words.

Somehow we made it to the hospital, and just as we arrived, my water broke.

A few hours later, our daughter, Rosalynn, was born. She weighed six pounds, and I thought everything would be all right. But I started to worry after some time went by and they didn't bring her to me. Leonard finally came in, ashen and drooping, and told me she had bronchial pneumonia. The doctors said that she might have been better off if she had been born at seven months instead of eight. This didn't make sense to me, but it wasn't the last time I'd hear this. The lungs are the last vital organs to develop, and Rosalynn's just weren't far along enough. Daddy and Mama came and prayed over her, but after a couple of valiant days in an incubator, she went back to God.

The possibility that Rosalynn could die never dawned on me. The pregnancy had gone smoothly until my early labor, and even then I thought carrying her for eight months was certainly long enough. After a few sleepless nights, and a lot of praying, I decided I didn't want a funeral. I gave her body over to science, in the hope that maybe some other parents might be spared our grief, that some other child might have a chance to live. My parents had never heard of anything like this, but we were all so steeped in our grief that they didn't object.

Leonard blamed himself, though even if he had been home when my labor started, Rosalynn still would have died. I've since come to think that if my faith had been as strong then as it is now, maybe my prayers might have made some difference and pulled her through. The hardest part, though, was going home from the hospital a few days later without her. Women went to the hospital to have their babies and came home with their babies. All except me.

Now she was back with God, and Leonard and I had to help each other through our pain. He promised to stop fooling around, and in a few months we would be eager to try again to have a child. But I had had two showers, and I made him get rid of all the baby clothes and toys and furniture that decorated our apartment. I didn't need wall-to-wall reminders that I had come home without my baby, that Leonard had been unfaithful, that my teenage years had ended so abruptly and tragically.

I would become pregnant again within months. But the experience of my early married years made me start looking at Leonard with more of a jaded eye. So many of the men I was attracted to would have recessive monogamy genes. It ran in my family, too: I found out only recently that my grandfather wasn't my uncle Leroy's daddy. My mother's mother, I learned, had a fling in her late forties that produced him. Even my own father had a little action on the side. When I confronted him with this years later, he said: "Well, you know your mother wasn't much interested in sports. I wanted someone to go to the games with." A few more kicks at the pedestal.

I still loved Leonard, but married life was hardly turning out to be the idyllic escape I'd imagined it would be when we eloped. My career suddenly assumed a new importance. I didn't know it then, but before too long I'd be hanging a good many of my hopes on it.

CHAPTER 4

A Little Man in a Toupee

he fifties finally turned into the sixties and the
country survived rock and roll—and, more
important, rock and roll survived the country.
Congress subpoenaed several deejays to testify
at the so-called payola hearings of 1959,
which must have looked like the final solution
to some senators who wanted to cleanse the
minds of America's teenagers by purging
this lewd, lascivious (and not coincidentally,
African-derived) menace. But though the
hearings broke Alan Freed and some of the
other influential early deejays, they couldn't
break the music. Elvis survived the army
(though many said he was never the same),
and rock and roll was alive and well, if a bit
rudderless.

After a brief mourning period, I started working with the Blossoms again. We were still just about the only black backup group in L.A., and as some of the people we worked with during the Darren and Cooke sessions started rising through the ranks, they carried us along on their cresting waves. We had met the producers Lou Adler and Herb Alpert while they were apprentices working with Sam Cooke. Herbie was a fine-looking man, and he could blow the bejesus out of his trumpet, but even in those days what he really wanted to do was sing. This was like me deciding I wanted to play the trumpet. "Herbie!" we'd yell. "Pick up your horn!" (Of course, several years later we were all scratching our heads when Herb Alpert, singer, had a No. 1 record with Burt Bacharach and Hal David's "This Guy's in Love with You." That's the incorruptibility of great songwriting, or the democracy of pop music, but it sure had nothing to do with Herbie's voice!) Lord, did we love that man.

Lou Adler was the ultimate California dude. He never overheated. And I never saw him wear socks the whole time I knew him. His hair was always in a ponytail, and he was forever en route to or from a Lakers game. We were instant friends, and that was probably why he got away with paying us five dollars a song. "Oh, we'll make it up to you later," Lou and Herbie said. Their words were good, though; once they started making money they were the first producers to pay us double and triple scale.

"Before the Blossoms," Lou says, "what you basically had was the Johnny Mann Singers, five white guys and three white girls who could sight-read but had no connection to the music. I never played an instrument, but with the Blossoms, I could explain with hand movements and nonmusical talk what I wanted, and they could interpret it. They were not in any way hung up."

What Lou—and we—discovered was that the Blossoms were like those keyboards that put 162 different rhythms, instruments, and styles at your fingertips. White and black, chaste and loose, church and Broadway and jazz. And because of that, the work started pouring in, from artists as musically and kinetically unrelated as Doris Day and Bobby Day, Roy Rogers and Ray Charles. "I was very connected to the background singers," Lou says. "I thought they were some of the best talent in the industry. In '61, '62, '63, a lot of the records were really manufactured, where maybe the artist wasn't that great but there was good production and good songwriting. I always thought the backup singers should step up."

Early in 1962, we had one of the two best sessions of my career, with Bobby Darin, who was recording an album of Ray Charles songs for Atlantic. Of the literally thousands of songs I have sung on, I have rarely felt as strong a connection to the material as I did during those sessions. The songs—"(The Night Time Is) The Right Time," "I Got a Woman," and "Drown in My Own Tears"—moved something inside me the way spirituals did, maybe because they were like secular spiritual songs, and because Bobby did justice to them. He didn't sound black, but he was true to the spirit of the songs. Ray himself was experimenting in those days with his country-and-western album, and I think Bobby was doing the same by recording R&B songs. He wasn't trying to mimic Ray. He was just showing his love for the man and the music, and it came through.

We worked on this album in Los Angeles every day for two weeks, three or four hours a day. Bobby was a true gentleman, very quiet, very professional, always telling us how glad he was that we were making this record with him, as if he needed us

to give the sessions credibility. He was married to Sandra Dee at the time, and one day she came bubbling into the studio. "Bobby was just raving about you girls, so I just had to meet you for myself," she said. The album, *Bobby Darin Sings Ray Charles*, didn't sell very well, but it was a high-water mark in all our careers. No matter how many show tunes or folk tunes he was famous for, he really was one of rock and roll's greatest singers. We would find out years later that Bobby had a weak heart—it gave out on him in 1973, when he was thirty-seven—but that's probably because he poured so much of it into his records.

Right after those sessions, I got a call from Lester Sill, a producer and music publisher we'd done a few sessions with. I knew and liked Lester well enough that we had exchanged gifts at the holidays. He owned a record company with another guy, and he said his partner wanted to meet me, to talk about recording "a song or two." I saw it as just another session call, and a few days later I was being introduced to a little man in a toupee, sitting at a piano. "Darlene," said Lester, "this is my partner, Phil Spector."

Lord, why is it the days that change your life always tiptoe up behind you, and you never feel their whomp until years later?

In early 1962, my life had spun 180 degrees from those bleak days two years before, just after I lost Rosalynn. That's because I had basically achieved everything I could ever imagine I would have wanted. I had a handsome husband (who, for the time being at least, was keeping his fly zipped around the ladies at the Mayfair market), and the Blossoms had so much session work that we thought about farming some of it out and establishing

our own background-singing agency. And on March 11, 1961, our first son, Marcus, was born, without a hiccup or a hint of trouble. After you've lost a baby, you basically run your whole pregnancy on nerves, and I don't think I really relaxed until they put him in my arms and I counted all his toes and fingers and ran my hand through his thick, fluffy coal-black hair. Only when you know the ending can you have a true fairy tale.

Leonard was rock steady as a provider. Yes, he had caroused, and on the weekends he could put away his liquor, but he never let any of it interfere with his job, and I always knew where our money was. He got up early in the morning with Marcus, and I slept in until he left for work. Recording sessions in L.A. didn't start until one in the afternoon, so mornings were my quality time with Marcus. I fed him, changed him, and sang lullabies and nursery rhymes to him. He watched me suffer through the routines on the old *Jack LaLanne Show* and gurgled and smiled. He was my perfect audience of one. Then I dropped him at my mother's or at Leonard's mother's house, and Leonard got him at the end of the day. Leonard was in many ways the strong, silent, macho type, but he wasn't threatened by my work (and he would have been a fool if he were, because I was making as much as he was).

The Blossoms were singing on as many as three sessions a day, sometimes for nine hours straight, with acts like Jan and Dean, Bobby Darin, Shelley Fabares, and even a few who didn't become big stars. There were so many sessions that it's impossible to remember all or even most of them; what I remember most from those days is that almost overnight, we were making boatloads of money, $22.50 an hour, sometimes $200 or $300 a session. It was the best of all possible worlds.

And that was my life when the call came in to our service from Lester Sill. I thought it was strange that he wanted to take just me to that meeting and not Fanita and Gloria, but I trusted his judgment, and anyway, work is work. He picked me up on a steamy July day, and we were off to meet his partner at Gold Star, then still a relatively obscure studio on Santa Monica and Vine. It was a dingy place that hadn't been painted in years. The entrance was in the back, and you had to go through an alley to get to it. There was a hamburger stand near the entrance, run by a slick character named Brother Julius. The carpet was in tatters, and you could fit maybe one and a half people in the hallway at the same time. I almost didn't want to go in because the entire security consisted of a girl near the door who must have booked all the sessions. Jackie De-Shannon, the great singer and songwriter who was just coming up in the business herself, would later joke that the bathroom at Gold Star was "the best place for crabs in all of Los Angeles."

Lester led me down the hall and into the studio, and there, at the piano, sat his partner in Philles Records, Phil Spector. Phil was a hotshot in New York. Before his eighteenth birthday, in 1958, he had written and sung on a No. 1 record by the Teddy Bears called "To Know Him Is to Love Him." But nobody really knew him in L.A.—and you would never guess that he had grown up in California by looking at him, with his pasty, Lord Fauntleroy face, waiflike frame, and dark suit and tie. He smelled like perfume—in those days if men wore anything, it was aftershave like Old Spice or Mennen Skin Bracer. Phil smelled like musk. As dark as it was inside Gold Star, he wore his sunglasses. And when he stood up, in four-inch heels, I was still taller than he was. And that was with his toupee on.

He was very polite and all business. Whatever he knew of my reputation, he didn't let on. To Phil, everything was about the song, and within three minutes he was playing from a lead sheet on the piano. I usually learned songs from the songwriter's demo, but Phil didn't want any instant interpretations influenced by the songwriter's style. He wanted me to learn it from scratch. Lester disappeared down the hall and for about half a hot minute I got the creeps being alone with this man in the studio. But that was the first and last time I was ever close to being afraid of Phil Spector.

Phil and Lester's label had one main act, the Crystals, a girl group out of New York. They'd already had two Top 20 hits— "There's No Other Like My Baby" and "Uptown," tenement anthems that were sung by urban teenagers with a nobody-knows-the-trouble-I've-seen grit. But for some reason, the smoke puffs of these songs never quite reached me in L.A. I knew the Shirelles, the Chantels, and the great Marvelettes. But the Crystals? Their name on Phil's résumé did nothing to impress me.

Phil played through the song a few times: "See the way he walks down the street," he sang in his reedy monotone. It sounded like just another tribute to a teen dream, this one from the wrong side of the tracks, or the police blotter. I can sound like a swooning teenager, I thought. (There I was, only twenty years old myself, but with a husband, a child, and a mortgage; the transition between my teens and adulthood lasted about five minutes.) But the whole time I kept wondering why he just didn't cut it back in New York with the Crystals.

It turned out that Phil wasn't necessarily looking for a gee-whiz-shoo-bee-doo lead vocal. As we worked through it, he encouraged the low, growling side of my voice, the righteous

indignation and in-your-face testimony that I usually saved for church. Soon we were joined by Phil's arranger, Jack Nitzsche, a quiet, gangly man in severe specs who always looked like a cross between a beat poet and a chemistry-lab nerd hatching a plot to blow up the world. In a couple of hours Phil was happy with the key and with Jack's sketches for the arrangement. Then he asked if I would be able to do the session at the end of the week. I wondered what the hurry was, but I soon found out Phil had plenty of reasons for recording the song in L.A. other than wanting me to sing it. A version of the song, "He's a Rebel," had *already been* recorded in New York, by a then unknown singer named Vikki Carr. Phil had been tipped off to "He's a Rebel" by Aaron Schroeder, who was the manager of rock and roll's college boy, Gene Pitney, who had written it. So Phil didn't have time to send for the Crystals. He had to get the record out fast, because he was sure this song was going to make him king of the hill.

Phil offered me a flat fee—$3,000—which was triple scale, and a king's ransom, especially for a song like this. (The song sounded like a trifle to me because I still had those Ray Charles songs we cut with Bobby Darin in my head.) Phil brought in hip-and-hot musicians like pianist Al Delory and drummer Hal Blaine and saxophonist Steve Douglas, who would be the core of what came to be known as "the Wrecking Crew," and Phil waved his heavily ringed hands over the whole thing as if he were invoking some incantation. It could never be too big for him. He wanted more: two pianos, heavier percussion, louder drums. And as we went into the fade, I got so carried away throwing down this gospel riff—"No, No, *No!*"—that I lost the rhythm and sang it off beat. I was embarrassed as a musician—

I never made mistakes like that—and also because I lost control. I told Phil I had to do it again, but he wouldn't let me. "I like the mistake," he said with a glint in his eye. If you say so, I thought derisively. What kind of man is this who lets glaring mistakes like that into his records?

No matter how layered or loud "He's a Rebel" got, it was still just pop music to me, on the radio for a few fast weeks—if it was lucky enough to even get there—and then forgotten a second after it fell off the charts. At the time I didn't even mind that Phil was going to release the record under the Crystals' name. Some of the musicians didn't know about this subter-fuge, though, and as they caught wind of it, one after another they came to tell me as if I were the last to know. "Sure I know it's gonna be the Crystals," I said. "So what? The man paid me triple scale." I just wanted to take the money and run. Hmmm. I thought I was being smart.

Sometime that day I went home, put Marcus to sleep, and had dinner with Leonard, and then we got into bed. And at some point I'm sure he asked me how the session went. And I'm sure I said, "That little shrimp is crazy. He thinks he's gonna take the world by storm with this song."

Leonard said, "Is it that good? Is he that good?" And I said, "Oh, you know, it's a cute song, but it's probably not going any-where."

CHAPTER 5

Hey, Mister, That's Me at No. 1

earing your voice on the radio is a dangerous
kind of epiphany, because it can instantly
throw everything in your life and out of focus
at the same time. It's like having a kaleidoscope
spin in your mind. In an instant you see your
parents, husband, brothers and sisters, friends,
the kid who whupped you in third grade, the
kind choir director who let you know you
could sing and the gym teacher who made you
feel you had no right walking, all the people
you want to celebrate the moment with you
and all the faces you want to rub in it. Yet at
the same time you're floating suspended above
it all, disembodied really, from everyone and
everything in your life, especially everything
that ever went wrong. It's not a part of you

anymore, it never happened, it's canceled, because there you are blaring out of a two-inch transistor or the grille of a dashboard. You've passed on to Top 40 heaven.

That's the way it was with me. I was on the freeway coming home from a recording date, probably late in the summer of 1962, when I heard "He's a Rebel" on the radio for the first time. By then the Blossoms had done hundreds of sessions and had been on the radio as many times, on some pretty big hits, too. If you listen to "Johnny Angel," by Shelley Fabares, which had been a No. 1 hit earlier in the year, you'll hear me and Gloria and Fanita on the "shadums" in the background. But we were there anonymously, part of the backdrop, dressing for the lead singer. Sometimes even *we'd* forget we had sung on a big hit. Merry Clayton, another great session singer and a floating member of the Blossoms, had to remind me, almost thirty years later, that we had sung on Betty Everett's big hit "The Shoop Shoop Song (It's in His Kiss)," and our voices are practically sharing the lead with Betty!

But "He's a Rebel" was different because I was singing the lead vocal. I heard it on KGFJ, which was the big black/R&B station in Los Angeles. Now, I have never considered myself an R&B singer. If anything, I'm a rock and roll singer, but to hear "He's a Rebel" on KGFJ along with hits by James Brown and Solomon Burke gained me admission to a rather inaccessible club. I didn't even mind when the deejay said, "That's a hot new prospect from the Crystals." I knew it was me, and, no matter how the missionaries at church might chew and crow, I was proud of it.

Phil Spector had done it. Our version of "He's a Rebel" came out days after the Vikki Carr record, and radio jumped

on ours, thanks to some fancy dancing by Phil's promotion team. Of course, I'd like to think that ours was better, but that wouldn't be fair, because I never heard Vikki Carr's. (And, thankfully, neither did too many other people.) "When I heard Phil's version," Gene Pitney said, "I knew he'd got it." It's interesting to note that Gene said "Phil's version," because this record, and all the records that followed, were definitely all about Phil. In those days the producer's name wasn't necessarily on the record labels, but on Phil's it was almost as prominent as the artists' names. I think Phil probably would have even liked the labels to read "By Phil Spector," with "Vocal Assistance from the Crystals" in small print underneath.

Finally, Phil had perfected the sound he'd been laboring for, from the rolling thunder of Hal's drums to Al's clawed piano keys, to Steve Douglas's feverish tenor sax, which he played like a sailor who's been on a boat for a year, a three-day leave waiting at the other end of his solo. The song had to be there to begin with, of course. I never thought about how grabbing that key change right before the chorus was until I heard it on the radio. (Thank you, Gene Pitney.) And there I was, right in the middle of it, the supporting beam of the whole thing, with Gloria and Fanita among the throng of backup singers Phil put on the session. Phil would keep adding more to his style of production over the next two years, but "He's a Rebel" was the herald announcing his arrival, the one that leveled the pop landscape and laid the foundation for the Wall of Sound. Raise the lintels, because there was a new messiah of Top 40.

Everyone at home was thrilled when "He's a Rebel" started streaking up the charts, and I think Mama and Daddy were secretly happy that my name wasn't on it, because it would mean

fewer headaches for them at church. (Daddy had already heard a few variations on "Oh, Reverend, was that *your* daughter I heard on the radio singing that rock and roll?" Daddy's response was invariably, "Yes, sister, and what were *you* doing listening to rock and roll?") In November, a few weeks after the Cuban Missile Crisis, "He's a Rebel" replaced "Monster Mash," by Bobby "Boris" Pickett and the Crypt Kickers, at the top of the charts, which gave me the added distinction of knocking myself out of No. I, because the Blossoms had sung backup on that one, too! Not that we had any kind of celebration; it didn't really feel like my record. But everyone who knew was thrilled. Everyone, that is, except the real Crystals.

Gene Pitney remembers being backstage at some theater in New Jersey, around the time "He's a Rebel" was in the Top 10, teaching the song to . . . the Crystals. The group, which included Barbara Alston, Delores "Dee Dee" Kennibrew, and a new fifteen-year-old lead singer, La La Brooks, were furious that Phil had used them in a shell game of guess-the-artist. But to him the singers were no more important than the third violin or the second engineer. He was the star of his records, and if that meant bruising the egos of his own artists, then the Crystals were just a sack of August peaches. And Phil did a good job of keeping us all separated, so it wasn't until much later that I crossed paths with the real Crystals. For years they've asked me to stop telling people that I sang "He's a Rebel"!

The Blossoms, meanwhile, went back to mostly backup, but some of the producers we worked with tried to make a quick killing while our voices were still in record buyers' heads. One of our first sessions after "He's a Rebel" was with Duane Eddy. "Duane Eddy?" I said. "He does instrumentals. What does

he need backup singers for?" When we got to the studio, sure enough, there wouldn't be a need for any backup singers, but he had written a lead vocal for all of us to share, on a song called "Dance with the Guitar Man." This was Duane's attempt to get a piece of the twist market. Of course his song was much better than 90 percent of the twist records that were coming out, just because the man was incapable of cliché with his guitar. And "Dance with the Guitar Man," while you could twist to it, was as much a surf record, with that inside-out twang that Dick Dale and later Carl Wilson of the Beach Boys wrapped their fingers around. We even got billing on this one: The label copy read "Duane Eddy and . . . the Rebelettes." Another blindfold for listeners, as if they were contestants on *What's My Line?*

The Blossoms' core—Gloria, Fanita, and me—had held together solidly for five years, but I had the feeling that Gloria was nearing her saturation point. Fanita's whining, which seemed almost cute when we were first starting, was getting louder and nastier as I got more attention. Gloria was getting sick of having to fight Fanita on every career move we made. But it wasn't just that. Gloria wanted to get her social work degree and settle down. When the few singles we got to record as the Blossoms—songs like "Son-in-Law" and "Big Talking Jim"—barely registered a peep on the charts, I think she made her mind up: It's been a lovely trip, but it's time to go home and get on with the rest of my life.

Just before Gloria left the Blossoms, near the end of 1962, Phil Spector called us back, this time to record a song called "Da Doo Ron Ron." I still don't know what those words mean.

It was the kind of record that gave plenty of grist to rock-and-roll haters who decried "unsophisticated" lyrics and the "clangorous, uncultured, unrefined noise" that accompanied them. But "Da Doo Ron Ron" was practically code for the kids. It had a language that they understood but could never explain, and not just in the words, but in the music's sonic boom, especially Hal Blaine's drum fills, which are like thumping virgules between each line of the chorus. Buckle up, baby, because this one won't just make you dance. It will give you whiplash.

I wasn't going to do the song anonymously, as I had done "He's a Rebel." I wanted either my name or the Blossoms' on it and a contract to go along with it. No wham-bam-thank-you-ma'am session fee. As we worked on the song, Phil kept assuring me we'd get the deal done, but he would never be available for a contract meeting. Finally I stormed out of Gold Star with just a few backup tracks left to record. Only then did I get a call from Phil's lawyer, saying that he had a contract for both me and Fanita to look over. (Gloria, though she sang on "Da Doo Ron Ron" and some later Spector sessions, had officially left the group by this time.)

It wasn't just the quality of "Da Doo Ron Ron" that made me want to sign a contract with Phil. And it wasn't just the money, either. I could have gone back to being a straight session singer and been very comfortable. But Gold Star was busting at the seams with promise. At the end of 1962, you could almost hear the hits that were waiting to be born there. In Detroit, Motown was already being called a hit factory, and Phil saw himself as a West Coast Berry Gordy. Even though my name hadn't been on "He's a Rebel," I knew that it could have been, and you know the rest of the story. Once you get a taste of the spotlight, you

crave it. It becomes an addiction. So there we were in Phil's law-
yer's office, Fanita and I, ready to enlist with this little Napoleon
of the music business, for 3 percent of 90, which meant that
we'd each get about a penny a record, minus recording expenses.

Not long after we signed the contract, Phil decided to shelve
"Da Doo Ron Ron" temporarily (for even more devious rea-
sons, as I would find out later). Instead he had us record the old
Disney song "Zip-a-Dee-Doo-Dah" from the movie *Song of the
South.* When Phil gave us a Walt Disney song to sing, I knew that
the man was crazy. Phil paired me and Fanita with a male singer,
Bobby Sheen, who was Phil's answer to the falsettos like Smokey
Robinson and Frankie Vallie, who were scoring big on the charts
in the early sixties. We turned that little kids' song upside down
and inside out by slowing it down to a mind-numbing pace and
then letting loose with a few gospel whoops that might have put
the fear of God into some overseers in the 1800s. As sancti-
fied and twisted as our vocal was, it was only a setup for Billy
Strange's weirded-out guitar solo, which like so many great mo-
ments of art happened by accident. Phil said, "Play something."
Billy hit on a twangy, country-western type thing, and Phil said,
"That's it!" If I had had any doubts that Phil had his finger on
the pulse of American teenagers, they were erased when "Zip-
a-Dee-Doo-Dah" hit the Top 10. If he could make that song a
hit, I thought, then he could make anything a hit.

Not long after the session, Phil wanted us to go on the road
as the group he put on the label: Bob B. Soxx and the Blue Jeans.
That meant Bobby, Fanita, and me. Gloria, who never wanted
to go on the road, was lucky she got out when she did, because
the two months or so that we were on the road as Bob B. Soxx
and the Blue Jeans was perhaps the most miserable time of my

life until then. So far show business had been very comfortable for me. My work was close to home, which was warm and sunny Southern California. But suddenly Phil Spector had shipped us east to play the fabled Chitlin Circuit, a string of clubs and theaters on the East Coast that catered to black audiences and was notorious for not paying performers well even as they were being run ragged from one stop to another, sometimes overnight. I felt like the poker player who wins big early and starts wagering more chips until she realizes that there's a lot more game to play, and her pile slowly dwindles.

When we got to New York, we played the Brooklyn Fox and the Apollo for ten days, and the city was a sad sight. It wasn't the gleaming vista of high-rises I imagined from Rock Hudson–Doris Day movies. It was dark and dirty, with junk on the streets and brown water in the rivers. The city looked like a great big toilet. In California even the alleys were clean and green, but the only greenery I came across in New York was something that had dried on a subway platform. We didn't want to touch anything, for fear that we would catch some disease.

Of course, there was also the weather, the first real winter of my life. Lord, talk about a winter of discontent. It was so gray and cold, and the heaviest clothing we'd brought were light coats and sweaters. By the time we finished buying parkas and hats and gloves, we looked like Eskimos. It was all so depressing. I was away from Marcus for the first time in his life, and I missed him and the rest of my family terribly.

At the Brooklyn Fox, we shared the bill with Dionne Warwick. Now that her first record, "Don't Make Me Over," was a hit, she was about a rung or two away from the headliner status she would enjoy for the rest of her career. When we met her,

she was still living with her parents in East Orange, New Jersey, and she invited us all over for Christmas dinner. They lived in a small but charming two-story house with gleaming wood floors and tasteful antiques. When I walked in, it was as if the Top 10 had come to life in her dining room: There were the Shirelles and the Four Seasons, who had never eaten "black" food before. Lord, the way Frankie Vallie chowed down on the greens, he looked as if he'd just discovered ambrosia. Mrs. Warrick (the name Dionne was born with) was a fabulous cook, and the columns of cakes and pies she baked helped ease the pain of being so far away from home.

The Apollo was even more daunting. The crowd was full of bravado and soul food from the joints that ringed the theater, and they wouldn't settle for amateurs, whom they booed off the stage. You had a whole mountain of pop acts appearing with you, from the one-hit wonders scrambling for their footing to the phalanx of legends at the top, singers like Ruth Brown and B. B. King. With this no-mercy crowd, we didn't just have to be as good as them, we had to be better, five or six shows a day.

This crowd may have been tough, but they had good ears and knew we could sing. The only trouble we got into was when the emcee told them that we had sung "He's a Rebel." The Crystals were local heroes, so this was a big slap to them, and we could hear the crowd bristling. But the emcee also arranged for the orchestra to have a chart of the song, and when we started singing, the audience knew it was no lie and gave us a standing ovation.

For a lot of the performers, singing at the Apollo was a once-in-a-lifetime thrill, like meeting the president or the pope, and there were plenty of instant souvenirs available. We were

barely offstage before some overcoated huckster began offering us pictures of ourselves onstage at the Apollo or hugging Ruth Brown. In fact, there was very little you couldn't buy backstage at the Apollo. That's where I got my first mink coat. It cost only $500, a real steal, probably in more ways than one.

It was a good thing that we took money with us, because we were making only $900 a week for the three of us—Bobby, Fanita, and me. That was supposed to pay all our food and cab expenses. In California, when we did studio work, we were always taken care of, but nobody was there in New York feeding us or driving us around. We ended up finding the cheapest chicken joint in Harlem, where we could get three courses for $1.70. There was another kind of coldness, too, that we'd never known and that no parkas could insulate us from: the stares of New Yorkers, especially the cabdrivers, who were happy to pick us up at our hotels in midtown but who threw us out when they heard we were going to the Apollo. We were hungry and overworked and lonely, foot soldiers in the pop music war half a world away from our families at Christmastime.

The next stop was Baltimore, where we stayed at Mom's Place, a boardinghouse that became the home base for a lot of the female entertainers who passed through town. "Mom"—we never did know her real name—would always have a warm cup of something for us any time of day, and she let us know where we could get our hair done or where to take our laundry. More important, she was our anchor when some of the baser temptations of show business started their inexorable tug. There were wild parties after the shows, and they were exciting to us because we got to meet and hang out with some real legends (or at least

future legends), as well as with some artists whose time at the top was brief but blazing. So in one night we might see Little Eva, who sang "The Locomotion," and the Orlons, the Philadelphia group who had about four hits and were never heard from again, and Marvin Gaye. Lord, he was as handsome as Sam Cooke. Maybe even more so, because he was so shy. Even though Fanita and I were married women now, we turned into giggling, stargazing schoolgirls around Marvin. He was married, too, but you'd never have known it then because of the harem he had around him. Fanita and I became spot backup singers for Marvin during these shows, singing "Stubborn Kind of Fellow" offstage. This, and my fur coats, were about my only pleasant memories of the Chitlin Circuit.

We were so busy looking at Marvin that we didn't get involved in some of the crazier things happening at these parties. There was rubbing alcohol finding its way into the drinks, and for the first time I saw people doing cocaine and even harder stuff. When that started happening, I grabbed Fanita and we headed back toward Mom's Place. She would always be up waiting for us. "How you girls doin'?" she'd say, carrying a tray of tea and cookies. I wondered if she knew what was being served at the party we'd just come from. I think she probably did. She made everyone feel like a star, just because she treated us all as if we were her own kids.

When we got to Cherry Hill, New Jersey, I knew I had had enough of the tour. I was down to 105 pounds and smoking up a storm. Fanita and Bobby might have stayed out longer, but without me there was no act, so we booked the first flight back to Los Angeles. Somebody asked me what we were doing home

so soon. "That's easy," I said. "We were starving out there." In California, I had my home, my husband and child, and regular session work. And Phil had some more songs for us to record.

When I look back on my days with Phil Spector, I realize that they were very much like a courtship and marriage. (Not that we were ever involved. The funniest question a reporter ever asked me in my forty years in show business was whether I'd had a romance with Phil. I whooped so long and loud I must have raised the roof. He's the last man I would be interested in, and besides, he never got fresh with me. He was petrified of Leonard.) What I mean is that at the beginning, Phil was very solicitous and complimentary, the equivalent of roses and candy every day. Then I signed the contract and things started to get a little ugly.

One of the first records we worked on under the contract was a song by Barry Mann and Cynthia Weil, "He's Sure the Boy I Love." Barry and Cynthia tapped the same life-in-the-projects pulse that they had captured on the Crystals' "Uptown," with one of my favorite couplets: "He'll never be a big businessman/ He always buys on the installment plan." This guy certainly was no Johnny Angel. Phil dressed up "He's Sure the Boy I Love" to the nines: A timpani announces a ruminatively sly spoken intro and then Hal Blaine kicks the song into a swinging gear that never decelerates. It was an especially exciting session because Phil told me that this would be the first record to have my name on it. Except "Darlene Peete" and "Darlene Wright" didn't grab Phil. He wanted to called me "Darlene Love," after one of his favorite gospel singers, Dorothy Love.

And so in January 1963 I became Darlene Love. I didn't mind it because I didn't think the name would last. I figured Phil would just decide to call me something else again two or three records down the road. Besides, I liked Dorothy Love; it was a good match. And that was one of the last times Phil Spector and I ever saw eye to eye on anything.

CHAPTER 6

1963: The Golden Year

*I*t's easy to liken Phil's recording sessions to a circus, with Phil as the ringmaster, directing a parade of singers, musicians, and arrangers to the center ring when it came time for them to perform. If Phil didn't shoot them from cannons, he at least made everyone jump through hoops of fire. He also took so long to get the density of sound he wanted that we were often in the studio until four o'clock in the morning. A lot of that time was spent just sitting around waiting for his command, and sometimes we fell asleep right in the middle of the studio floor.

But for me it was also kind of like a bingo game. You know how those bingo lifers surround their cards with good-luck charms

and talismans—stuffed animals, rabbits' feet, old peanut butter jars? That was Phil. But his goodluck charms were people. The more he had around, the more comfortable he felt. Phil was basically insecure—what genius isn't?—and so by surrounding himself with all manner of musicians and flunkies who were there to do his bidding, he felt protected and more powerful. As long as I knew him, Phil was always bookended by two burly men with biceps like tree trunks. Phil's father died when he was nine years old, and I think these guys filled out Phil's manhood, becoming almost extensions of himself. They drove him around (I never saw Phil behind the wheel of a car; I think he was terrified of it) and protected him from the everyday, which gave him more time to create what he later called "little symphonies for the kids."

Phil's main right-hand man during these days was Nino Tempo, a saxophone player and the brother of April Stevens, with whom he sang for Atlantic Records. Nino, though he was from Niagara Falls, looked as if he could have been one of the Belmonts, filling out his T-shirt with a linebacker's build and oozing a kind delectable machismo, equal parts ego and heart, like those great post-doo-wop Italian groups in the early sixties or like Sylvester Stallone in *Rocky*. You never saw Phil without Nino in those days. There is a famous shot of the two of them in the control booth, with Phil listening intently to a playback while Nino stands beside him in a goonlike pose, arms crossed, his biceps bulging almost into the face of the ever-harried engineer, Larry Levine, in the foreground.

But Nino wasn't there just for decoration. Phil bounced a lot of stuff off him (indeed, if you ask Nino he'll happily take credit for some of Phil's greatest ideas, perhaps not unjustifi-

ably), and those two characters were often the last to leave the studio, sometimes at five or six A.M. They would be messing with the tracks long after Larry Levine had gone home.

The sessions were packed with future somebodies: Leon Russell, a piano player and arranger who would later write the Carpenters' big hit "Superstar" and "This Masquerade" and went on to have a substantive solo career of his own; Glen Campbell, in those days a guitar slinger; and a sixteen-year-old runaway named Cherilyn Sarkisian. She was the girlfriend of Sonny Bono, a songwriter and song plugger ten years her senior who was then Phil's No. 1 gofer. ("Sonny's main job was to get cheeseburgers," Nino said.) Sometimes Phil would let Sonny sing background—I think Phil didn't really care who was doing backup; if the janitor happened by, he would have thrown *him* into the booth, too. On the "He's a Rebel" session, though, Sonny was so far off his part that we had to keep doing it over. Finally even Phil, master of the fiftieth take, was getting impatient. "Well, y'all just take Sonny out and we'll be fine," I said. So Sonny was yanked, and we finished in one take. No hard feelings, though. Sonny and I were fast friends, and of course, he would later *neigh* and *ribbit* all the way to the bank.

At first Cher was this waif who was just hanging out and hanging on, and nobody knew she could sing. Then one day I was late (one of the few times in my life, because of car trouble) for a session and Phil told her to jump in. Cher remembers, "Philip said, 'I need some noise. Sonny says you can sing, get out there.' And that was the beginning of a very interesting life. It was also a chance to sing next to Darlene!"

Even though she was only sixteen, Cher knew her way around, and I admired the way she stood up to Phil. For start-

ers, she always called him "Philip." And she wouldn't take any of Phil's crap, either. I mean, before she started singing, she was just Sonny's girlfriend and had to be respectful. Otherwise she might jeopardize Sonny's job. But any time Phil started in with her, she gave it right back. "When I met him," Cher says, "he was taking French lessons, and he thought he was such hot shit. He came over to me and said in French, 'Do you want to go to bed?' So I said back to him, in French, 'Yeah, okay, for money.'" A lot of this sass showed up in her vocals. Lord, when she sang, she was so loud that we had to position her about ten feet away from the microphone!

And occasionally, a pretty young blonde would show up, standing out from the rest of the crowd by the way she dressed, the way she talked, the way she demurred to the whole showbiz scene. This was Annette Merar, who would become the first Mrs. Phil Spector. We didn't see her much because Phil had her squirreled away in New York, where she was going to college. She reminded me of Sandra Dee.

Everyone was deferential to Phil—everyone, that is, except me. In all my years of working with him, I could never get the picture out of my mind of that man I saw at the piano the first day we met. He looked like a little kid in a sandbox. Phil heard my mouth early on, and often. He always kept the studio as cold as a meat locker, and once when his mother, Bertha, came down I thought she would turn blue. "Phil, turn the heat on, your mother's freezing!" I yelled at him. Everybody else felt the same way, but nobody dared speak up, as if they were afraid of losing their meal tickets. Even Cher, who wasn't otherwise intimidated by him, didn't speak up. For me and Phil, though, the shit really hit the fan right after "He's Sure the Boy I Love" was released.

He had told me that this would be the first release under my own name, and I was thrilled. I knew we had a winner. So you can imagine my excitement the first time I heard it on the radio, eagerly anticipating the deejay announcing, "That was Darlene Love." The deejay came on, all right, only to say that this was the new smash from . . . the Crystals. I thought it was a mistake. And then the blinders came off. I had been duped.

I practically turned the car around and drove to Gold Star to hunt down Phil. I had gone along with the "He's a Rebel" sham because I thought there had been so little ventured, and if "He's a Rebel" hadn't gone to No. 1, nobody would have cared, not even the real Crystals. But now Phil was pulling the same crap with me. His word, I would soon discover, was worth about as much as yesterday's paper: good for lining the cat litter box, and not much else. Our honeymoon was short.

After I found out about "He's Sure the Boy I Love," I confronted Phil, right around the time he was getting ready to release "Da Doo Ron Ron." I didn't need reasons: They all added up to more money for Phil. Radio was more likely to play a record when it was by an established name, especially when it was the follow-up to a smash like "He's a Rebel," and Phil didn't want to take any chances that "He's Sure the Boy I Love" would be ignored. The Crystals' name could sell it more than mine could. And then he wouldn't have to pay me any royalties, either. Phil was always looking to angle his way into a bigger cut of the profits, and angle his coworkers out of them. For instance, "He's Sure the Boy I Love" ended up being the last of Phil's big hits that did not list him as a cowriter. He still wouldn't let us hear demos, but I don't imagine the songs were different, at least in terms of the words and music on the sheet music, after

Phil finished with them. I guess he got the songwriters to agree to share their credit by arguing that his contribution was as important as theirs. It was his vision, he figured, that turned them from words and music into malt-shop classics. But ultimately it was just Phil's business acumen at work again: Songwriters are guaranteed to get paid every time their song is performed because of copyright law. Producers and artists aren't.

When I saw Phil, I threw it down. All he would say is "It'll be all right, doll, you'll get the next one." And the next one was going to be "Da Doo Ron Ron." The only thing that kept me from taking his head off was the quality of that song, in all its nonsensical glory. But guess what? I didn't get that one, either. Phil and I had butted heads during the recording session for "Da Doo Ron Ron," and not just because he was dragging his feet over the contract. He simply wasn't used to resistance. It came on him like a sucker punch. Fanita remembers, "Phil met his match in Darlene. He wasn't getting what he wanted and passed some comment about 'you people,' and Darlene marched right out of the studio. She wasn't going to take that." So now, either pissed because I called him out in front of everyone or worried that the Crystals needed another hit or just wanting to prove that no one mattered on the records except him, he stripped my voice off "Da Doo Ron Ron" at the eleventh hour, and had La La Brooks, the new lead singer of the Crystals, sing over the finished track. Phil later said I sounded too old on the song; yeah, right, call me Moms Mabley. I can swear, though, that I still hear my voice on that lead vocal. I don't think Phil erased all of it, but kept just enough to give La La an idea of what he wanted, and then bolstered her voice in the final mix. (La La was a great singer and didn't need my help, but this was

the loudest of Phil's records, and I would bet he left my voice on to keep the meters in the red.)

I still ask myself why I stayed with him, even though I already know the answer. There was a contract, true, but with all this chicanery going on, I might have had grounds to sue. However, only a few months had passed since "He's a Rebel" and I could still taste its glory. "He's Sure the Boy I Love" was in the Top 10 while all this nonsense over "Da Doo Ron Ron" was going on, so I knew that Phil, for all his deception, really was a genius.

Some of my friends had already seen the bad side of Phil, and maybe I should have learned from them. Lou Adler incurred his wrath years before when Phil was still with the Teddy Bears. "I don't think he liked me very much," Lou says. "Jan and Dean were on the same bill with the Teddy Bears, and I think I stepped on Phil's guitar while trying to get Jan and Dean a better position on the stage."

Gloria, meanwhile, had almost immediately pinned him. "I don't remember Phil Spector being fun," she says. "The sessions were fun, and so was everybody else: Sonny Bono, Jack Nitzsche, Nino, Leon Russell, Jim Horn, all those guys. They were fun people. Bobby Sheen. But Phil wasn't fun to me. He was sneaky, and sneaky people make me nervous. Now he never did anything to me. He paid me. Fine. Good-bye. We never passed two or three words. I'm the type who jokes around, but with him I was not comfortable. He probably doesn't remember my name. I didn't like the creep."

By the time "He's Sure the Boy I Love" was released, Phil had already muscled his partner, Lester Sill, out of the business. Phil had started receiving songs from another husband-and-wife

songwriting team, Ellie Greenwich and Jeff Barry, and he must have smelled the potential hits and profits he could make from them. I guess he didn't want to share any of this with Lester. He bought Lester out on the promise that Lester would have some share of the next Crystals record, which was supposed to be "Da Doo Ron Ron." However, after the deal was cut, Phil had the Crystals record a song called "(Let's Dance) The Screw," which was assured zero airplay. Phil would leave a lot of torched bridges behind him before he was through. We never really caught wind that Lester was out until long after it was done, because Lester had stopped coming around to the sessions. But when we found out and asked Phil what was going on, he got very cross and just told us it was none of our business. No one, especially the lowly singers, was going to tell Phil Spector how to run his company.

Phil finally did release the debut Darlene Love single, a song called "(Today I Met) The Boy I'm Gonna Marry." Written by Ellie Greenwich and her first songwriting partner, Tony Powers (and, if you believe the label copy, Phil), it was sort of a doo-wop-meets-gospel ballad that really lets me blow off some steam (and by then I was a pressure cooker). In those days the song-writers were never around when the songs were being recorded; in most cases, they were in New York while we were in L.A. So Ellie Greenwich (whom I didn't meet until more than twenty years later) didn't hear "Today I Met" much earlier than record buyers and radio listeners. Ellie says, "All I remember thinking is, Oh, that voice. Certain singers make me go crazy. Darlene was definitely one of them. Dusty Springfield was another. When I put this record on I was laid out on the floor crying. It's still one of my all-time favorites." Lou Adler told me recently

that of all my Spector singles, this one, not "He's a Rebel" or "Da Doo Ron Ron" or "He's Sure the Boy I Love," would go down as one of the greatest rock-and-roll records ever made. Paul Shaffer, the great bandleader on *The Late Show with David Letterman,* says the word *imagination* in the song was one of his five favorite rock-and-roll moments.

Unfortunately, the song didn't make as big an impression on the public at the time. There were girl groups and girl-group-sounding records under every rock in 1963, and Phil was even competing with himself in those heady days of bouffants and hoop skirts. "Da Doo Ron Ron" (credited to the Crystals) and "(Today I Met) The Boy I'm Gonna Marry" (credited to Darlene Love) entered the charts within a few weeks of each other. "Da Doo Ron Ron" soared to No. 3; "Today I Met" went only to No. 39. It deserved better, everyone said. "The next one will be the one." Funny. I'd heard that before. And I'd hear it again and again.

CHAPTER 7

New Girl in Town

first me the Ronettes—Ronnie Bennett and her
sister Estelle and her cousin Nedra Talley—
back at the Brooklyn Fox when we were out
promoting "Zip-a-Dee-Doo-Dah." My first
thought was that, Lord, if I were these girls'
mother I wouldn't let them out of the house.
They were still teenagers, but with their teased
hair, lavender lipstick, and white go-go boots
they looked like hookers. I thought my teenage
years had ended abruptly with marriage and
losing a baby, but for these girls there had
been no middle step between teddy bears
and ripped stockings. And they were already
veterans of the music business, having made a
few unsuccessful singles for Colpix. I thought,
When did these girls go to school?

Ronnie's mother had heard of Phil Spector, and, after the girls' first singles flopped, she started calling his office incessantly—though Phil was recording in Los Angeles, he still lived in New York. She finally got him on the line, and I think he promised he would come to see their show just to get rid of her. I don't know if he ever made it to the Fox, but he connected with them somewhere in New York, and, as the legend goes, Ronnie ran home to her mother uptown and announced that she had just met the boy she was going to marry.

What did they see in each other? A nineteen-year-old from Spanish Harlem and a Jewish California baby mogul? With twenty-twenty hindsight—the corrective lenses of retrospect, as always—it's easy to figure out now: In Ronnie, Phil saw someone he could not only love but shape; he could be both lover and Svengali. (Phil had earlier expressed an interest in my sister, Edna, who was tagging along for some of the sessions. Edna was still a beauty, but now that she had graduated from high school and wasn't so shy around all the music-business types, she had beauty with attitude. Even Nino wanted to date her at one point. But I shooed Phil away. "I think the words were 'I'll cut your throat,'" Edna recalls.) For Phil, the big issue was control, and Ronnie would let him have all of it. Ronnie saw Phil as more than a lover. He was also a father figure and a ticket to success. Nothing sexier than brains, the old saying goes, and deep pockets don't hurt, either.

But there was one problem: Phil was already engaged to Annette Merar. The two women were polar opposites. Annette was pretty, a demure blonde, while Ronnie was attractive, a brazen brunette. Annette was quiet and educated, while Ronnie was loud and rough: Annette was a breath of fresh air and Ronnie

was a smoky nightclub. And Phil, with his star ascendant, probably thought that not only could he have both but also that he deserved both. He married Annette on February 14, 1963, after he had already met and was clearly smitten with Ronnie. The words "Phil and Annette" would be inscribed in the end groove of every Phil Spector single that was released that year, including the Ronettes' records! This man's epitaph should be, "I got away with it."

Ronnie claims that she didn't know Phil was engaged to Annette when she met him and that I was the one who told her when she came to L.A. later to start recording that Phil and Annette were married. I remember the conversation—I can hear myself in the bathroom of the Glass Onion, a discotheque, saying, "This man is already married"—but to this day I don't believe she didn't know. How couldn't she have known? She wasn't stupid; Annette, though not a regular in the studio, wasn't exactly scarce, either, and the marriage wasn't a secret. Ronnie had a mild attack of conscience—it lasted all of a day—and then she continued recording. It wasn't long before she and Phil started spending a lot of time together out of the studio.

I've never been one to impose my morals on others—"Let he who is without sin," etc.—and I had to look no farther than my own husband and my sainted father to find similar behavior. What really pissed me off was that Phil followed his heart and his crotch into the recording studio—because the arrival of the Ronettes signaled the beginning of the end of Darlene Love.

Right around the time Ronnie got to L.A., things were heating up for my career. The second Darlene Love single, "Wait Til My Bobby Gets Home," which I sang with Edna on backup, reached No. 26, thirteen places higher than "(Today I Met) The

Boy I'm Gonna Marry." (Edna was turning into quite a singer. She had a great soprano that could wiggle and bend and run notes the way Aretha did, and the way I never could. Before she got out of her teens she was singing with Andrae Crouch, future gospel god.) And the third Darlene Love single might have been the best of them all: "A Fine, Fine Boy," which was as close to pure R&B as Phil ever got. Many of Phil's singles charted R&B, but I think he felt that most of his audience was white, though he produced black artists. So we must have done the ending of that song twenty times, to the point where I sounded as if I'd just come in from the fields.

But already Phil had shifted his attention to the first Ronettes single, "Be My Baby." It was being released around the same time as "A Fine, Fine Boy," and Phil threw all his promotional efforts into it. As far as I was concerned, there was room for all of us, but with "Be My Baby" Phil wasn't just making a record, he was declaring his love to Ronnie. As the writer Dave Marsh said in his book *The Heart of Rock and Soul*, "He built a rock-and-roll cathedral around what little her voice had to offer." Nino Tempo remembers it that way, too: "Doesn't every man, when he's in love, want to give the world to his woman? He came over to my parents' house and played it on the piano for me, and even though Phil is not the greatest piano player, I still didn't think much of it. But he said it would be by the time he was finished with it. Then when we got the track going, Hal was just playing a single beat on four and I told Phil that was boring, so we added those extra eighth notes, that dah-dah-dah." (Good old Nino. He also took credit for those thunderous drum fills in "Da Doo Ron Ron" and even for bringing Cher on the scene because he had dated her first. Nino told me recently,

"I got a call from Sonny not long after he and Cher were living together. He was upset, and said, 'I think she still has some feelings for you.' " Nino was so smooth and so charming, I didn't mind his bragging. It was also probably all true.)

By this time Ronnie had been given some intense vocal coaching by Phil, who yapped his orders from the control booth. I might have been able to sing her under the table, but she was an expert at working her limitations to her advantage. She didn't sing "Be My Baby" so much as coo and pout it, with her protruding "I'll make you the happiest man in the world" lips. "Be My Baby" became a No. 2 smash, and "A Fine, Fine Boy" stalled out at No. 53. It was destined to be my last chart single with Phil. And how twisted in a way, too, because the backup on "Be My Baby" included me and Fanita and a host of other non-Ronettes.

CHAPTER 8

From Bob B. Soxx to Christmas Stockings

My saving grace during the long, hot summer of 1963 was a project we had been slaving over for months. Sometime in the spring, just as Ronnie was arriving on the scene, Phil got the idea—the quake, as we came to call it—to make a rock-and-roll Christmas album. Critics over the years have called this both the ultimate act of blasphemy and a miracle bestowed by a rock-and-roll God. In reality, it was neither. There had been plenty of rhythm-and-blues and rock-and-roll Christmas songs before Phil: "Merry Christmas Baby," by Charles Brown; "Jingle Bell Rock," by Bobby Helms; "Rockin' Around the Christmas Tree," by Brenda Lee; and especially the Drifters' "White Christmas," which could make you think that the Three Wise Men

found the baby Jesus in a juke joint. Elvis had done an entire Christmas album about five years before, and even if many of the arrangements were traditional, remember that in 1957 Elvis was still the enemy to the starchy establishment, and that a Christmas album was condemned as just the latest degradation being foisted upon America's innocent teenagers.

But if Phil didn't exactly invent rock-and-roll Christmas, then he definitely juiced it up, taking the kite-in-a-storm of Elvis and the Drifters and building it into a nuclear power plant. Phil came to me and said he needed help choosing the songs—he was a Jewish guy from the Bronx, what did he know about Christmas music? (He knew plenty, it turned out. He was just trying to butter me up. And who wrote "White Christmas," anyway? Irving Berlin, another Jewish guy from New York.) But everyone's usual initial reaction when Phil came up with his latest brainstorm—"The man has really flipped this time"— dissipated as the project took shape. I was actually thrilled that Phil asked me to help him pick the material. I loved Christmas music, and this would be the first time Phil let me have a say in what I would record. I picked "White Christmas" and "Winter Wonderland" and "Marshmallow World"—from the traditional to the candy-coated—and Phil asked Jeff and Ellie to write something original.

The summer of 1963 was especially hot, and we were holed up in Gold Star almost the entire time, until two, three, four in the morning. For once we all welcomed Phil's slave-driving schedule. The more we did the songs, the more the whole project took on its own life, personality, and history. We didn't know we were building monuments in those days, except when it came to the Christmas album. Early on we knew that this was

a landmark, that once-in-a-lifetime opportunity that God bestows on some to change the course of events.

Jeff and Ellie really delivered the goods with "Christmas (Baby Please Come Home)," proving one more time that the best Christmas songs, like the best love songs, are about loss: "White Christmas," "Have Yourself a Merry Little Christmas," "I'll Be Home for Christmas," "Blue Christmas," "Merry Christmas, Darling," all holiday classics for the lovelorn. "Christmas (Baby Please Come Home)" was so good that I just assumed it would go to Ronnie.

But poor Ronnie didn't have enough circuits to handle the high-voltage performance that Phil wanted, and so he gave "Christmas" to me, and it turned out to be the record I'd been waiting to make with Phil in the year I'd known him. This song was even more powerful than "He's a Rebel," and this time it would have my name on it. As with all the sessions, Phil didn't want us to be too prepared, so we never even knew what keys we were going to sing in until we got to the studio, where Jack would be working on the charts while we were waiting to record. The more we worked, the greater it all sounded. One night it got so late that my head just dropped behind me and my big old red wig fell off! All the musicians were happy, because that finally ended the session.

Recording "Christmas (Baby Please Come Home)" nearly killed all of us. Leon Russell was on the piano, and by the last takes he was playing so hard it was almost like a concerto. He played himself right off the bench and onto the floor and kept on playing. Cher was on background and has this to say: "Darlene started to sing and the hair stood up all over my body. It was a performance that made time stop. When she finished,

Fanita fell over with both her hands up in the air." Phil was so enamored of the song that he called Ellie at about two o'clock in the morning and on the spot had her write a non-Christmas lyric to the song. Over the phone she came up with "Johnny (Please Come Home)." It was so stupid, because Phil was taking a good thing and running it into the ground. We did a new vocal, and Phil was going to release them separately, but in the end decided to nix "Johnny." "Christmas" was meant to be a Christmas song. For once, Phil showed some principles.

The Christmas album, I would later realize, was Phil Spector at his best and worst. The work itself was clearly his masterpiece, and everyone attached to it felt a hem-of-his-garment thrill. I could almost forget—almost—all the double crosses and disappointments of the preceding months and forgive Phil. That's how great the Christmas album was. But the sessions were also when things really started to get a little weird at Gold Star.

Ronnie had arrived on the scene in the spring, and though she never came to the sessions until everything was done and it was time to put her lead vocal on, she hung out with the rest of us. She and Cher bonded immediately; they were both teenagers on their own, Ronnie with her mother's blessing, Cher without—hitching their lives to the fortunes of music-business huckster boyfriends. Cher's situation was more precarious because at the time Sonny was mainly running out for cheeseburgers. But even though I was five years older, married, and a mother, the three of us got along like old girlfriends, rapping the usual rap about boyfriends, usually two of us ganging up on the other one. "Ronnie, why the hell are you interested in Phil?" "Cher, why the hell are you interested in Sonny?" One

day, during a break in recording, I suggested we all go out for a bite. Little did I know that a hamburger could invoke the wrath of God.

It seems that Phil had given Ronnie explicit instructions not to leave the studio while he went to attend to some other business. But Ronnie was easily bored, and when I asked her to come with me and Cher, she jumped at the chance. Besides, we were only going out to Brother Julius's hamburger stand in the parking lot. We'd probably be back before Phil even knew she was gone.

But Phil did check up on her, and he hit the roof. I don't think he wanted us to see him as mad as he was, but he couldn't hold it in. "I provided for her entertainment," he said. And when I saw what this "entertainment" was—a comic book, a ball and jacks, one of those wooden paddles with a ball and string attached—I almost fell to the floor laughing.

Of course, I was the only one with my mouth going. I spoke up for Ronnie; this little man didn't scare me a bit. "What do you mean, she can't go out? What is she, a dog with an invisible leash?"

Phil could not be contained or consoled. "She had no right. I specifically told her not to go anywhere. I left her a comic book and a ball and jacks to play with. . . ."

Lord, I knew it was time to call for the white coats. After that I was branded the instigator and Ronnie wasn't allowed to hang around me anymore. He did let Cher and Ronnie continue to "fraternize," because he saw Cher as just a puppet of Sonny's who wouldn't rock the boat too much (especially because Sonny was practically a puppet of Phil's). But he knew he had no control over my mouth, and he didn't want me putting any ideas

into Ronnie's head. So Cher was assigned to "look out" for her, and she got into the same trouble all over again. "Philip didn't let Ronnie do anything," Cher says. "Finally one day I convinced him to let us go shopping, and we went up to Corky Hale's on Sunset, and we must have been gone too long, because when we got back Philip and Sonny were in the parking lot, getting ready to go track us down. Boy, did I get in trouble for that."

Ronnie could drive, and Phil would let her go out only if she took an inflatable doll (with a Magic Markered mustache and a hat to make it look male) with her so that men would stay away. One time when Phil wasn't looking I asked her where she went on those drives. "Oh, only to the drugstore to read movie magazines. I'm only gone for thirty minutes." When I heard that story, I could never really resent Ronnie or the Ronettes for all the attention they received, even at the expense of my career. I saw the steep price she was paying for it. I didn't know who to feel more sorry for—Ronnie or Phil.

In the end I had four songs on the Christmas album, the Ronettes three, the Crystals three, and Bob B. Soxx and the Blue Jeans two. If I wasn't singing lead, I was on background, and I put together most of the vocal arrangements. It wasn't a sequence of songs, it was a sequence of detonations, one bigger and louder than the next. Phil should have put warnings on the shrink wrap like the kind they put on boxes of TNT: HANDLE WITH CARE; CONTAINS EXPLOSIVES. The one exception was the final "song," an instrumental of "Silent Night" with a voiceover from Phil, at his most treacly. "Hello, everyone, this is Phil Spector," he said, then thanked all the artists who worked on the album as well as "you, the audience," with the benign condescension of a monarch addressing his subjects. But that's what

this album was meant to be: Phil's official coronation. Long be-
fore Michael Jackson dubbed himself the King of Pop, Phil had
staked his claim to the throne.

We didn't finish the album until the end of September,
and that didn't give Phil much time to get it pressed and pack-
aged in time for a holiday release. Titled *A Christmas Gift for
You,* it pictured all of us on the front against a white-blanket
background, and it marked the first time any of us would ever
appear on a real "album." Phil was a singles-maker; while most
albums by early sixties artists, even those on the Philles roster,
were throwaways—you know, *Downtown and 11 Others*—Phil was
going to make his first concept album a classic. It was set for re-
lease on November 22, 1963, a Friday. A little late in the game,
but Phil was banking on an out-of-the-box smash that would
sell for years to come.

He was right about its selling for years to come, but Phil,
in the end, probably wished that he had finished a week earlier,
because if it had come out on November 15 instead, somebody
might have actually heard it in 1963.

I don't remember talking to Phil on the night of Novem-
ber 21, but knowing his ego, I can imagine how he must have
felt when he went to sleep in his New York penthouse apart-
ment. "Be My Baby" was just ending its run in the Top 10, and
the next Ronettes single, "Baby I Love You," another Jeff-Ellie
love letter from Ronnie to Phil, was ready to roll. "Christmas
(Baby Please Come Home)" had gone out to radio on early
pressings and was getting tremendous response. The album
would ship the next day and be in stores before Thanksgiving,
which fell late that year. None of us knew that our lives would

be irrevocably shaken the next day. I wouldn't be surprised if November 21 was the last good night's sleep Phil Spector ever had in his life.

I was in the kitchen, cooking dinner, doing some ironing, with the TV on in the living room, though I was barely listening. Somehow the newscaster's words eventually lodged in my brain between stirs, and I knew I must have heard wrong, till I finally looked over at the screen and saw the hurried, blurred panic, and then I froze over the stove, wooden spoon in hand. The president had been shot. And even though the reporters didn't say that the back of his head had been blown off, I knew from the gravity of the newscast that it was pretty bad. I probably picked up a napkin to wipe away some tears, and with them, all thought of the Christmas album.

I don't know if President John F. Kennedy was a rock-and-roll fan. I think his tastes probably ran more toward Frank Sinatra and Nat Cole. But he was certainly the first rock-and-roll president, the first to be elected after rock and roll shook the nation. He was young and handsome and energetic, and he and his pretty young wife did the twist at the White House. Can you imagine Eisenhower doing the twist? LBJ? Nixon? Those guys were born with rusty hips.

While Kennedy—both the man and the image—was ruling the nation, Phil Spector was ruling the pop charts, and though I never thought I'd say this, there were a lot of similarities in style. The president was bold and brash and upbeat, with a direct line to America's young. So were Phil Spector's records. It's impossible for me to separate the weeks that "He's a Rebel" was climbing the charts from the Cuban Missile Crisis. Turn on the

radio and there I was singing, turn on the TV and there was the president staring down Khrushchev. And Phil must also have felt the unlimited promise of the day, the thrall of Camelot.

So much has been written, theorized, speculated about the events of the afternoon of November 22, but I know this much is true: When Lee Harvey Oswald (or someone) fired shots at the president's motorcade in Dallas, he delivered a wound to the nation's psyche that took more than a generation to heal. And when that happened, an arrow was fired into the balloon of Phil Spector, and his slow, leaky descent began. There would be more hits, more headwinds he would catch that would carry him for a while, but as Annette Merar Spector would say, Phil never had a year again like he had in 1963.

The first casualty was the Christmas album, which Phil yanked immediately. With a shade being drawn over the country's mood, this album suddenly seemed so . . . inappropriate. Its amplified holiday cheer would have been a bit like wearing bright red to a funeral. Very few boxes got out of the warehouse, and I think today only a handful of the original pressings still exist. Today they go for thousands of dollars on the collectors' market. (I've still got mine, sealed and locked up.) Forgive me for stating the obvious, but we were all feeling crushed: first the president and now the album. We all understood Phil's decision, of course, but that proved to be no salve. Phil disappeared for a while, and whenever I ran into someone who had worked on the album, we commiserated over the lost opportunity and wondered if Phil was ever going to put it out again. We had all worked so hard on this baby and were so proud of it that it almost became like a child to us, one we lost on the way to the delivery room. I had been there before; and though los-

ing the Christmas album was in no way as devastating as losing Rosalynn, it had a familiar bitter taste.

As Phil withdrew *A Christmas Gift for You*, so he also started to withdraw himself. And the country's teenagers, having lost their young president, turned their ears across the Atlantic.

CHAPTER 9

Jackie Robinson à Go-Go

ven while we were working for Phil, Fanita and
I, sometimes with Grazia Nitzsche, who was
Jack's wife, or Merry Clayton in tow, would
continue to do sessions as the Blossoms. It
bugged Phil to no end, but there was nothing
he could do about it, because our contract
didn't prohibit us from background singing.
We did more sessions for Jan and Dean, and
for a singer Lou Adler was producing named
Johnny Rivers. Johnny was a laid-back country
boy from Louisiana; whatever we did he loved.
We also sang on "In My Room" for the Beach
Boys. Brian Wilson was a genius, a master, and
he was freer than Phil, although sometimes just
as crazy. With Phil, you sometimes felt as if
he were striking a whip, but Brian applied the

gentle stroke, even when he emptied his pool and recorded us at the bottom, which he did for the "In My Room" session. He got a great sound, but Lord, if somebody had turned on the water, we'd have been like the Egyptians in the Red Sea! Brian was a sensitive, tortured soul, and he told Phil he wanted to produce the Blossoms; Phil said he was willing to let him do that, but then he reneged, not for the last time.

Somehow amid all this work, Leonard and I managed to have a fulfilling life. In 1963, we bought a house at 7726 South La Salle in West Los Angeles, a corner lot with three bedrooms that cost $22,000, which with two salaries we could manage easily. But we wouldn't have been able to afford it if I had relied on Phil for any regular income. After Fanita and I signed the contract, we got a few royalty statements, with all kinds of deductions, for things like units returns and "cartage." After all the deductions there was, of course, no money, only a note that said, "Hopefully there will be something left next time." With my session income, though, Leonard and I were living well. When I look back now, that period between 1962 and 1964, with both my career and marriage flourishing, was among the happiest of my life. And God added to the blessings when, during the making of the Christmas album, we conceived our second son, Chawn, who was born on April 27, 1964.

So how does that old maxim/cliché go? Nothing is ever as good as it looks or as bad as it seems? Before Chawn was born, I woke up from a dream when I found out that Leonard was cheating on me again—Lord, why did it always happen when I was pregnant? I don't know what offended me more, his infidelity or his thinking I was so stupid that he could hide it. He came in one day with Duke Covington in tow and told me he

had to take Duke home, that he'd be gone about half an hour. I
didn't think anything of it, but they were gone only a few min-
utes when I remembered we needed some milk and ran out to
catch him. And Lord, did I catch him.

He had driven only halfway down the block when the car
stopped and Duke got out, then got into his own car! I was
screaming at them, my greatest concern still being the milk,
when Duke saw me and raced around to Leonard's car. "I think
Darlene saw us," he said, panting so hard that he was fogging up
Leonard's windows. Leonard, instead of running away, put the
car in reverse and drove it back to our driveway.

"Was there something you needed?" he asked nonchalantly,
as if I were a dissatisfied customer at the market where he
worked. Come to think of it, if I had been, maybe he would
have paid more attention to me.

"I was just going to tell you to get some milk. Why'd you tell
me you had to take Duke home when he was parked down the
street?" He didn't say a word. He just got back in the car and
didn't come home for two or three hours. And when he did, he
was totally brazen about his unexplained absence. He spared me
the lurid details, but from his unapologetic stance I knew he'd
been with one of his girlfriends.

"Do you think I'm crazy?" I said. "Better yet, do you think
I'm blind?"

He poured a beer and poured himself away from me, and
that was really the moment when I started to imagine what
life would be like without him. We'd have a few more years of
false restarts and pockets of happiness, but after this round of
free juice—I found out later that his latest conquest was a high
school girl, whom he impregnated—he could never be the focus

of my life again. Thank God there was plenty of work to do. It kept me from wallowing in the mud of self-pity.

Years later friends asked me how I could work so much when my children were so young. But the idea of a stay-at-home mother, so canonized in the frenetic nineties as a golden ideal of a time gone by, was a myth, at least in my family. The women always worked, no matter how young their kids were (and in my mother's family, her mother brought home all the bacon). Fanita had a baby and she kept working; so did Grazia Nitzsche. It was only when I started working in Las Vegas and I met the wives of managers and casino owners and all manner of high rollers that I saw women who didn't have jobs; they looked as strange to me as I must have to them.

By the time Chawn was born, though, backup sessions with the Blossoms were about the only work I was getting, because the Darlene Love career had ground to a halt, almost overnight. My experience on the Chitlin Circuit with Bob B. Soxx and the Blue Jeans made me loath to go on the road as Darlene Love, especially when there was regular session income right in my backyard. Not that there were any new hits to go out on the road with, anyway. Phil was totally distracted by Ronnie, and President Kennedy's death had made us all take a long, deep breath of a time-out.

In the weeks following the assassination, the radio was dominated by two songs that accurately gauged the country's mood: "Dominique," the gentle French folk song by the Singing Nun, embraced by a country in desperate need of a bedtime lullaby, and "Louie, Louie," by the Kingsmen, the garage-rock anthem whose unintelligible lyrics mirrored the indecipherable events of the day. And then, six weeks after the president was killed, four

messengers from the east arrived breathlessly to announce that the mourning period was officially over. "I Want to Hold Your Hand" was released. It was time to start the party again. Little did we know that we weren't invited.

The Beatles were already the biggest recording act in their native England but for the past year had had no luck with a handful of record companies trying to crack the American market. It wasn't until Capitol bought their contract and created a *War of the Worlds*—like hysteria about their arrival that they finally broke through. Perhaps the same frenzied phenomenon would have occurred if the president hadn't been killed, but now American teenagers had no hero, no repository for their hopes and aspirations. And along came these four cute British boys in matching suits, with their hair in matching states of mild dishevelment, their stripped-down guitar-based songs almost the opposite of the records I was doing with Phil. They were spare, simple, fresh, two-and-a-half-minute outlets for nervous energy. The Spector records were layered and labored, like *Moby-Dick*. About the only thing Phil's records had in common with the Beatles' was that they were both loud.

"I Want to Hold Your Hand" was No. 1 about five minutes after it was released, and by the time the Beatles appeared on *The Ed Sullivan Show*, they were dominating the radio. Suddenly everything on the charts seemed to have a British accent, whether it was by the Beatles or any of the boatload of groups that followed. It wasn't just an invasion; it was a true coup. And for years I never understood it. Here were these guys with guitars and long hair who all sounded the same. (Thank you, Miss Dusty Springfield, for being the exception. There was a woman who could *sing*.) I never really cared for—or performed—any of

the Beatles' songs until much later, songs like "Hey Jude" and "Let It Be" and "The Long and Winding Road." I loved those songs, but to me their early stuff was like the early Elvis songs, "Hound Dog" and "All Shook Up." Great jukebox finger-poppers, but not classics.

Phil was as taken with them, though, as the average teenager, not least because they toppled him from the charts. "Baby I Love You," the second Ronettes single, stalled out after a promising start, well below the Top 10. And it wasn't just the girl groups who were suffering. Nino Tempo and his sister April Stevens had a huge No. 1 hit in '63, before the flood, with a cover of "Deep Purple," the old big-band hit, and late in the year released the follow-up, "Whispering." "I walked into my record company," Nino said, relaying a good-news-awful-news scenario. "The product manager told me, 'We sold thirty thousand records yesterday and none today.' Overnight, it was finished. If only we'd had six more months, we could have made a lasting impression, really been superstars."

There would be American artists who had hits in 1964 (like the Dixie Cups, who were the first American group to have a No. 1 hit after the Beatles arrived, with Jeff and Ellie's "Chapel of Love," which Phil originally recorded with me). But the girl-group era was officially over, and it wasn't long before Phil was flying to England for an audience with the Beatles, who were big fans of Phil's. I think he might have been angling to produce them, but they had George Martin, and as much as they loved Phil's records, they weren't about to dismiss their own masterful producer. While Phil was in London, he did get the Ronettes on a tour with another of the London upstarts, the Rolling Stones. Though the Beatles were somewhat wary of Phil, he was royalty

to them, and they asked if he would accompany them when they made that first trip to America for *Ed Sullivan*.

Meanwhile, I was left in the lurch back in L.A. I called Phil's office to find out when the next session was and was told he was either still out of town or unavailable. There were a few tracks in the can, like "Chapel of Love," but Phil had slaved over it so long that it sounded like a dirge; the pure charm of the song, which Ellie and Jeff later captured on the version they produced for the Dixie Cups, was sapped by a lugubrious tempo that made my walk down the aisle sound more like the march to Bataan. When I could finally catch up with Phil, he always said that he was too busy or that he hadn't found the right song yet. Then he disappeared for weeks. I wouldn't hear from him until he needed me to sing backup for a Ronettes session.

Phil's reserve of material had run dry, but it was his own fault. Jeff and Ellie had grown tired of signing over one-third of their publishing income to Phil, and they had found their own acts in New York to produce—the Dixie Cups, the Jelly Beans, and the Shangri-Las. These groups were all on the Red Bird label, which was owned by the legendary songwriters and producers Jerry Leiber and Mike Stoller. Jeff and Ellie had one more big year, with hits like "Leader of the Pack" and "People Say" and "I Wanna Love Him So Bad," and even rode the coat-tails of the Brits when Manfred Mann recorded a year-old Jeff-and-Ellie song called "Do Wah Diddy Diddy."

Without Jeff and Ellie, Phil had to find a new, hungry team willing to sign over part of their songwriting credits in order to get their songs recorded. Eventually he settled on Vinnie Poncia and Pete Andreoli, who wrote "The Best Part of Breakin' Up" and "Do I Love You" for the Ronettes in 1964. These

songs were hits, but just barely. There was just too much British product blocking their way.

So the Blossoms—now Fanita, Grazia, and me—did what everybody else did: We started looking east, too, and our savior came in the form of a stocky little man from England. We were singing backup for Jackie DeShannon at one of her live gigs when she introduced us to Jack Good, a TV producer who was hoping to do a rock-and-roll program in the States, in prime time. The only rock-and-roll shows that existed so far were *American Bandstand* and its clones, on which artists lip-synched while swooning teenagers offered canned applause and a suited smoothie pretended to know all about an artist's latest greatest hit. Jack's show was going to be live, and there would be no boundaries to the kinds of acts he would book. It was meant to be as cutting-edge as possible, modeled after the British show *Ready Steady Go.* The title would be just as aerobic: *Shindig.*

Jack's taste for black music ran deep and long, and he wanted to bring us on the show as regulars; his only problem was that he wanted an all-black group, and Grazia was white. Having an all-black group would be radical enough; a mixed group, he felt, would never fly. Grazia, disappointed as she was, put on her best "I won't hold you back" face, and it didn't take us long to find Jean King, a wonderful soprano we met through the producer H. B. Barnum.

Almost everybody on the pilot was black. There was Chubby Checker and Sam Cooke and us. Oh, and a couple of white boys who just *thought* they were black. On the set one day I heard this deep, sonorous voice surrounding me as if it were coming from an empty oil drum. I turned around and saw Bill Medley, one half of the Righteous Brothers, tall and thin as a beanpole.

Lord, I asked myself, where was all that voice coming from? By the end of our first conversation, Bill had me doubled over with laughter, whether he was doing an impression or telling a mildly off-color joke or just acting crazy. The more I laughed—and, honey, when I laugh, as when I sing, I let it all go—the more Bill cut it up. Bill always said that my laugh was as good as any narcotic to him.

The Righteous Brothers—Bill and his partner, Bobby Hatfield—weren't known outside California much yet, and *Shindig* and Phil Spector would do a lot to cure that. Bill and I were instant friends, but we were both married then, so my mind never wandered over into the danger zone. I had never been attracted to a white man before, and for now I still wasn't. But I was never able to get his voice out of my head, and during the next few years it only got louder.

Jack's conviction and commitment to us almost killed the whole show. ABC picked up the pilot and put the series on its fall 1964 schedule, but with one condition: Lose the Blossoms. You can have blacks as guest performers, but the prime-time audience, Jack was told, just wasn't ready to see blacks as regulars every week. Jack stood up for us, and ABC was so eager to have the show that it gave in and let the Blossoms be the house singers. The show was such a success that it was broadcast twice a week. And just as Eddie Bill had done years before when we were just teenagers starting out, Jack warned us that behind every microphone and camera there would be people looking for an excuse to have us fired. As ridiculous and racist as it seemed—watch yourself, girl, you're black—it became a point of pride for us not to give anyone an opportunity.

We sang with anyone and everyone on *Shindig*. Aretha Frank-

lin was one of the guests that first year, and we became fast friends. She sang "The Shoop Shoop Song" with the Blossoms, and it was like woodshedding. Even performing a silly pop song like that, she had the gift of almighty fire. And, Lord, could that woman eat! Before the show she filled up on macaroni and cheese, fried chicken, and greens. Recently I was shocked to find an old issue of *Jet* magazine from those days and see how small she was. Most singers, myself included, can't think of performing on a full stomach, but not Aretha: She'd fill her plate, have a cigarette or two, and then announce herself ready to go. Something must have worked, because she would open her mouth and hit any note she wanted.

Of course, not all the acts were classics. On *Shindig* we also sang backup for artists like the Kinks and the Rolling Stones. I thought Mick Jagger was such a spastic. I mean, the worst dancer I'd ever seen before this was Sonny Bono, who was bad even for a white boy. He could make Pat Boone look like James Brown. But Mick, Lord, I thought he was having a seizure. And then there was Freddie and the Dreamers, whose lead singer flapped his arms in the breeze like a wounded ostrich. What was happening to music?

Even after *Shindig* was a hit, Jack continued to get grief from the network about the "color" of the show, and the more grief he got, the more black acts he booked. "You watch," he said, "one show is going to be *all* black acts." Sure enough, the face of the show just kept getting darker and darker until, save for the Righteous Brothers, Donna Loren, and Bobby Sherman, who were regulars, the whole lineup one week was black acts. And they weren't just the current chart toppers. There was one show devoted entirely to Ray Charles, and another with Clara Ward,

one of my all-time gospel heroes. But the biggest kick of all was having artists like them and the Supremes and the Four Tops all come on the show and treat us as if *we* were the stars.

The Blossoms weren't the only members of the Phil Spector diaspora to find an oasis in *Shindig.* Two of the other regulars had made some records as Caesar and Cleo and were now going by their "real names": Sonny and Cher. We used to laugh at the wild, raggedy getups they would wear, the fur vests and the bare midriffs. Sometimes you couldn't even see Cher's eyes because her hair was so long and dark. And Sonny with his flat butt, Lord. But now here they were with us on *Shindig.* It was like Beauty and the Beast. Cher wasn't pretty, but she was striking, and her voice was strong. Sonny couldn't sing at all, so he made Cher sound even better. They were the last people, though, of all the Wrecking Crew regulars, who we ever thought would make it. In fact, we were shocked when they became so successful.

But it didn't matter that Sonny couldn't sing. All those years when he was taking our coffee orders and singing off-key on the sessions, he was soaking up everything Phil was doing, and after a handful of failed singles (not any of them on Philles—Phil didn't think they were good enough, or Sonny needed to prove he could do it on his own), they landed on Atco, a division of Atlantic, after a referral from Nino Tempo. Between their appearances on *Shindig* and their hippie drag, they were setting the stage for "I Got You, Babe." As a record, it's just a Phil Spector knockoff with an echo bouncing off the wall and all the instruments leaking into one another like runny eggs. But "I Got You, Babe" wasn't just a record—it became a real groundswell, because beneath all the gloop there were many true notes struck,

probably because it was their life story. Cher was a runaway and Sonny was a loser and everybody told them they would never make it. Boy, did we laugh when we first heard it. And look who laughed last! Say what you will about Sonny, but without him Cher would never have had a career.

Meanwhile on the show I was making friends I wouldn't even meet for another twenty years. Luther Vandross was a teenager in the Alfred E. Smith projects in New York during the years the show was on, and he was a faithful viewer. "The Blossoms had that *hoot* thing going, the thing that's so overwhelming it makes you dizzy, as if all the oxygen has left the room," Luther remembers. "They didn't sound too brassy. They were so smooth. I remember a cover version of a Velvelettes song that the Blossoms did on the show, a song called 'Needle in a Haystack.' I was impressed with how mature Darlene's vocal was. She sounded so grown-up. I didn't have my real mature stuff until much later in my life than Darlene had. And then of course there was that fabulous blond wig she wore, which was a different look for a black singer."

Paul Shaffer, who educates viewers nightly about sixties music as the bandleader on *The Late Show with David Letterman*, was also a teenager in Canada when *Shindig* was on the air. "*Shindig* showed me a lot of the roots of black music," he says. "I remember the show that was an entire tribute to Ray Charles, and he sang 'What'd I Say,' with the Righteous Brothers in the crook of the piano doing the call and response. Another show had Marvin Gaye singing 'Hitch Hike,' and all of a sudden it started to snow, and there was the sound of a choir, and the Beach Boys appeared singing a Christmas song. The show is still an inspiration to me; a lot of the things I do on *Letterman*, I try to think

of how they would have done it on *Shindig*. And of course there were always the Blossoms, singing on a raised platform above James Brown, Adam Faith, anybody and everybody."

And my own brother Alan, who was in the military, was having a hard time convincing his army buddies that I was his sister. "Some of the guys started in, saying, 'Look at that girl,' and passing remarks. I had to straighten them out about it. I was ready to do battle."

The Righteous Brothers and their blue-eyed soul sound were making an impression, too—on Phil Spector. Phil wasn't having any more luck on the charts toward the end of 1964 than he had at the beginning, when the British Invasion broke. As one Ronettes record after another failed to set the world on fire, he finally decided he had to produce a male act. Phil had produced Curtis Lee and Gene Pitney in the pre-Philles years, but the glory records were all made with female singers. Phil was just more comfortable with female artists; there were no clashing male egos, for one thing, and I think he felt he could communicate his ideas better (like giving dictation; to Phil the singers were little more than secretaries who could carry a tune, anyway).

But now he had no choice. If he was going to get back in the game, he needed to find a male act. There had been some discussion about his producing the Rolling Stones, but they were already stars and didn't need Phil's meddling in their sound. But the Righteous Brothers, who sounded like the second cousins of Ray Charles and Sam Cooke respectively, were like surfers still waiting for the perfect wave. With *Shindig* they paddled a little closer to it, and with Phil they finally caught the Big Kahuna.

Phil bought their contract from Moonglow, a small L.A. label on which the boys had had a few local hits, soul rave-ups like "Little Latin Lupe Lu" and "Justine." Phil's sixth sense, dormant for almost a year, roared back when he decided to slow them down and find a killer ballad. He had renewed contact with Barry Mann and Cynthia Weil for the first time since "He's Sure the Boy I Love," and they delivered "You've Lost That Lovin' Feelin'." Honey, there was never a doubt about this one.

"It took a month to do that record," Bill Medley recalls. "That was as long as most people took to do an entire album. You used to go in for three hours and come out with three songs. But Phil was dead-ass right; the record just kept getting better and better." Phil called the Blossoms in to do the backup (along with Cher and a few other session singers), and even with the snail's pace, its length (more than four minutes, though Phil put 3:05 on the label), and the fact that Bill's and Bobby's vocals boiled over at the climax so much that it seemed as if they were singing to each other, the song was an instant No. 1. Phil was back on top. "It was," Bill said, "the first adult-sounding record that kids could get into."

We naturally thought that Phil would next turn his attention to me again. I did record a few songs, including "Stumble and Fall," backed with "(He's a) Quiet Guy," probably my favorite of all the Spector singles after "Christmas (Baby Please Come Home)." But Phil withdrew it almost right after it came out and never told me why. I couldn't figure out why Phil wouldn't want to cash in on the Blossoms' weekly appearances on *Shindig*— "Lovin' Feelin' " got a lot of exposure on the show. ("Jack Good wouldn't let us do it at first," Bill says. "He thought it was too

slow. Then when it was a hit, he let us sing it.") With the right song, we could capitalize on being in front of millions of viewers every week. But Phil wasn't interested.

Bill remembers that he and Bobby both went to Phil and said, "Record the girls." But the only girls—or girl—he was interested in was Ronnie. Mann and Weil also gave Phil "Walking in the Rain," and it became the Ronettes' last big hit, late in 1964. As for *Shindig*, it was almost as if Phil didn't want the help. Whatever success he had, he wanted to achieve it himself. Around this time, Burt Bacharach, who with his partner, Hal David, was writing about a hit a month, not just for Dionne Warwick but also for Dusty Springfield, Tom Jones, and Jackie DeShannon, approached Phil about producing the Blossoms. But Phil wouldn't let us go. Brian Wilson, who had been trying to get Phil to let him record us for more than a year, told us he was wearing down Phil's defenses and that Phil was finally going to let him do it. But it never happened. We really were caged birds. The last Phil Spector song I recorded had a title that was truly prophetic: "Long Way to Be Happy."

It had now been three years since the session for "He's a Rebel," that "cute little song" that in the end made me a convert and follower of Phil Spector, the record that started the Wall of Sound, and the song that made me stay with him so long. How could it be over so soon? Now Sonny and Cher were superstars, the Righteous Brothers were tearing up the charts, and the Blossoms—and Darlene Love—were still "the best backup singers in the business."

I didn't hear from Phil again for months. The Righteous Brothers left him after only a year (and what a year: four Top 10 hits, though after "Lovin' Feelin'" Bill had as much to do with

the production as Phil did), and Phil was floundering again. At twenty-five years old, he was already backpedaling, yearning for his "glory year" of 1963. He called Jeff Barry and Ellie Greenwich, who had divorced but were still working together. According to Ellie, he said he wanted "a love song, and a rock-and-roll symphony." Jeff and Ellie's love had faltered, but they were still pros and came up with "I Can Hear Music," a gentle, almost melancholy song that fit right in Ronnie's mewly range. That was the love song. As for the rock-and-roll symphony, it would turn out to be Phil's waterloo.

My relationship with Phil had withered so severely that when he needed us for a session, he didn't even call us himself. This time Grazia Nitzsche, who was still singing backup on his sessions, told us to be at Gold Star on a spring afternoon in 1966; I had no idea what the song was or who it was for. Turns out we would be backup for "I Can Hear Music," and once again I would be one of the phantom Ronettes. When I walked in, though, Phil wasn't playing "I Can Hear Music," but the other new song from Jeff and Ellie, "River Deep-Mountain High." I loved it and thought it might even be for me.

"What's that?" I asked.

"Oh, it's just a song," Phil said.

"Who's it for?" I said, practically holding my breath before Phil responded.

"Oh, I'm not sure yet," he said.

But he knew full well. He had been eyeing Tina Turner, of Ike & . . . , for some time, and in her he saw the R&B credibility he had been craving for so long. Tina, whose hard-dancing-hard-loving-mama act, as directed by her husband, Ike, had been tearing down houses for years. In fact, her love slave

in go-go boots made Ronnie look like Little Bo Peep. But Ike and Tina hadn't really scored a big crossover hit yet, and Ike's dollar-sign eyes lit up when Phil offered him a deal. Ike would get the cash. Phil would get Tina. The name on the label would be Ike & Tina Turner, though for all we knew Ike was in Alaska when we did the session.

No matter how you felt about Phil personally, his sessions were always thrilling for all the singers and musicians, whatever our role, either as spectators or participants. The louder a song got and the closer we got to the finish line, we were all egging him on: "Go, Phil, go." We were his personal cheerleaders, as if we'd hitched a ride on a comet. But the session for "River Deep" was miserable. The studio was crammed with singers. Besides Tina, there were Fanita, Jean, Clydie King, Grazia, and me. It was mass confusion. This time it was all din, no music. No one could hear anything, and the musicians could barely make sense of Phil's directions because everything was submerged in echo. He kept overdubbing the backup singers, and by the time he got to Tina, he worked her so hard that she had to hold herself up by the overhead microphone. She had never before had anyone make her sing the same few words over and over again, and by the time she got to about the fortieth take, she was screaming and losing her voice. She thought she sounded horrible, but she hung in there. And that's exactly how Phil wanted her to sound, like a woman on the verge of submission. I'd never seen anyone, not even Phil, treat an artist like that in the studio. Nobody's heart was in it, except Phil's. By the end of the session I was wondering what I was doing there. It was a Wall of Sound, all right: a wall of water, and everyone was drowning.

Ellie Greenwich told me that when she got an acetate of the recording, she ripped it off the turntable before it was halfway through and threw it across the room (shades of Mama and "Work with Me Annie," though at least she listened to the whole song before venting her rage). Ellie thought Phil had really lost it. And disc jockeys, whom Phil could always count on to give his records a chance, were suddenly otherwise engaged when Phil's promotion men called. True, we all thought the record was crap (although it was huge in England—go figure). But it probably deserved a little better than No. 88, which is where it crashed and burned.

Phil's arrogance and hubris had finally caught up with him, and there was probably some collective bad karma emanating from every singer, songwriter, musician, engineer, promotion man, and disc jockey he had stepped on. "River Deep-Mountain High" could have been the greatest record ever made (indeed, that's probably what Phil was aiming for) and it still wouldn't have mattered. The Phil Spector era was officially over. After that session, he withdrew with Ronnie. (He divorced Annette in 1965 and finally married Ronnie in 1968.) In his house in Bel Air, Phil's wounds festered and disfigured him. I didn't see him for almost a decade. The week we did the session for "River Deep," the Righteous Brothers were No. 1, with "Soul and Inspiration," their first release without Phil. Cher was No. 2, with "Bang Bang," written and produced by Sonny. And there I was, with no identity and now no producer. *Shindig* was canceled after only two seasons. It had become too gimmicky, with location shows (including four from Hawaii, not that I complained about that). We lost the Righteous Brothers to their shooting

star, and as Jack Good seemed to lose focus, the energy diminished from a bonfire to a pilot light.

At twenty-five years old, I was too young to be taking stock. But that's just what I was doing. And now God was giving me some more directions: into the desert and out of a marriage.

CHAPTER 10

One Strike and You're Out

The Blossoms went back to doing sessions; Lou Adler especially kept us gainfully employed, with more work for Johnny Rivers and some for the Mamas & the Papas. Johnny Rivers was a real oddball, at least musically, in that you couldn't hang any particular style on him. He wasn't British, he wasn't R&B, he wasn't folk rock, though he could sound a bit like any of those. He did some Motown covers and originals by West Coast songsmiths like P. F. Sloan. On ballads like "Poor Side of Town," our backups were courteous and light, but sometimes we let it go, as we did on Johnny's remakes of "Baby I need Your Lovin'" and "The Tracks of My Tears." I can remember feeling the spirit, and I just let loose with some

gospel clangs. Lou kept the tape rolling. Johnny Rivers isn't re-membered today as one of the all-time greats of rock and roll, but thirteen Top 40 hits in a row don't lie.

It didn't matter who Lou was working with, because we loved him dearly, and sang on all his sessions, even an entire album for Peggy Lipton, who was his girlfriend and the star of *The Mod Squad*. Peggy's voice was thin as cheesecloth, but she was a sur-prisingly okay songwriter, and all of the songs on her album were written or cowritten by women. If the writer wasn't Peggy, then it was Laura Nyro or Carole King. That had to be a kind of first in pop music history. Lou surrounded her with the best musicians and arrangers. For him, the focus was always the art-ist, whereas with Phil, the focus was always Phil. If I had done "He's a Rebel" with Lou, I realize now, the Blossoms might have been as big as the Supremes, because Lou would have nurtured our career, not just the song.

With Peggy, we'd be ready to go in and do our vocals and Lou would call us over and say, "Go easy on her, girls," which I knew meant, "Go easy on her, Darlene." Lou was used to my mouth running. But we never had cause to trash Peggy. She was so even-tempered, such a sweetheart, that we never thought about dishing the dirt on her. I think she was even a little em-barrassed to sing in front of us. Finally we just went over to her and said, "Go on, girl, sing. It's gonna be all right."

The Peggy Lipton album sold about twelve copies, but we didn't care. Working with Lou reminded us that not everyone in the business was a shark who treated talent like fresh chum. He was still ponytailed and sockless, and to this day has the same phone number he had thirty years ago. He was married to

Shelley Fabares for a few semesters in the mid-sixties, but they didn't divorce until years after they split up. He told me he just always liked saying he was married, even with the girlfriends and kids who came later. Lou came to my father's church a few times and helped us with some benefits, and today is still the most laid-back person I know. (Maybe that comes from all the weed he smoked. Once or twice I admit I "inhaled" after a session; we were working on Johnny Rivers's *Whisky à Go-Go* album, for which the Blossoms simulated live audience sounds one night, and after a few hits on a joint, I got in the car to go home. I stopped at a red light and realized I was about twenty feet behind it. And that was it for me and drugs.) Lou later produced Carole King's mammoth album *Tapestry*, which included "You've Got a Friend," a song I perform in concert, often with Lou in mind. Lou never forgot the days when he was struggling and paying us $5 a side. "We'll make it up to you when we're rich," he would say. And so he did, long after that debt had been retired.

The Righteous Brothers also gave us a lot of work in those early post-Phil years, asking us to tour with them, paying us something like $3,000 a week and even giving us a solo spot as their opening act. We thought they were being incredibly generous, just as Lou had been, remembering when we sang on their sessions for practically no money. Now they were big stars and they were spreading the wealth.

What we didn't realize was just *how* big they had become. We got out on the road and found ourselves playing before audiences of twenty thousand and thirty thousand, doing full-month stints in Vegas. Suddenly $3,000 a week started to feel

like peanuts. "Lord, you didn't tell us you had become this big," we told them.

Vegas was very convenient for us because it was so close to home, and we could take the kids there if we had to. But it was also where my marriage started to unravel. Leonard never minded my sessions, no matter how late they ran, because he always knew where I was, but once I went on the road, he started inventing fantasies about me and other men. And that's just what they were—fantasies, because I can honestly say that while I was married I never fooled around.

But believing that I was cheating let Leonard feel less guilty about his own infidelities, and so the accusations started getting louder and uglier, even though he could never put a name or face to any of my so-called boyfriends. Finally one night when we went to see Marvin Gaye in L.A., at a nice little club called the Crescendo, he committed the unforgivable sin. We went with Fanita and her husband and Jean and her husband for a night on the town as special guests of Marvin. We knew him from the old Chitlin Circuit shows and from *Shindig*, and though we didn't see him much, we always tried to catch each other's shows. Sometimes if Marvin didn't have background singers available, the Blossoms would do spot duty, just as we had when we first met him at the Apollo. He was really sexy, like Sam Cooke, but in an aw-shucks kind of way. And he sang as if he were writing soul's constitution. But it was his shyness, that slight downward tilt of the chin, and the questions in his eyes that made him irresistible to women. He was more gorgeous now than he was when we met him back in 1962. And Marvin made men insanely jealous. Bill Medley, while he admitted that Marvin was one of the great singers of our time, said he didn't think Marvin

really wrote all the songs he got credit for, like "Dancing in the Street" and "The Bells." (Turns out that he did.)

As a confidence booster, Marvin put us right up front and made a lot of eye contact; in fact, he practically played the whole show to us. That was all the "evidence" Leonard needed. He'd been drinking since we left the house—it took only four or five drinks for him to be stoned out of his gourd—and all through the show he interrogated me in his stage whisper. First, "What's going on between you and him?" and then, "Have you been messing around again?" and finally, "Are you fucking that nigger?" The basis of all these accusations? A few smiles and eye locks. I kept on telling Leonard that Marvin was just a friend, and Fanita's husband, Ruben, kept trying to calm him down. Finally Leonard dragged me by the hair out of the club and into the parking lot, and in front of the car belted me in the face. I never went back into the club to tell people we were leaving. I didn't want to be any more humiliated than I already was.

The thing you never think will happen to you had just happened to me. I was being two-timed, and now I had been hit. Why did he do it? Leonard didn't mind enjoying the fruits of my labor, but he was jealous of the praise I was getting. In my church, as in the Catholic Church, divorce was forbidden; you stayed with the sucker no matter what he did. But once I got smacked around, that was the end. I could get past the cheating, but I needed to get hit only once. I called the cops and had him locked up. I wasn't going to help him get out, either. When he sobered up, Leonard apologized profusely and tried to make things right, but I'd had enough. He didn't fight me when I asked him to move out. Any time I'd be tempted to go back with him, all I had to do was think of the baby girl he had with that

high school chippy a few years back. He'd cry and say the child made him think of the little girl we lost, and then I'd get even angrier.

I think he knew that even if we could make it work for a few months, we'd be lighting the same slow fuse, which would inevitably lead to some sweet young thing and more drinking and lies and accusations and finally end in the same kind of blowup we had at Marvin's show, and then he'd beat my butt coming and going. Besides, there was really nothing left to save.

I eventually got full custody of Marcus and Chawn—in fact, throughout the whole divorce hearing Leonard was very contrite and admitted to the judge that the divorce was his fault. "I blew it," he said. He didn't even have his own lawyer. "Let her have anything she wants." We remained friends after that, and he visited the boys often. Leonard was a lousy husband but still an attentive and concerned father, so when I had to go out on the road it was never a problem for him or his family to take the boys. Whenever he was with the kids he was the sweet man I married.

Marcus was seven years old and Chawn was four when Leonard and I split, but my biggest concern was not that they'd need a father, because Leonard was always around, but that I needed to keep making a living. The judge awarded me only $35 a week in child support because I was making $300 to $400 a week on average, which was a lot of money in the late sixties. So in order to maintain our lifestyle, I had to keep working. A lot of people ask me how I could have gone out on the road when the boys were so small, but the reality was that I liked my work, and I knew that the work I was doing then would be making a life for them later.

And, to be honest, motherhood wasn't the most important thing in my life. I loved my boys, but I loved to sing, too, and I often think that if I'd known I could have had a career singing, I wouldn't have gotten married and had children as soon as I did. So I didn't lose much sleep leaving Marcus and Chawn with our housekeeper, or my mother, or Leonard and his family. Every now and then my father would hint around. "Don't you think she should be at home?" he would say. Sometimes I'd leave them with my youngest brother, Alan, who wasn't too responsible. Years later I found out that he took them to pool halls or sent them home by themselves on the bus, even though they were really too young to know what they were doing. The Lord must really have had his radar working on those days.

But everybody on the road had kids and they all kept working, so any nagging doubts I had were easily quieted by a chorus of like minds. The best cure for one potential guilty conscience is to be around someone else with a potential guilty conscience. If the boys got sick or otherwise really needed me, I would be there. But I think Hillary Clinton was on to something when she said, "It takes a village to raise a child." For me that village included not just my family and friends but the occasional concierge and lifeguard at the hotels in Vegas, where the boys spent a lot of summers. And it wasn't long before there was a new man in our lives. If there's anything that I would learn about God's plan for all of us, it's that you should bet on the long shot.

CHAPTER 11

A Princess and a King

America lost a little bit more of its innocence as each year in the sixties passed by. By 1967, the Vietnam War was raging, the Summer of Love was sweltering, and everybody was tuning in and turning on. I was lucky enough to escape the deadly tendrils of drugs—after that episode following the Johnny Rivers session I just wasn't interested—but the rest of my family wasn't so lucky.

My younger brothers, Joseph and Alan, had both been in and out of trouble since high school. First it started with cigarettes and cutting school, which in the early sixties were bigtime offenses, but then they graduated to harder stuff. Alan especially got so bad with drugs that all of us had to bail him out at one

time or another. One night I was over at my parents' house and left my rings and watch on the windowsill while I was doing the dishes. We went out for a couple of hours, and when we got back my jewelry was gone. We knew Alan had taken them to hock so he could buy drugs; when he came back he was ripped to the gills. He wouldn't admit it, though. All of us wondered if this boy was going to make it. We were sure we'd get a call from someone telling us he'd been shot.

We thought the army might straighten him out, but not long after he went to Vietnam he lost a leg in battle and came back more addicted than ever. (Alan was the third member of my family to lose a leg. Both my father's father and brother had a leg amputated. We began to wonder if the men in our family were cursed.) Alan went back to live with Mama and Daddy, and when they were away at a convention, he started tripping on heroin. It got so bad that Alan and Joseph broke the thick plate-glass window in front of the house and then Joseph took off Alan's wooden leg and started beating him with it. Luckily Edna was going by the house and found him lying on the couch, where he almost certainly would have died. I know what you're thinking: How could this happen in such a good family, such a religious family? Believe me, if we hadn't had God to get us through those times, my brothers might not be alive today. Eventually both Alan and Joseph turned to God and survived, but not a second too soon.

Music, meanwhile, was changing faster than money at Vegas gaming tables. Start at one end of the dial and by the time you got to the other end, you could have crossed not just a dozen musical time zones but practically hemispheres. The Beatles were going psychedelic. Aretha was demanding respect. Jimi

Hendrix was splitting the seams of his guitar. And yet there was still plenty of room for pure popsters like Johnny Rivers or the Monkees. Even Frank and Nancy Sinatra had a No. 1 song together just before the Summer of Love, "Somethin' Stupid." And Nancy, of all people, was one of the Blossoms' benefactors in those early post-Phil years.

We met her through her producer, Lee Hazlewood, whom we did dozens of sessions with, including, early in 1968, a song called "Sweet Ride" for Dusty Springfield. I had always loved Dusty's voice and her ability to sing rhythm-and-blues songs, even though she was a pop singer from England. She didn't sound black, she just sang everything from her gut and always turned a mirror on a song's best intentions. We had never worked together before, and I'd heard all kinds of horror stories about her throwing teacups out of rage, berating musicians, and generally being a scourge to everyone who crossed those panda eyes of hers.

But she couldn't have been nicer; in fact, she had asked Lee to book specifically, because she was "in awe" of us! She was very hard on herself, and worked her lead over and over. But it was a real pleasure being around her, and my only regret is that we never got to work together again. She went back to England after that, and though she later moved to the States, our paths never crossed. But I'll always remember "Sweet Ride" as one of those truly magic moments in the studio, gone almost as soon as it occurred but playing in heavy rotation in my memory.

Nancy Sinatra was no Dusty Springfield, but her records had something else going on besides her voice. She was just pure sex kitten, a white, somewhat more dangerous version of Ronnie Spector, and she had the right producer in Lee, who surrounded

her with very sympathetic arrangements and wrote songs perfect for the softcore persona she was projecting. "These Boots Are Made for Walkin'," as a song, was pure schlock, but as attitude, it was pure gold. And her father's bankroll didn't hurt, either, because she recorded for his label, Reprise.

Nancy was the first to acknowledge her vocal limitations, and she knew what a great singer was. After all, she had grown up with one of the greatest voices of the century across from her at the dinner table. And that was why she wanted us, with our reputation for making anyone we sang with sound good. She was a practical joker, and insecure—she'd write us little notes with happy or sad faces at the end of the day, to evaluate her own performance. But the thing that impressed me the most was her work ethic, which I think she got because her parents didn't send her to private schools and made her get a job when she was fifteen years old. So she never acted like Daddy's spoiled little girl, simply because that character wasn't in her repertoire.

We went first class all the way with Nancy. Everybody did. The musicians, the arrangers—she treated us all like royalty. One of the greatest shows we did was at Caesars Palace in Vegas. Las Vegas was, of course, her father's playground, and so he went all out, sending invitations to people as if they were being asked to make a command appearance. Frank came to the rehearsals after a few afternoon cocktails and he sweet-talked everyone, making sure that his little girl was being taken care of. Finally Nancy had to throw him out. The whole show was really being run by Hugh Lambert, Nancy's future husband and one of the top choreographers in L.A. He was something of a task-master but never gave us a hard time.

Elizabeth Taylor, Ronald Reagan (who was then governor

of California), and Natalie Wood all showed up, along with a few limos full of Frank's Rat Pack pals. The Queen of England sent her regrets. It was especially gratifying when Nancy put the spotlight on us and said that she "must be a fool to be on the stage with singers so talented." The euphoria of the evening was broken only when I bumped into a fan after the show who had that look my father always had whenever he'd caught us doing something wrong.

"How could you?" he said.

"Excuse me?" I said, looking over his shoulder for the nearest security guard. My fans had generally been effusive and, thankfully, nonthreatening, but you never knew when there would be a homicidal maniac lurking behind an autograph request.

"You're Darlene Love. How could you be singing backup for Nancy Sinatra?"

I've never been a woman of few words. Ask Phil Spector, or Bill Medley, who once dubbed me "Motormouth." But for a few seconds I was Zechariah, struck dumb by a truth I had failed to acknowledge. What *was* I doing singing backup for Nancy Sinatra? This man was suggesting that I had somehow demoted myself and had gone back to a school I had already graduated from. I was making a nice living, true, but not a career. I don't remember what my reply was; probably something like "Putting food in my kids' mouths." But that man's words would stay with me, reduced to a murmur for many years, one that I could turn down but never completely off.

Nancy was signed to do a movie with Elvis Presley, *Speedway*, one of the last of the "musicals" he made. (You know, boy-meets-girl, she's unimpressed until he exhibits some derring-do and bursts into a few songs with an invisible orchestra.) Elvis

must have caught one of Nancy's shows, or heard about us from Nancy directly, because the next thing I knew we were getting a call to sing on his 1968 TV special. This was going to be Elvis going back to his roots; no silly production numbers or contrived guest stars. Just him in front of an audience, cutting loose in black leather. And now the king of rock and roll had personally requested our presence.

I had never seen Elvis perform, and more than ten years had passed since he remade American teenagers in his own image. Now he was in his thirties, usurped a bit by the Beatles and, despite all the movies, without a major hit song since the early sixties. I wondered whether his heart was really in it, and then when we met, I found him to actually be rather shy and introverted, and a zealot about his health.

Funny how when people think of Elvis now they see the bespangled, bloated caricature, his arteries stuffed like sausages with the by-products of peanut-butter-and-banana sandwiches, his veins poisoned by a deadly river of amphetamines and barbiturates. But when I knew Elvis, he treated his body like a temple; he abhorred drugs, did karate regularly, and ate no more or less than the rest of us. He was so quiet sometimes we had to touch him just to make sure he was real. And he had gorgeous hair—it was jet-black. It wasn't his natural color, but Lord, did it make him shine.

Elvis loved gospel music, and most everything he learned about it he got by going to black churches in Tennessee when he was a teenager. He told us he was too afraid to go in, but would just stand outside with his ear pressed to the door, like a kid with his nose against the plate glass of a candy store. Only he didn't need money for the prize just on the other side, just a

pair of golden ears. When he told us this, we bonded with him instantly. We would be in the middle of a rehearsal and all of a sudden there would be this glaze in his eyes and he would put up his hands and stop everything. You could never tell when these spells would come on. It was almost like some inner seizure, and his only relief would be a dose of gospel songs. So he'd grab his guitar and say, "C'mon on, girls," and we'd go off in a corner for a couple of hours and sing all the "Oldies but Goodies": "Precious Lord," "Take My Hand," "Wade in the Water," "Get Back Jordan," "Didn't It Rain," "Amazing Grace." Some of his people passed a few comments about overtime and glared at us as if we were the cause.

But they clearly were only interested in Elvis the star, and they didn't realize that for Elvis the star to function, Elvis the man, the man that he was before all the madness, had to be fed first. And Fanita, Jean, and I were blessed to see a side of him that so few people ever saw. That's why I always say I knew the other Elvis.

This was a crucial moment in Elvis's career. Despite the common perception that his manager, Colonel Tom Parker, had a golden collar around Elvis's neck, Elvis wasn't deaf to the whispers that he was never the same after he got out of the army, or even since his mother died. Now both of those apocryphal events were nearly a decade past. He was married and a new father. I think more than anything he wanted to prove that he wasn't content just being a legend. He wanted to be relevant again.

Once he got in front of an audience, that difficult decade melted away. As Elvis whirled around the stage, got down on his knees and swiveled those hips with a seismic force, it was

clear that this concert wasn't about nostalgia or about a performer and an audience willing to settle for good intentions. You've heard of the "chill factor." Honey, this was all about hot flashes and goose bumps. And when we did "If I Can Dream," Elvis took it to another level altogether. All of a sudden I saw my daddy, ready to leap over the pulpit if that's what it took to shake loose the faith from any reluctant parishioner. Anyone who hears "If I Can Dream" and still calls rock and roll the Devil's music is committing blasphemy. Where was that tut-tutting fan now to tell me that I was Darlene Love and ask what I was doing in the background? The recording of "If I Can Dream" was one of the most unforgettable moments of my career, period.

The special was a smash. Elvis was back and ready to reclaim his throne, but first he had one more movie to make, *Change of Habit,* which was a little more dramatic than his usual fare, but still nothing Robert Redford lost sleep over. Elvis was playing a doctor working in an inner-city clinic with some nuns, one of whom was Mary Tyler Moore, who was in between her icon-setting TV roles of Laura Petrie and Mary Richards. Elvis asked us to be in it, but I wasn't a big fan of his movies. I thought Elvis could be a really great actor, if only he got a good script. This one wasn't any better or worse than any of his previous movies, but we weren't about to say no, especially because he wanted us to play his trio of get-down-with-gravy singing nuns!

The set for *Change of Habit* was in a black neighborhood about ten minutes from where I lived, and it was, of course, always closed. We alternated days between shooting scenes and recording music for the soundtrack, and Elvis was surprisingly accessible. His entourage numbered only about five to seven

people, and we never met the Colonel or Elvis's wife, Priscilla, who were never around. We never got to know Mary that much, either, because she tended to disappear when her scenes weren't being shot. One day during a break, while Fanita and Jean went for something to eat, I took a stroll down near Elvis's "honeywagon," which is what trailers were called in those days. The door was open, and there was no one around, so I wandered over. Another appointment with history.

I stuck my head in the door and found Elvis picking at some food. "Hey," I said. "I can't believe they left you alone."

"It doesn't happen very often," he said, that sly grin on his face. "C'mon in, want something to drink?" Hmm. More regular-folks stuff. He still had on the black shirt from the last scene we'd shot, with the collar open, a morning's worth of perspiration dripping off him. His hair was pretty short for him, but tousled and dented here and there. He was eating fruit. I never saw that man put any junk food in his mouth, not even so much as a single french fry.

We talked for a few minutes about—what else?—gospel songs, and then about the big number we were going to shoot in the church, which would feature the Blossoms with Elvis. Then I noticed this glint in his eye. All of a sudden I wasn't being looked at. I was being looked over.

"Y'know," Elvis said, falling back onto the couch, his voice curling up into a mild, mellow drawl, "I've never been with a black woman before. I've never even thought about it. But I'm thinking about it now."

I thought he was joking. I mean, I could imagine the conversation afterward. Elvis: "So, how was it for you?" Me: "Well, as your first black woman. . . ." But Elvis wasn't laughing. I wasn't

really attracted to him, but sometimes it's easy to confuse awe with sex appeal, and besides . . . this was Elvis! Elvis had been married to Priscilla for a little more than a year, but even so, once I thought he was serious, I found myself being drawn into his current. Who would believe that I was on the verge of having sex with the King of Rock and Roll?

I stammered a bit, but just when I thought he was going to make a move, he fell back on his futon and said, "Hell, what would my people think? My grandma and granddaddy might spin in their graves."

I didn't know if I should be flattered or insulted. What was he saying? That black women weren't good enough for him? That *I* wasn't good enough for him? This was the man who sang and twitched like a black man on stage, who, in fact, presided over the musical miscegenation of the fifties. Was that all that blacks were good for? Then I remembered how Elvis felt about gospel music, and his story about standing outside black churches afraid to go in, and I realized this was just another threshold he couldn't cross. If he did, he just wouldn't be able to explain it to all the conflicting voices in his head.

So we ended up just talking until the lunch break was over and it was time to do our big "scene," in which Elvis examines me at his clinic. It got cut from the final print, though the Blossoms were still in some of the church scenes and in the big musical numbers.

Change of Habit turned out to be Elvis's last movie. With his recording career resurrected, he started touring again, had another wave of hits that lasted into the seventies, and became a fixture in Vegas. He wanted to take us with him, and shortly after the special we got a call from a man at Elvis's label, RCA,

offering us $1,500 a week. The only problem was, we were already making $5,000 a week. And we knew for a fact that he was paying some of his musicians $2,500 a week each. Jimmy West, our manager, turned him down flat. Not long after that, the Colonel himself called. "I can't remember being more scared," Jimmy says. "Here was the most powerful man in the business, sweet-talking me in this Southern drawl. 'Son,' he said, 'take this job. The girls will become stars.' But he still didn't offer us more than $1,500. I told him no. It was probably the hardest decision I ever had to make." Instead Elvis hired Cissy Houston and the Sweet Inspirations. They got $1,500. And they never became stars.

Once Elvis left our lives, I found myself returning to the void. The voice of that man from the Nancy Sinatra concert kept popping up like a chronic ache that you can treat but never really cure. "What are you doing singing backup?" I wanted to be a star in my own right, but I was more concerned with survival, and unlike Cher, I didn't have some tiger like Sonny telling me to get up and go out on my own. My divorce went through just after we finished *Change of Habit*, and now both boys were in school, so there was more time for me to stew in this frustration. Technically I was still under contract to Phil, whom we hadn't heard from in years. We knew he finally married Ronnie in 1968, and his only hit in those days was "Black Pearl" in 1969 for Sonny Charles and the Checkmates. He was treading water as we were; only he had all the royalties from the Wall of Sound years and we didn't.

There were still some perks in these years. Frank Sinatra was running some benefits for Hubert Humphrey's presidential bid in '68, and he took us along for some of them. It was very ful-

filling meeting people like Ella Fitzgerald at these events, even if I was still putting a career of my own on the back burner.

But God was placing me at a crossroads, with no clear indication of which way to go. Finally, one day I looked in the mirror and said, "You're only twenty-seven years old, you still look good, you're still making money, you're still singing, you've got your kids and you've got the Lord. When the time is right, you can start all over again." And then, as Miss Sarah Vaughan sang, love walked in.

CHAPTER 12

Tall, Light, and Handsome

hen I married Leonard Peete I was eighteen
years old and knew nothing about love. There
was a great physical attraction between us, a
kind of deep infatuation that lasted a few years.
I *believed* I loved him, and to this day I still think
that was true. But somehow, in the express trip
of our relationship, the freeway from going
steady to marriage and children, we took a
detour around romance. Maybe in the end
that's why the marriage didn't last; it wasn't just
the drinking or the fooling around or the abuse.
I had a deep-seated need for a soul mate. Before
I start sounding like something out of *The
Bridges of Madison County*, let me say that I didn't
have some stranger ride into my life, teach me
what love was all about, and then disappear

into the sunset. I found my tall, dark, and handsome—make that tall, light, and handsome—at the blackjack tables, and he ended up being an old friend, probably the last man I would ever dream I would fall in love with.

Bill Medley and I had floated in and out of each other's lives for about five years, from the early Moonglow sessions to *Shindig* to the Phil Spector records. There was no thunder, at least on my end, when we met. As I said, he always made me laugh. But the idea of being attracted to him—or any other white man— never crossed my mind. To me, he was just one more in a carton of good eggs in the music business, the people like Lou Adler and Johnny Rivers who made the business fun for us. And anyway, I was married, and so was he. It's not as if he were some forbidden fruit; I didn't even know the tree existed.

But our relationship was one of slow accrual; remember that line in "He's Sure the Boy I Love," "He always buys on the installment plan"? With Bill, it was as if he had my heart on layaway, and every time he made me laugh, he made another payment. I got a real window on his character when he stood up for the Blossoms, first to encourage Phil to record us and then telling Jack Good to feature us in our own spot on *Shindig*.

"Jack never utilized their talent enough," Bill says of the early *Shindig* episodes. "Darlene was the best singer on the entire show, while these other stars were going in and out. Finally Bobby and I put our feet down and said we wanted to do a number with the Blossoms, and not some cute pop songs, but something where we could get down a little, like '(The Night Time Is) The Right Time.' As great as Darlene's talent was, she wasn't hung up on it. She always made you feel comfortable. I mean, I was married and she was married. I probably thought she was cute,

but in the beginning there was just an enormous respect for her talent. And she certainly didn't have eyes for me. Her husband, Leonard, got to be a friend."

By the time the Blossoms went out on the road with the Righteous Brothers, though, *Shindig* was long gone. And both of our marriages were in trouble. Bill's wife, Karen, was tired of being left at home in Orange County while Bill was on the road, and he was adamant about her staying there to raise their son, Darren. The Blossoms worked with the Righteous Brothers before and after Nancy Sinatra and Elvis, so I was around Bill when my own marriage had its painful end. While I'm sure Bill and I didn't compare notes on divorce lawyers, as the months went on we were two of a kind after the shows, unattached and looking neither too far forward nor too far back. Bill, in fact, wasn't looking any farther than the blackjack tables. So I tagged along, too keyed up after the shows to go back to the room. I became something of a good-luck charm to Bill, though not because he won more when I sat near him. "It was all so hectic," Bill said, "and a little overwhelming. I'm sure I was swimming in all of it. It's a real art form, being a star."

While I nursed my glass of wine, Bill soaked up beer practically by the barrel. The poor cocktail waitress could barely place the little napkin down before Bill was guzzling a bottle and asking for another. Where is he putting it, I wondered, in that stick of a body? He wasn't a sloppy drunk, though. He just got sillier and sillier. He would pick me up and throw me over his shoulder like a sack of potatoes; our relationship, even when we were just friends, was always very physical, and as we got to know each other better, we played rougher and rougher. One night I saw him coming around a corner and threw my shoe. It

curved like a boomerang and hit him upside the head. And he just laughed and laughed.

Bill often made "black" jokes. And I suppose I gave white jokes right back to him. Neither one of us was ever offended, though; the race card, to us, was always the joker in the deck, and we used it, I think, to take the sting out of any real racism we faced. Bill's favorite was, "What do you call a black astronaut?"

"I don't know, what?"

"A coon to the moon."

Maybe I should have been offended, but I wasn't. I knew where Bill's heart was on racial equality, and besides, though I didn't realize it, I was falling in love.

Still, I worried about Bill. The Righteous Brothers were true headliners now, making $50,000 to $60,000 an engagement; they had successfully crossed that narrow, wobbly bridge from hit-record makers to stars, a crossing I hadn't been able to make, always running back to the start when it swayed or a plank gave way under my feet. I had seen plenty of people hurtle and crash on the way. But now that Bill was safely on the other side, he was still lonely and depressed. It made me wonder if stardom was really what I wanted.

When the tables got cold for Bill, we walked for what seemed like miles, two lost souls wandering through the steam of the Las Vegas night. I had no marriage and no real career, Bill had the career but no marriage, and before we knew it, the walks got longer and longer and the talks got both sillier and more serious. And the more time we spent together, the more we became like two radio signals getting closer and closer to each other's range. After a few months we were locked in, loud and

clear. And even then I never thought anything would happen. I still didn't see myself with a white man, even as my feelings for Bill were deepening. I always dropped him off at his room, making sure he got in safely, especially if he was drunk. Sometimes I stayed to talk, but then I went back to my room, usually around two or three o'clock in the morning. One time, though, Bill was so drunk that I couldn't leave until I was sure he would be all right. Wasn't I surprised to find myself still there and in his bed the next morning!

Bill rolled over around the crack of noon and looked pretty confused when he saw me there. In that deep growl of his, rasped over even more with the sediment of sleep and a night of overimbibing, he moaned, "Did we, uh, do anything last night?"

I knew that Bill had passed out almost as soon as he hit the bed, but I decided to milk the situation for everything it was worth. "Well, we tried," I said, "but let's just say the only performing you did last night was on the stage."

Bill sat up and looked hurt for about half a second, and then we both burst out laughing. "That *laugh* of hers," Bill remembers. "It was so loud. . . ." I think Bill ended up laughing himself sober. And then he said, "Tonight, I'm walking you home again, and this time I won't be drunk."

"Yeah, Medley"—I always called him Medley—"I'll believe it when I see it." Then we giggled some more, and I left to go to the hotel gym. The minute I closed the door, I wondered what I had got myself into. Here I was, essentially, with a date to go to bed, and I thought, We're going to ruin the friendship by having sex. And I'd be lying if I said I didn't care about race. I figured I didn't know anything about going to bed with a white man, as if it were the final frontier. I didn't know if Bill had any experi-

ence with black women, either. Not that I knew of any differences firsthand. I just figured there must be something. I was afraid I wouldn't know what to do, and I had the shivers all day every time I thought about it. I couldn't really tell anyone, either, especially not Fanita and Jean. I was more nervous about what was going to happen that night than I ever was about singing in front of an audience.

The show went off without a hitch and then we fell into our familiar routine: Bill and Bobby and the Blossoms and some of the musicians gathered at the bar, peeling off a couple at a time as the night wore on, until just Bill and I were left. Normally Bill headed for the tables then, but that night he just took my arm and led me to the elevators and back to my room. Funny, I felt as if I were living my life in reverse. With Leonard, I was never hesitant or scared of sex; I was a seventeen-year-old woman of the world. With Bill, I was a twenty-seven-year-old as skittish and jumpy as a teenager on her first drive-in date.

My intuition turned out to be right: There was a big difference being with Bill. But it had nothing to do with his being white and my being black. It had everything to do with being in love. There was gentleness, compassion, a lot of foreplay and giggling and sighing and just holding each other quietly, all those lovely clichés you read about in romance novels but never experience. When I was married, my husband and I basically just had sex—committed the act—then rolled over and went to sleep. But with Bill "the act" was almost an afterthought, the punctuation mark at the end of a very sweet sentence.

"I think we were both a little stunned when it happened," Bill says. "I certainly loved my wife when we got married, but the thing between me and Darlene was just a lot different and

a lot deeper than any relationship I'd ever had. She was the first person I had loved who was also like a great, good buddy of mine." Bill's nickname for me was always "Pal," which was the name of a teddy bear he gave me on the road when I was sick for a couple of days.

When the rosy glow of realizing we were in love wore off, we—or I—snapped back to the reality of a white man and a black woman in show business having a relationship. At first Bill wanted to tell the world about us—"Hell," he said, "I was just a naïve kid from Orange County"—but I knew better. I had learned a lot of lessons since my family visited that drive-in in Texas in the fifties, and one of them was that America, despite the civil-rights movement and the era of free love, wasn't ready for an open black-white affair.

And my concern was more for Bill than for me. Nobody knew or remembered who I was, but the Righteous Brothers were huge stars, and their audience didn't consist of free-thinking hippies piling into vans and heading for Monterey, the Haight, and Woodstock. Their audience was middle America, albeit a swath not entirely unhip or deaf to soul. But they could take it only in small doses. Bill and Bobby were clean-cut, all-American types, blue-eyed soul versions of Jan and Dean. They sang a lot of standards like "Unchained Melody" and "Ebb Tide," and the people who came to see them were basically white and four-square, only slightly rounded at the corners. And despite the breakthrough of *Guess Who's Coming to Dinner?* this was still a time when Petula Clark incurred the wrath of network censors by pecking Harry Belafonte on the cheek during one of her TV specials.

So we played it cool for a while. People saw us together all

the time, but they were used to that. We always kept separate rooms on the road and always made love in mine; it seemed less incriminating for him that way. Finally we told our two best friends, Jimmy West, our manager, and Mike Patterson, the road manager, because they were getting suspicious. Mike even noticed that a change had come over Bill: "Man, Medley's in love." But nobody thought for a minute that it was me. Finally the guys in the band all got drunk one day and cornered Bill. "What the hell is going on with you?" they said.

I was standing right next to Bill, and he decided he couldn't hide it any longer. "All right, I really do love the lady." I never saw a bunch of drunks quiet down so fast; this was as strong as anything they'd swallowed all night. We had blacks and whites in this group, Italians, Jews, blue-eyed soul brothers. And one by one, after they caught their breath after this collective cold shower, they all gave their blessing. Jean, for one, said she couldn't care less; she thought it was great. There were, as I re-member, only two dissenters: Fanita and Bobby Hatfield.

Fanita didn't surprise me; I don't think I could have done anything right as far as she was concerned. She thought it would hurt our business if the public found out. "I told Darlene, you don't shit where you eat, because the Righteous Brothers were involved in our career," she says. "And it was sad, too, because we knew Leonard."

As for Bobby, Bill says he doesn't remember any objections. "Bobby and I couldn't talk about the small things that bothered us," Bill says. "Never mind something big like this. I didn't get much feedback from anybody, except one guy, one redneck ass-hole who I won't name, who said, 'Jesus, I understand you and Darlene are going together. . . .' "

Bill has a selective memory, or else he's just being kind. I remember very distinctly Bobby telling him that it was okay for him to have sex with a black woman, but what kind of fool was he to go and fall in love with one. Mr. Holier Than Thou. Little did Bobby know that I knew he had eyes for Fanita. But I guess that must have just been about sex (especially because both of them were married at the time).

So our love had finally dared to speak its name, but only in soft whispers among our closest friends. Even if we didn't have to sneak around as much anymore, we still had Bill's career to think about. He kept his own room on the road and I kept mine, and in the end our relationship never became part of the public domain, even though it had the most public of expression, because every night Bill told the secret of our love to thousands of people. When they heard the Righteous Brothers' song "(You're My) Soul and Inspiration" they had no idea that the person Bill had in mind was only ten feet away onstage. Sometimes I guess art really does imitate life.

CHAPTER 13

Brown-Eyed Woman

ill and I never lived together during our
relationship. He had his house and his son in
Tustin, in Orange County, and I had my boys
in L.A. We didn't see any need to uproot any
of them. It was only a forty-minute ride to
his house, and we were together enough on
the road. My boys loved Bill. Chawn was only
about four or five years old when we started
seeing each other, so his memories are feelings
more than events or facts, but he says now that
when he thinks of Bill Medley, he remembers
"laughing out loud. He was always doing
something to crack us up. He taught me to talk
like Donald Duck. Nothing but good times
around Bill."

Even with what felt like stolen moments

of romance, our relationship just kept getting better and better. Having sex was, strangely enough, like something purifying. It was never dirty or complicated or inhibited with Bill. I didn't know that was possible. My religious background had made me think that you had sex to have babies, but you did it practically holding your nose with the lights out, then you rolled over, got up, cleaned up, and went to sleep. With Leonard I was able to shake some of those inhibitions, but even so it was always just a physical thing. But with Bill it was satisfying, every time, on many levels, from the physical to the emotional to the spiritual. It's hard to say why it was so wonderful. Often Bill would run to the piano after we had just made love and write a new song. "Listen to this, Pal," he'd say, and something gorgeous would pour in from the other room. The Blossoms even recorded one of these songs, "Stand By." Great art might often come from pain, but, honey, not always.

Some of the best times Bill and I had happened away from the spotlight. "I used to bring Darlene down to my house in Orange County," Bill says, "and we would just hang with all my friends who weren't in the music industry. They all had pretty normal jobs. They were construction workers and pool cleaners, and they all loved Darlene. It was always great to get away to someplace where she wasn't Darlene Love and I wasn't Bill Medley of the Righteous Brothers."

One weekend we got a rare break from touring and rented a house in Palm Springs. It was one of those stop-the-world moments when God is only as far away as a cool drink, a roaring fire, and a Ray Charles record on the phonograph. Bill told me the whole place would be stocked, and it was, with more beer and peanuts than I'd care to consume in a lifetime. Med-

ley was the worst eater in the world, so I went shopping. He joked, "Uh-oh, we'll be eating watermelon," and he was right, with fried chicken, potato salad, macaroni and cheese, greens. "I guess I'm officially black now," he said. We were playing our race-in-the-hole card again.

And if you saw him then, you'd wonder just what Bill's color was. We went out in the sun during the day, and he turned three or four shades darker after just a couple of hours. In the evening we were naked in front of the fire listening to either Ray Charles's country-and-western album, the one he did with a white choir behind him, or Aretha Franklin's Columbia albums, which she made before "Respect" and all the great soul hits of the late sixties. On the Columbia albums, she was all over the map, singing jazz, Broadway, pop, and R&B, and it seemed the perfect soundtrack for a romance that itself was crossing over cultural "formats."

We didn't get much flack from the Righteous Brothers' organization. Their only official request was that we didn't run afoul of the tabloids with our romance, which wasn't a problem, because we preferred the privacy, anyway. The only negativity, at least from my end, continued to come from Bobby Hatfield. He got especially pissed when, on Bill's birthday, he and the boys in the band chipped in and sent a high-priced hooker to his room at the Sands. An hour later she came back and they demanded a report. "Well, I almost feel like giving you your money back, because he didn't do anything but talk. And who is this Darlene Love? That's all he talked about." Bobby was ready to hit the roof. All that Bill would admit was that he was offered all manner of fringe benefits on the road, but he certainly declined anything—or anyone—who proffered their wares while we were

dating. I knew that Bill never played around on me. After being married to Leonard, I knew all the signs and all the tricks. I could track the scent of a cheater, and I never smelled it on Bill.

As perfect—or as close to perfect—as our relationship was, Bill was bearing some heavy burdens in those days, mostly from the devastation of his divorce. But there was also Bobby. For a long time Bill had wanted to stretch out and get more solos, but in the end the best he got was half a record. Bill and Bobby were basically functioning like a married couple that continued to live together but slept in separate beds.

Though the Righteous Brothers continued to draw in concert, their records hadn't fared too well in 1967 and 1968. They had become the kind of act that was lucky enough to have reached that superstratum where the take at the gate is immune to the capriciousness of the pop charts. (Think of someone like Neil Diamond today.) With their recording career stalled, Bill decided to go solo. Not permanently, but he just had to see what he could do on his own. The Righteous Brothers would always be there.

Bobby's response was basically, Don't let the door slam on your butt on the way out. He got a new partner, Jimmy Walker, who sang in the group the Knickerbockers, and they continued touring as the Righteous Brothers. Of course this was like making a thick shake with skim milk: still as sweet, but not as rich. Bill then signed a deal with MGM to record his first solo album, called, appropriately, *100%*.

He put out the call to the usual suspects for material: Barry Mann and Cynthia Weil, Carole King and Gerry Goffin. Little did he know that Barry and Cynthia would come back with an autobiography. They wrote a song for Bill called "Brown-Eyed

Woman," which was about a white man being in love with a black woman, and when it came time to do the session, he had me sit right in the middle of the studio while he sang it to me. It was eerie; the song's lyrics mirrored our own relationship. It was almost as if he had asked me to sit naked in front of everyone. It was really strange because until then Barry and Cynthia had no idea that Bill and I were together.

The Blossoms had already stopped touring with the Righteous Brothers by the time Bill went solo. They got Clydie King, Venetta Fields, and, of all people, my sister, Edna, to sing for about half of what we were charging. I guess it's a sign of how strong Bill's and my relationship was that this didn't affect us. We were able to separate out the business and personal aspects. And Jimmy West got us bookings on our own as the Blossoms, including a tour of Australia that was my single-most frightening experience on the road.

We were on a bill with a lot of Motown acts; this might have been one of the last "Cavalcade of Stars" packages that toured the world. We got there for Stevie Wonder's last show, and performed on a bill with the Four Tops, who, like most of the Motown acts, we knew from *Shindig*. After the show one night we were at a party at the hotel where the Four Tops were staying, and Obie Benson, one of the Tops, moved onto the stool next to mine.

"Hey, Obie, what's up?" I said.

I could smell the liquor on him even before he said anything. "I'm going to have you," he said.

"What?" I said.

Obie, like the rest of the Tops, was a casual friend; we respected each other's music and partied on the road, but we

weren't very close. I had certainly never flirted with him. Now it was as if he had spoken in some foreign tongue, without a hint of softness or humor. He was stern, like some animal trainer trying to break a resistant dog. As it turned out, he was speaking the language of rape. "I will have you tonight."

There I was, four thousand miles away from home, being treated like the prize of a bounty hunter. I tried to shoo him off, tell him I wasn't interested, but he wasn't hearing a word I said. Bill wasn't on this trip, so I had to rely on the other Tops to get me out of this jam. While Duke Fakir and Lawrence Payton and some of the guys in our crew distracted Obie, Levi Stubbs led me away—into a closet near the bar. Even there, though, I could hear that drunken fool ranting. "Where is she? She's mine tonight." Levi found the promoter and he took me back to our hotel, but it wasn't long before Obie was on my trail. We alerted security not to let him up to the room, but somehow he got by them and was pounding on my door. "I will have you tonight," he bellowed.

The other Blossoms were still at the bar, so all that was separating me from this crazy man was a door that wouldn't have been sturdy enough for me if it had been made of foot-thick steel. "You better leave me alone," I said. "My boyfriend's going to be here soon." Bill wasn't even in Australia, but I was desperate.

"I don't give a damn about that white motherfucker," Obie yelled. Instead of scaring him off, I had only made the situation worse. If a white man was good enough for me, then he certainly had to be. Finally I screamed, and a couple of the boys, catching up to him at my door, carted him off. I had seen what liquor could do to Leonard; I probably still had the scar from

that night at the Marvin Gaye show. But I had never been eye to eye with the kind of demon that stalked me that night. This time I eluded one of fate's crueler snares, but only by a photo finish.

The next day Obie, sunglasses covering his red eyes, apologized, claiming it was "all just a misunderstanding." I suppose I forgave him. But I wasn't going to chance any more encounters with "misunderstandings." I never opened my door to anyone if I was alone on the road. And I lost another nick of my trust.

Some years later we were playing the Copacabana in New York, and the Temptations were in town and staying at the same hotel as the Blossoms. A few of them came to party with Jean: there was a time when she was heavily into drugs, and they knew she was always good for a few tokes. It was our last night in town, and I was in my room, packing, with the door to Fanita and Jean's room open, when Eddie Kendricks, one of the Temps' lead singers, wandered in. Eddie and I were friends, and even if he and Jean had been getting high, there was no reason for me to expect him to make any unprovoked moves.

After a few minutes I went to the bathroom to get my cosmetics case, all the while chitchatting about nothing in particular. When I stepped back into the bedroom, I saw Eddie, buck naked, on top of the bed. I wasn't so much scared as I was mad.

"Excuse me," I said. "Didn't you just have your clothes on a minute ago?"

"Oh, c'mon, you know what I want."

The door to Fanita and Jean's part of the suite was still open, so I started screaming, "He's naked, he's naked. Get in here." Fanita and Jean came running, their "Who's nakeds?" and "What's the matters?" making the siren ever more shrill. In

a blink, Eddie had gathered his clothes and was running naked down the hall to his room, leaving a trail of socks and underwear along the way. The next day he told Jean that I had seduced him, but Jean wasn't having any of that. Finally he told her he wanted to apologize to me, which he did, eventually. I later told Dionne Warwick this story and she confronted Eddie after one of her shows.

"So, Eddie, I hear you tried to rape Darlene."

"Oh, that was all a misunderstanding." Right. Another misunderstanding. Always the first excuse for a rampant libido. Well, I knew one thing; another incident like this and somebody was going to end up crippled or worse. And what would I say? "It was just a misunderstanding."

CHAPTER 14

"Sing It to Me, Pal . . ."

My contract with Phil Spector finally ran out and Lou Adler signed the Blossoms to his new label, Ode Records. He picked "Stoney End," written by Laura Nyro, as our first single. Laura was the hottest songwriter in the business. She was a twenty-one-year-old prodigy who had already written future classics like "Wedding Bell Blues," "And When I Die," and "Stoned Soul Picnic." In 1968–1969, a Laura Nyro song was always just around the corner.

"Stoney End" already had a gospel feel to it, so we just accented it a little more, redirecting the song's gaze from outside the church looking in to inside the church looking out. Some of the chorus parts were too high for me, so Jean took the lead, and it ended up being one of

the most mature lyrics we had sung to date, especially the line "Now I don't believe I want to see the morning." This was "Wait Til My Bobby Gets Home" after Bobby never came home. I hadn't had this good a feeling about a session since "Stumble and Fall," one of the last songs I did with Phil.

Ode Records was distributed by CBS in those days, and CBS wasn't coming through for the label's releases. The Peggy Lipton album and the debut album from the City, Carole King's group before she went solo, both died on the vine.

"I believed in 'Stoney End' so much that I released it twice," Lou says. "One reason I left CBS was that record. I thought it got lost."

Well, not entirely. One person who must have heard it was the producer Richard Perry, who a few years later was assigned to produce Barbra Streisand's first "rock" album. And the next thing we knew, there was Miss Barbra in the Top 10 with her version of "Stoney End." Lord, I thought, I must be good, if the queen of show business is stealing my licks.

"I think Richard Perry listened a lot to my records," Lou says.

Lou then moved his Ode label over to A&M Records, where he reunited with his old buddy Herb Alpert and made another fortune, with Carole King and Cheech & Chong. The Blossoms even sang on C&C's "Basketball Jones," a dopey (and I don't mean stupid) song if ever I heard one.

After "Stoney End" failed, the Blossoms hopscotched to a couple of different labels looking for that elusive hit. After Ode, we got a deal with Invictus, which was run by the legendary Motown songwriters Holland-Dozier-Holland. We were thrilled to have the chance to work with the people who had basically put Motown on the map. They had written virtually all of the hit

songs recorded by the Supremes and the Four Tops. We flew to Detroit even before we signed a contract and started work on a wonderful song called "Touch Me, Jesus." The session was miserable, though; the studio was practically a tower, with us on the floor and one of the Holland brothers behind the glass at the top. We did a take and then he sent one of their flunkies down with instructions about how we were to do it again. Finally, after four or five "notes" from our invisible director, I turned to the courier and said, "If he wants us to change something, you get that nigger to come down and tell us himself." After that, there were no more orders from on high; Mr. Holland delivered his instructions in person.

We had been there three or four days and were almost finished with the song when we got a call from Jimmy West.

"Girls, stop everything," he said. "Don't sing another note. Go back to your hotel now. You're coming home."

"Why, what's up?"

There had been some problems negotiating the contract. "Let me put it this way," Jimmy said. "They not only want your drawers, they want what's in them, too."

We never signed the contract, and we headed back to Los Angeles. Holland-Dozier-Holland, though, apparently taking a trick out of Phil Spector's book, finished the session without us and then released it, with our vocals, under the name the Glass House. It started to get some airplay until we hit them with a lawsuit, which made them pull it off the market. Phil Spector, we were learning all too frequently, wasn't the exception in the business—more and more he was looking like the rule. And we were beginning to feel cursed. Some artists go an entire career and never find the kind of material we had with "Stoney End"

and "Touch Me, Jesus." Yet both had gotten gummed up in the heavy, clunking machinery of the music business, which all too often could seem impervious to talent. "Oh, being talented," Nino Tempo says, "it's like being one-legged." That's the kind of wisdom I found myself imparting to anyone who wanted to be a singer—and I had to keep reminding myself of that over and over, too.

We tried again to break through when Bell Records signed us for two singles. Even though the heyday of girl groups was long past, the Supremes, minus Diana Ross, were still having hits, and my sister's group, the Honey Cone, who, to paraphrase the writer Robert Christgau, sounded like Michael Jackson and the Vandellas, had a No. 1 song with "Want Ads." (They were signed to Hot Wax Records, another label owned by Holland-Dozier-Holland. I guess they were willing to play ball with them, plus my sister had her boyfriend, Greg Perry, who wrote and produced the sessions, around to keep H-D-H in line.) So record companies were still willing to take a chance on female groups, and Bell was especially interested when Bill said he would produce.

Bill and I were still together, but we hadn't been seeing each other as much, especially now that he was out on his own. Bill was getting more possessive of me. He wanted me to be at home, not on the road, so that I could be on call for him. He would have his accountant, David Cohen, phone when he wanted me to show up at one of his concerts, usually on a moment's notice. He was very impulsive. Once, in Seattle, we just started walking and walking. The neighborhood near the hotel was pretty, with street lanterns and big houses; it was only Oc-

tober, but it felt like Christmas. We must have walked for an hour, lost in the glow of our dreams, because we didn't notice right away the trash washing up against our feet, or the broken windows, or the dark bars. Bill was pretty drunk, but when we finally realized we "weren't in Kansas" anymore, he sobered up in a hurry. We were getting a few catcalls from some of the "fine establishments" we were passing. Faceless, racist comments were being hurled at us from out of the darkness and smoke. "Pal," Bill said, clutching me with one arm and feeling for the roll of bills, about $5,000, in his pocket, "where are we?"

We doubled back in a hurry, and eventually found a taxi to take us to the hotel. "I was never worried," Bill says. "If anything happened, I knew Darlene would protect me." I was only too glad, though, that I didn't have to defend either of us. Re-entry to our fantasy land couldn't come fast enough for me.

Another time when we were in Seattle, we almost got married. Bill and I were in our hotel just staring at the snow falling in big white sheets outside, two Southern California natives mesmerized by a force of nature that was instilling a kind of childlike wonder in us. Bill was so taken with the snow and its innocent aura that he told me to get on my coat. "We're going for a ride, Pal."

"In this weather? At this time of night? Where are we going?" I demanded.

"We're gonna get married."

No matter what kind of practical objection I could throw at Bill—What about blood tests, a license, finding a judge?—he wouldn't be deterred. "I want you to be Mrs. Bill Medley," he insisted. I dressed as slowly as I could, practically one thread at a

time, just to stall until he came to his senses, and kept throwing the same questions at him over and over. But he caught on to my game and finally just grabbed my arm and we were off.

We must have driven until two or three o'clock in the morning, looking for a preacher or a justice of the peace, and even though the snow wasn't sticking, Bill scared me when he got behind the wheel because he often steered with his legs! And I started getting more worked up as we talked about what it would be like after we were married. And that's where, if I look back on it now, I can see the beginnings of our relationship going south.

We weren't really concerned about race; we already knew that our love could transcend any narrow-mindedness we faced. But Bill insisted that once we were married, I stay home.

"And what is it you expect me to do there?" I said.

"Take care of our boys," he replied.

"That's it? No career?"

"You can still do sessions. But I don't want you out on the road."

Bill and I never really fought. Or at least we never had the knock-down-drag-out kind of fights I had with Leonard. But he knew I was mad when I stopped talking. We stopped by a few churches that were locked up, and even found one preacher, who had his shingle hanging like a doctor's. But we had no license, so we ended up not getting married that night, which was probably a good thing. As special as our relationship was, it was clear we still had a lot to talk about.

How can I not sing? I thought. I was afraid my talent would vanish if I didn't use it. I liked being a mother, but singing was

my first priority. I would have gone nuts just sitting at home playing house while he was out on the road.

But Bill was adamant about this, and because we were both stubborn, neither one of us was going to give in on the question of my career. Not only didn't Bill want me going on the road, he didn't even like it when I went out socially, unless it was with the wives of the other guys in the crew. You can chalk part of this up to macho posturing—Bill could beat his chest with the best of them. But it was more than that. Bill, as much as he liked singing, really disliked show business; I mean, who doesn't, really, once you've been dipped in its slimy vat? So I think in his heart he thought he would be doing me a favor. He must have been thinking, I'll go fight the showbiz wars, honey, you stay home where you'll be safe. But the more we talked, the more boxed in I felt.

Eventually we just stopped talking about marriage altogether and made the best of the times we were together. When Bill produced the Blossoms for Bell Records, the song "Stand By," we were arguing about interpretation. And after about the tenth take, when he still wasn't hearing what he wanted, I started to get hot.

"What are you talking about, Medley?" I said. "It sounds fine to me. I'm not doing it again."

"C'mon, Pal, just one more time." He was looking for more feeling, more tenderness than I guess I was giving, and by that point I was so mad that I was probably incapable of it. By then I had taken the headphones off and was really ranting.

"All right, Motormouth," Bill said.

That was all I needed to hear. I don't think I stopped yelling

for half an hour. "This man is nuts, he'll drive us all to drink, this is insulting, I'm tired of this, you don't know shit about what you're doing. Let's go home." Then everyone went silent.

Bill turned off the microphone in the booth and sent everyone home. Then, with the intercom back on, he said, "Except you, Pal."

When we were face-to-face, he said, "You know, you were insulting me, too." Then he wrapped his arms around me in the middle of the floor and said, "Okay, sing it to me, Pal." The tape was rolling, and we got it done. I hated to admit it, but he was right. The song was a killer ballad, and it's still one of those surprise wonders of my career, and my time with Bill.

That's how it was with Bill and me, though; even the fighting was special. Every argument, even the prolonged ones, evolved into warmth and humor, and any bad feelings were disabled before they had any impact. When it was just the two of us, as it was that moment in the recording studio, there was no challenge we couldn't overcome. But it wouldn't be just the two of us for very long.

CHAPTER 15

"Imagine the Voice . . ."

In the summer of 1970, Bill was performing in Vegas and I went to visit him. One night he came back to the room with a gravity in his voice that was as uncharacteristic as it was unwelcome. "Pal, I have something to tell you. Karen is coming to Vegas."

I knew, of course, that Bill had been in touch with his ex-wife over the years. They had their son, Darren, to raise, even if they were apart, and besides, Bill is not the kind of man who can just conveniently wipe his emotional slate clean, even after a divorce. It was one of the things I loved about him, and also one of the things that disturbed me the most. He and Karen had loved each other once, and had had

a child together, and she was coming to Vegas to stir the pot fueled by Bill's sensitivity.

"Why is she coming to Vegas?" I asked.

"She just wants to see me. I think she's lonely."

Okay, I thought, but couldn't she just talk to him on the phone? I knew Karen knew about me and Bill, so I figured that we'd just go on as we had been and that Karen would have her own room, come to see Bill, and then be gone. Then I got the second bombshell. "And she'll be staying in my room."

I knew we were in trouble. I was mad, but I didn't blow up at him. I moved into the suite with Gloria and some of her friends, who had come down to see Bill, and Karen and Darren stayed with Bill the entire weekend. He tried calling me a few times, but I wouldn't pick up the phone, and I ended up going back to California without seeing him. And then I didn't answer the phone for a week. I didn't want him to know where I was. I wanted him to be as angry as I was. Finally I picked up when he called. "Karen took advantage of you," I said, referring to her using Darren as leverage to get back with Bill.

He tried to reassure me, but after that, little by little, I began to see that things just weren't going to work for Bill and me. He doesn't remember this episode in Vegas, but he agrees that Karen was the loose thread that eventually unraveled us. "It was purely by accident that we started seeing each other again," Bill says. "She had been dating another guy, and they broke up, and all of a sudden there was a problem with me seeing Darren on the weekends. So I told Karen, Why don't we all just go to Palm Springs, and it kind of came back for a minute. That might have been the start of things going south for me and Darlene. It was never like, bam, I woke up and just didn't want to be with her. I

was just feeling guilty about my ex-wife and wanted to take care of her."

I couldn't compete with Bill's past, and so my attitude was "Fine and dandy, I hope y'all are happy." But Bill saw through this, and even when he was back with Karen, he never ended it with me officially. For a while I didn't know if I was the other woman or if she was. And it was right around this time that I started feeling sluggish, and then I missed my period. Lord, what was I going to do if I was pregnant?

Bill was out of town—in fact, he was in Australia—when I went to the doctor and found out that I was expecting his child. If it had been a year or even six months earlier, I might have been overjoyed by the news. I loved Bill very much, and I wanted to have this child, our love child. Among other reasons, imagine the voice this child could have.

But the reality of our situation—Bill back with Karen, our relationship in limbo, at best—didn't allow me to swaddle my unborn child, or myself, in this fantasy for very long. I knew I couldn't have this baby. I didn't believe in abortion, and I still don't. But for a few weeks in 1970 I was blinded by the harsh reality of raising a child out of wedlock. I was determined not to use the baby as a way of getting Bill to marry me. I knew that would never work. I prayed and prayed, but for a while I—or God—kept finding the circuits busy. Suddenly my faith was on override. My decision to abort the baby was painful but swift.

Abortion still wasn't legal in 1970. The only way you could have one in California was to go to a psychiatrist and explain all the reasons you didn't want to have the baby. David Cohen was my "accomplice." He found me the shrink, and when I went I told him all the reasons I couldn't have this child: that I wasn't

married to the father, that he was back with his ex-wife, that I already had two kids. None of this necessarily added up to the emotional duress necessary, by law, for the doctor to recommend the abortion. I didn't even tell the doctor what I knew with certainty: that Bill would want to marry me and that I would always think it was because of the baby. The appointment was very balanced and organized, like a legal brief, an upside-down pyramid of thoughts held up by my refusal to think about the baby. If I had done that, I know the whole argument would have collapsed. I'm sure I raised the single-parent issue and the black-white issue (though that was really still a non-issue for us). I wanted to have the abortion as soon as possible, before Bill got back. The doctor wrote on his recommendation that the pregnancy had to be terminated because of "mental instability." It was a lie, and it wasn't, because I must have been unstable to not think for a minute of the baby.

I knew I owed Bill at least a phone call, and when I finally got the nerve and reached him in Australia, I tried to be as matter-of-fact as I could, to shore up my wall of defense. "Medley, I'm pregnant with your child," I said, and then before he could gulp down this news, "but I'm not going to keep it."

Bill, I could tell, was thunderstruck. The first few times he tried to speak, his breath was stuttered, like the way you are when you have the wind knocked out of you. And for Bill this might have been the hardest punch to the gut he'd ever felt.

When he was finally able to talk, he said, "Pal, please. We can work this out. At least wait until I get home."

I listened to his pleading, but my heart was closed on the subject. Finally I agreed to wait for him to get back. But I knew

that if I did, he would talk me out of it. My appointment was for the next day. I kept it.

"I remember thinking there had to be some way for us to work this out," Bill says, "and I wasn't so crazy about the idea of abortion to begin with. But I also knew at the time that 99 percent of the responsibility was going to fall on her shoulders. She had two children already and this baby would complicate her life terribly. It was easy for me to say keep the child. . . . I wouldn't consider myself Mr. Wonderful in those days. I'm not proud of how I dealt with my first and second wives. I was a pretty selfish guy. That's kind of what stardom does when you get it too early. It stunts your growth as a man. I had a lot of growing up to do. I've done most of it in just the last fifteen years. Darlene certainly had her feet on the ground a lot more than I did."

When I think back on our child, I think I wanted to have it more than anything in the world, and often wonder how life would have turned out if I had. But I acted so fast that not only did I not give Bill the chance to talk me out of it, I also didn't give myself the chance. Now when I think about the abortion, I realize that it was a decision that I left God out of, too. As my boys were growing up, I would wonder what the baby would have been like, but I had to let those thoughts go. There's a saying that has given me a lot of comfort through the years: "Let go and let God." There was forgiveness, eventually, but not before there was profound regret.

Bill and Karen did get back together, for about six months. As for me and him, we still never officially ended it. Bill says, "I never remember falling out of love with Darlene." By the time he

and Karen split for good, he and I had drifted so far apart that we couldn't reach each other anymore; the signals had floated too far out of range. But we never lost our feelings for each other; for me, whenever I think about Bill Medley, it's the same feeling I get when I'm looking through an old photo album and remembering some better version of myself that lasted for a few perfect seconds, except with Bill it was a few perfect years.

Today Bill says, "The baby would have, at the very least, kept us more in touch than we have been. I miss her a lot in my life. . . . You always know where she is and where she's coming from. She's always up to love you first." He says he has to go no further than one of his solo albums to punch up that old feeling. "I listen to this old record of mine," he says, "just to hear her doing her thing in the background. It's called *Someone's Standing Outside,* an album that's hard to find. I think it was distributed by the Secret Service. She sings in the chorus vamp, and her voice sticks out. It's the soul shining through. I think if you had a computer that could call up the perfect female pop voice, it would come out as Darlene Love."

Hmmm, so Medley could be prejudiced after all. One of the things that he taught me is that pure love doesn't exist only in the movies or in love songs.

CHAPTER 16

Take My Daughter, Please

*T*he psychiatrist, in the end, didn't lie. His timing was just a little off. I did have a breakdown, but not for five or six months after the abortion and my breakup with Bill.

It was a total eclipse; no matter where I looked for light—career, family, friends—there were only clouds, drawn blinds, shrinking pinholes. I would sit for hours in the dark in the house; it got so bad that I had to board the boys out for a while, to a woman from church named Betty Phillips. They didn't need to be around a mother who needed every shard of sanity for herself.

Somehow I managed to keep working. It was all I could do to pull myself together to get to the recording studio, and I hid the depression

from most of the musicians. But I was like the alcoholic who has a flask in his desk and a bottle of mouthwash in his pocket. Between takes I went to the bathroom or wandered around and took a long swig of the self-pity and depression that was controlling my life. Then when it was time to sing, I combed my hair and painted on a smile. Fanita and Jean knew what I was going through, and my parents and a few people like Betty at church, but other than that, I was sunny old Darlene, quick with a laugh and a note.

But when I got home I closed the shades and sank into the couch. I lost interest in everything. The TV burned all night and I barely noticed it. I just needed to know it was on. I'd be up half the night just staring into the nothingness, and the pills my doctor prescribed to help me sleep only kept me up later. My weight dropped to 115; about the only food I could muster the energy to fix was peanut butter and jelly. When the pills didn't work, the doctor asked me if I liked beer. I actually hated it. The only time I ever really drank it was when I was with Bill, and now it only reminded me that he was gone. But I started drinking one glass a night before I went to bed, and then I could go to sleep at night. But when I woke up, I was still alone.

Bill had come into my life almost immediately after Leonard and I split up. The Lord hadn't made me wait or given me time to feel sorry for myself. But in the spring of 1971 I suddenly found myself with no husband and no boyfriend and still no real career beyond backup singing. A lot of my friends were also Bill's friends, and once it was clear we were breaking up, everybody got a little tight, never quite knowing what to say or what to do. Any shoulders I could cry on were angled slightly out of reach by the pull of dual loyalty. The scorched earth of failed

relationships and missed career opportunities was spreading in Los Angeles and Las Vegas. In the summer I would turn thirty. I had to get away. And so into my life, God dropped a Welshman in tight pants.

The Blossoms were performing with Roger Miller in Vegas during a monthlong gig, and he had the same agent as Tom Jones. This curly-haired Welsh Don Juan poured himself into his spandex pants every night and then spent essentially the entire show swiveling and sweltering and stripping down, while he whipped thousands of women into frenzied submission. Bedlam was always just a split seam away at a Tom Jones concert. And, oh yeah, he wasn't a bad singer, either, but I wonder just how many of those underwear-hurling females ever really heard his voice.

Tom saw our show and hired the Blossoms to go out on the road with him, and that meant more than just Las Vegas. He took us all over the world, and that was just what I needed. Tom was getting a two-for-one package: an opening act and background singers. We thought we might get lucky and some record company mogul would really see what we could do. But, more important, when we started singing for Tom Jones, I was really never home.

Tom had leased his own Boeing 707, and everywhere we went women screamed for him like fools. Music, I learned, isn't the only universal language. For the shows, we did our set, then changed clothes and came back and sat with the band in the pit. At some point Tom always called us onstage, and every night dozens of women would poke, prod, and try to swat us away. They yelled, "Can you move, please!" or "Get out of the way!" even while we were singing. Swarms of women followed us back

to our hotel and begged us to tell them what room Tom was in. Some even offered to pay us. The craziest—and saddest—of these groupies were the women who came with their teenage daughters in tow. You've heard of stage mothers—"Hey, mister, can you make my daughter a star?" Well, these women had a different kind of claim to fame in mind. "I want Tom Jones to be my little girl's first," they said. Sacrificial virgins. Now I had really seen it all.

And how did Tom react to all this? At first he seemed to be such a shy, introverted man—just like Elvis—who had a wife and young son back in England. He could be a model citizen. But we also discovered he was a model libertine. Tom loved women, and in a perverse way they were his religion, his gift from God. To him it was almost a sin to turn them away. Lord, you've heard James Brown singing about being a sex machine? He had nothing on Tom. Any manner of star, starlet, groupie, or wannabe could be seen slipping dreamily into or out of his room at any hour of the night, sometimes in shifts. Tom's road manager "booked the acts." What these women saw in Tom was a mystery to me; Tom certainly didn't turn me on, and there was no obvious quid pro quo, either. All these women were getting, it seemed, was the sanctified honor of being selected by the sultan. Tom had a "booty scout" who spotted prospects in the audience and got their numbers. We witnessed this ritual at almost every show; as Tom's man approached and talked to these women, most of them reacted as if they'd just won a beauty pageant. "Look, look," one of us would say. "Tom's entertainment for the night."

In every city there was at least one party, and the Blossoms were always invited, though we respectfully declined. We were

the nerds. Lord, I was petrified to go, after some of the things we'd heard about drugs and orgies. Even Jean, who smoked weed like cigarettes, didn't want to go. But Tom kept sending his charge of charm into our lines of defense. He was especially adamant one night in Tacoma, Washington, so we hurried back to our rooms after the show before he could corner us into going. Jean and I changed quickly, took off all our makeup, set our hair in rollers, and got into our pajamas. Still there was a knock on our door a few minutes later. It was Tom and his bodyguard. "Hah," I told Jean, "no way he'll want us to come now, with the two of us looking like a couple of charwomen." But even that didn't scare him off.

"Why don't you girls come?" Tom said. When Tom sang, his voice was a stout lager. But when he spoke, his voice was like a liqueur, intoxicating you with a polite sweetness.

"Not tonight, we're almost asleep."

"Well then, sleep tight," he said, always the gentleman. I thought I could almost hear in his voice, "It's just a matter of time." But I was somehow never offended by his come-ons, maybe because he treated everyone with copious respect. He had nothing but the best around him: chateaubriand, Cuban cigars. I think he had the Dom Pérignon on tap. I got so sick of it that the only way I can drink champagne now is in a mimosa. And while we were working for him we made a ton of money, the most money we ever made on the road, almost $2,000 a week each. I often sat right behind him on his jet, and that was where he gave me some fabulous foot rubs. I would stick my leg up on his chair from behind, and he would slip my shoe off then go to work. No words or eye contact would pass between us. When he was finished, I'd pull my rejuvenated foot back and then fall

asleep, thinking, This man has great hands, and believe me, honey, it went beyond the kind of feeling you get with any good massage of physical therapy. He knew it, too. It was almost as if he was playing with me, trying to bring me to a climax. A few times I finally had to yell, "Hey, give me back my foot." He let my toes slip through his fingers, waiting for his next opportunity. But other than these sessions on the plane, I left Mr. Jones's magic fingers for the pleasure of others, knowing that they wouldn't have to wander very far to find a willing patient.

Some months later we played the Westbury Music Fair on Long Island, and we finally got to see just how rough some of the parties got. The promoter, who knew we would decline any invitations to attend, asked me and Jean if we would do the cooking, because the party was going to be held at his house. I think we agreed more out of curiosity than anything; for the time and effort it took to stuff and roast a turkey, we might have a lifetime of stories to tell.

And boy, they sure didn't disappoint, starting with the house, which was a mansion not far from the theater. I didn't think they had houses like this on Long Island, at least not that far inland, but, honey, the spreads in Beverly Hills had nothing on this. Its circular driveway was big enough for a fleet of limos. The lawns rolled practically into the next town, and the kitchen was so big that Jean and I had to scream to each other. That kitchen went on forever.

We cooked until it was time to go to the show, from eight in the morning to six at night. We made turkey, stuffing, sweet potatoes, greens, the whole works. There were a lot of people coming to the party and we knew this kind of food would go a long way. Since the party was after the show, and we had to go

back to the house to finish the preparation, we asked the promoter if we could stay. And after we were finished, Jean and I went upstairs and locked ourselves in our rooms. We didn't want anybody getting ideas if the proceedings got too out of hand. I think the guests started arriving just before we got ready for bed. After a little while we tiptoed out of our rooms. From the landing, like two kids peering between the slats on the banister, we finally saw what went on at Mr. Tom Jones's parties.

We felt as if we'd just stumbled into a porno film. Naked men were chasing naked women everywhere. And in the middle, on top of a round glass table, a woman who must have weighed maybe 200 pounds had one man underneath her and a couple of others taking turns on top. Jean and I dubbed this woman "Tabletop Tessie." Finally they had gotten so heavy that the table just shattered underneath them. It was a miracle that, beyond a few nicks and cuts, nobody really got hurt. That table must have cost about $40,000—it had a solid brass base—and the promoter ended up having to replace it before his wife got back into town. The police arrived not long after the crash, and the party, thankfully, never snaked its way upstairs.

For years Jean and I laughed whenever we talked about Tabletop Tessie, but the whole experience unsettled me, too. It was one thing to talk about all the women Tom had on the conveyor belt to his room, but another to see this kind of debauchery of the human spirit. People who have money and power, I came to realize, are often people who don't have God in their lives. They can do anything they want and get away with most of it, because they have to answer only to their checkbooks—and occasionally their vacationing spouses. I wasn't on the best of terms with the Lord in those days, anyway. I was lonely, and probably disap-

pointed with how my life was unfolding, and though I never got angry with the Lord, I think I tuned him out for a while. First with Bill and my baby and then, shortly after the Tabletop Tessie incident, with Tom Jones.

As I said, I was never really attracted to Tom, but after seeing all these women around him I had to wonder what the big deal was. One night in Vegas, I saw him walking around with Leslie Uggams, the singer and Broadway actress, whom I'd befriended some years back. I knew Tom had been in love with Mary Wilson of the Supremes, but their affair was doomed by Tom's allergies. "I would break out in hives whenever she came in the room," Tom told me in his Welsh accent. But I didn't know he had been sleeping with Leslie until I saw them that day. I cornered Tom later on that night.

"What's up between you and Leslie?" I said. "Are you tapping that, too?"

"Are you surprised?" Tom replied. "I've had a lot of black women. And I'll tell you, Miss Uggams does not represent the black race very well."

Who did this white boy think he was? "Does not represent the black race very well?" I wanted to knock his skinny white ass right across the casino floor. But one more time I was disarmed by his charm, even if it was really arrogance in disguise.

"Why don't you come up one night and see for yourself?" he said.

I must have been really lonely, because shortly after that I did find myself wandering up to his room, all the time thinking, You don't really find this man attractive, plus he makes racist remarks and you'll probably catch some disease. But I just *had* to find out what all the fuss was about. I had worked with a lot

of entertainers, but no one who had as much sex as Tom did. Either he was the greatest lover in the world or the greatest liar. I told myself I was simply on a "fact-finding mission."

I got into bed next to this hairy white man, thinking, Okay, just get it done with. But before he could really even kiss me, I knew it was all wrong. Luckily I still had my underwear on.

"I'm sorry," I said. "I just can't."

Tom got that wounded-puppy look in his eyes. "What's wrong?" he said. I don't think he was used to women being dissatisfied with his performance, and in this case we hadn't even really gotten started.

"It just doesn't feel right. And I will not have you telling some story about me just so you can get into bed with some other woman. I don't want to hear from someone that 'I don't represent the black race well.'"

Tom was very nice. He didn't try to force me to stay. In all likelihood, he probably called his valet in from the next room and had him send up another girl. I hurried back to the Blossoms' suite and told the girls everything that happened. That was another mistake. It wasn't too long before Fanita started telling people that Tom Jones "couldn't get it up while Darlene was there and asked her to leave." Lord, I'd been away from home too long.

CHAPTER 17

Uprooted

I could usually let remarks like the one that Fanita made about Tom Jones roll off me. The Blossoms, even without hits of their own, had lasted since 1956, since before I got there. It had become a second family to me. Even though Fanita and I had had our difficult moments, we were still like sisters. I saw her more than my own sister, Edna, and our problems were just like those of any sibling rivalry that can heat up and really level you for a while but that in the end only made us grow closer. Fanita and I, fifteen years into our friendship and partnership, still did family things, like Christmas shopping or taking our kids on vacation. And one of our greatest moments as the Blossoms came when Bobby

Darin presented us with the NAACP Image Award in 1971, which we won over more well-known groups like the Supremes and the Honey Cone. The ceremony was held right after we got off a tour, and Fanita just wanted to go home. The award was new, so she thought it was just a publicity stunt, and told our manager, Mike Patterson, that she wanted no part of going to the ceremony. But I went, and when we won, it was the only real recognition we'd received in our career. I think Fanita has regretted not being there ever since.

The situation got worse during a gig with Paul Anka at the Copa in New York. This was right before we started working for Tom Jones. Paul was a big fan of my Phil Spector records, and he and I had become friendly. I knew him better than Jean and Fanita did. In the middle of one show, he introduced us to the crowd as Darlene Love and the Blossoms. Though it was becoming fashionable for group names to "expand"—the Supremes suddenly became Diana Ross and the Supremes, the Miracles became Smokey Robinson and the Miracles—I had never pushed for top billing. This was just Paul being a fan, and in a sense, he was just showing me off.

I thought Fanita would tear down the place. She jumped all over Paul and started calling him out right there in front of the crowd. No amount of our shushing or joking could calm her down. Her mouth was running the wrong way down a one-way street. "Who do you think you are? Darlene Love is not the star. This group is not Darlene Love and the Blossoms."

This nice man, this future spokesman for Kodak, could be a tough little pit bull, and he wheeled around and said, "Listen, bitch, that's the way I introduced you, and that's the way it's going to stay." Thank God the show was almost over, because

Fanita walked off through the kitchen, to the elevator, without saying another word to us. Jean and I just stared at each other in disbelief. The next show Paul introduced us again as Darlene Love and the Blossoms. He made his point.

Fanita doesn't remember this incident. "I don't deny it," she says. "I just don't remember it. I remember Paul giving me the book *The Prophet,* but I don't remember that happening in the Copa. I do remember Mike Patterson calling us into the office and telling us that *he* thought the group should be called Darlene Love and the Blossoms, and that's when I hit the roof."

We never did change the name, and Fanita simmered down, but she could be a storehouse of slights, real and perceived. A few months later, when we were playing in Seattle with Tom Jones, she added to her supply. A local newspaper asked the Blossoms to do an interview—standard stuff, we thought, a few quotes here, a sound bite or two there, little postage stamps for our scrapbooks. The interview was scheduled for the morning after a show. Fanita and Jean were both late sleepers, and I was an early riser. When I knocked on their doors, they decided to blow it off. They said they would catch up to me later and then they rolled over. I didn't think anything of it, but I was still going to give the interview, no matter how insignificant. In our case, there was no such thing as small publicity anyway.

I figured I'd give the man my best "the Blossoms can sound black, white and in between" line, hit the gym, and then meet the girls for breakfast. Three hours later, I was still sitting with the reporter running my mouth and posing—with no makeup on—for *The Seattle Times.* When the article came out the next day, it was on the cover of the arts section and two pages long. Fanita went ballistic. She made the mistake of going to our

road manager, who said that from that point on I would be the spokeswoman for the Blossoms. End of discussion.

Jean was caught in the middle of all this; because she had joined the group later than Fanita and I had, she had never felt equal to us. She was always looking for someone to be the leader. I was the lead singer, but that didn't necessarily make me the leader of the group. If Fanita wanted to play the part, then fine. But Fanita started using her role as "leader" of the group and Jean's drug problem to drive a wedge between me and Jean.

Jean's drug use was really getting serious. I realized this when we were on the road with Tom Jones and one of the guys in the band came up to me with a wad of bills in his hand and said, "When you see Jean, give her this money."

"What are you giving her this much money for?" I said. There must have been $5,000 there.

"She's going to, you know, bring us some stuff back from L.A."

I wanted to confront Jean, but I found Fanita first and rehearsed on her. "Do you know that Jean is buying drugs for Tom Jones's band? She could destroy this group." Fanita told me I was too hot, that I should calm down, that she would go and talk to Jean. "You'll fly off the handle. I'll talk to her."

It was all a mistake that I had found out. I had warned Jean not to bring the heavy stuff on the road, and certainly never thought she would be selling. "It's not just Jean King," I said when I confronted her, "it's the Blossoms you're messing with." Jean wasn't too happy to hear this, so I guess that's why most of the time I let Fanita be the go-between. Maybe she could talk some sense into Jean. But Fanita only pushed Jean and me further apart. For a few weeks Jean stopped talking to me alto-

gether. And when Fanita came back, and I asked her what had gone on in their conversation, she said that Jean wanted to sing all the solos in the show! What craziness was this? Fanita just said, "Oh, she's ripped all the time. I'll take care of it." I should have gone to Jean directly and gotten everything out in the open. But I was so mad I let my anger blind me to what Fanita was doing.

It's amazing that we were able to keep our act together onstage. In fact, while all this turmoil was going on backstage, we were getting an incredible response from the crowd when we opened for Tom Jones. We only had fifteen minutes of our own, before the comedian, but we didn't waste a second of it: Our medley of current Top 40 stuff like "Get Ready" and "I'll Be There" shocked the crowd out of their seats.

After the first leg of the tour, we decided to ask for a raise and a little more time in the show. When our manager took our "demands" to Tom's manager, during a break in the tour, the response was, "Who do these three niggers think they are? They should consider themselves lucky just to be in the show." Of course we never heard any of this from Tom; all of these deals were done—and undone—by the hatchetmen who cut off the performers from the dirty work of the business. And before we could even negotiate, they hired some other girls to sing. I couldn't help thinking, Well, I hope these ladies represent the black race well.

Our old friend Dionne Warwick came to the rescue this time. It had been almost ten years since we first met, during that cold winter in New York at the Brooklyn Fox, when she took us home for Christmas dinner at her mother's house in New Jersey. About two dozen hits later, Dionne had become the

queen of what could be called boarding-school soul. Not that her upbringing was any more privileged than the rest of ours; she just had a sophistication to her singing, a regal bearing, and a high degree of musicianship. Those Burt Bacharach songs, with all their difficult intervals and sudden shifts in time signature, could be a real pain to sing, but Dionne could probably have done it while sipping champagne. To me, she was the Ella Fitzgerald to Aretha's Sarah Vaughan and Dusty's Billie Holiday. And where did I fit amid all these dueling divas? The critic Dave Marsh once said I was second in line only to Aretha. And I could probably, at any one time, sound enough like any one of them. Now Miss Dionne needed me, and the Blossoms, to sound like her. She was overhauling her stage show and wanted us to sing backup.

This was an occasion to rejoice, and also to get on the line to God. I loved this woman's music, and there were few more thrilling performers in concert. Listening to that instrument was like listening to a whole orchestra. We were good friends who could call each other in the middle of the night and talk about anything—usually standard girlfriend stuff, you know, the thrill of the guy and the thrill of the buy. But looking at Dionne onstage, standing and singing behind her, I had to take a long, hard look at myself and how our careers had diverged since that great turkey dinner in 1962. Back then we were about even; maybe I was even a little ahead. Now she was one of the biggest stars in the business and here I was singing backup for her. It was one thing to sing behind Nancy Sinatra, Elvis, and Tom Jones. We weren't really "competitors." They had a whole different piece of the pie. But singing with Dionne sort of made me feel like Tony Bennett singing behind Frank Sinatra. I didn't begrudge Dionne

or resent her success in any way. She deserved it. It was never a feeling of "Why her?"—just "Why not me, too?"

Dionne told us she couldn't afford to pay what we'd been getting from Tom Jones, but it was still decent money: $1,250 a week each, plus all our expenses. No matter how successful Dionne was, she was still always one of the most giving people in the business. On birthdays and at Christmas she really opened up her pocketbook, giving each of us diamonds and sometimes furs. She was a classy lady and spared herself no finery, either. The cleaning bills for her ball gowns could have paid my rent. She could be very old-fashioned too, like some aristocrat of old, primping for hours, sipping mint juleps on some antebellum porch, or else whooshing into the room like Loretta Young. And the next day she'd be at the fights screaming her head off. Dionne, like the rest of us, loved boxing, and she got us in to see and meet all the champs: Muhammad Ali, Ken Norton, Joe Frazier. The woman had clout.

Dionne didn't realize it then, but she was headed for a prolonged dry spell on the charts; it seems even the most gifted pop stars are subject to some kind of term limits. Dionne's run had lasted about as long as any president's could: eight years, from "Don't Make Me Over" in 1962 to "I'll Never Fall in Love Again" in 1970. Shortly after she won a Grammy for the latter song in 1971, she signed a lucrative deal with Warner Brothers and had her second child, Damon. She probably didn't count on her producers/songwriters, Burt Bacharach and Hal David, splitting up. Nor did she expect to become embroiled in a messy lawsuit against them, or that disco would supplant not just her but a lot of the great singers of the day, like Aretha and

Al Green. So she had to count on her concerts, and luckily, she could still fill the halls on her reputation and catalog.

What I wasn't counting on was that the first year with Dionne would also be the last for the Blossoms. Jean continued to use drugs, and I continued to let Fanita do all my talking to Jean. I still didn't realize she was making things worse.

Dionne was the one who finally figured it all out. One night she brought Jean and me together and said, "You all have to have this out right here and now," and before we were there but five minutes, trading insults and tears, she stopped "the fight."

"I think I'm seeing a pattern here," she said. "It's not either of you, it's Miss Fanita. She's the problem." I think Fanita has always hated Dionne for taking the wool off our eyes.

We withdrew our claws and survived this little contretemps, but we were unable to ignore Jean's drug use anymore, which was getting worse as the weeks went on. None of us were strangers to drugs; Dionne, for all the supper-club elegance of her act, had certainly seen plenty of musicians fall under the deadly spell. But it had never gotten as close to anyone in her organization as it had with Jean. Rumors got back to Dionne that dealers were coming to the hotel to meet "a girl working with Dionne Warwick." If Dionne was involved in any kind of drug scandal, however peripherally, it would weigh heavily with her straight suburban audience, which filled most of the halls after her records stopped selling. Like me, she had a revulsion toward drugs anyway.

Jean got so ripped one night before a show that she was falling down in the hotel room even before we went on. I heard Cissy Houston, who was also singing backup for Dionne and

who was standing in her bath towel, and Fanita screaming, "She's trying to kill herself," and I ran down to the suite and found Jean on the floor wedged like a human door stopper. I couldn't stand it anymore, and I started screaming at her. My rage got the better of my senses: "I don't give a damn if you go and kill yourself, but now you're ruining our career, too. If you want to kill yourself, why don't you just throw yourself out the window." Lord, I was so mad I wanted to whip her. Mercy was the furthest thing from my mind.

We called an ambulance and got Jean's stomach pumped—she had swallowed a handful of pills—and then we had to face Dionne. She didn't know how severe Jean's problem was until she saw her writhing on the ground, fighting not just with me but with her demons, and losing big on all cards. Dionne was seeing the enemy. I could tell by the steel in her eyes.

"What are you trying to do?" she said. "Bring me down?"

When we finally got Jean on her feet, Dionne didn't wait for the tears or the excuses or the apologies. Dionne fired her and the rest of us, too. Even her generosity dried up when her reputation was on the line. And so did mine. I needed a break from all the madness. Jean's overdose was just the last straw.

Fanita never forgave Dionne or me. "I was just very hurt," she said. I heard from Gloria that Fanita had a few stronger things to say, but I'll save them. The Blossoms, legends to some, strangers to most, were now part of rock-and-roll history. Fanita and Jean eventually made their way back to Tom Jones. I had no idea where I would go. The Blossoms went down as the longest-running opening act in the history of show business. We had no real hits of our own, no fifteen minutes of fame. God had closed a door, and he had taken his sweet time doing it. But

now there was no going back. And sometimes there's no more frightening feeling than never being sure when God is going to open another door.

It hadn't been very long since the Blossoms won the NAACP image award, the first real public recognition we'd had after fifteen years. But now we were facing another first—the first time we'd ever been fired. I had spent more time with the Blossoms than I had with my own children, and now the big payback was a pink slip and a drug mess. I loved Jean and Fanita in spite of everything, but I knew that I couldn't depend on them anymore. It was time to leave.

CHAPTER 18

Diamonds in the Roughage

oward the end of the Blossoms' run with Tom
Jones, I started taking Marcus and Chawn
to see their father play football on Sunday
afternoons. Leonard was still in good shape and
he played in a semipro league in Los Angeles
made up of has-beens and almost-wases. They
made a little money but played for pride and
the love of the game: a chance to live, if not the
whole dream, then at least a short scene from
it. Marcus was about ten years old by this time
and Chawn was seven and getting interested
in sports. I wouldn't just go into express drop-
off mode, either, the way so many parents
who share custody of children do. There was
certainly no romantic feeling left for Leonard,
but we were friendly, and I was a sports fan, so

I stayed for the games. This made the boys happier, too. And after a couple of games, one of my girlfriends said, "See that guy over there? He's one of the players' roommates. He wants to meet you. Just being friendly, nothing else."

I turned my head and there on the other side of the field was a man who would not have turned my head had it not been for my friend's urging. He was light-complected and had a mop of curls on his head—in other words, nothing like Bill, but then I knew no one would ever be like Bill. He also wasn't like Leonard, who was dark and stocky. I guess I was at a point in my life where I was feeling a bit surrounded by the grays of familiarity. Here was a man who, almost as if turning a knob on a TV, was restoring some color. Too bad I didn't realize that it was a flashing yellow light.

"My name's Wesley Mitchell," he said. "I've seen you here a few weeks now."

Wesley was there to watch his roommate play ball, but after a few weeks he started paying more attention to me than to the games. It was hardly love at first sight for me, but he was cute, and I think I was taken with the idea that he was obviously taken with me. There had been no one in my life since Bill. Not that I was scouring the land for anyone. This man could have walked away that first day and I wouldn't have given him a second thought.

But he didn't walk away. He kept coming over and talking longer. (I later found out he had to bribe my girlfriend with a fifth of brandy to get her to introduce us!) And he was smart enough to realize that he wasn't bowling me over, so he was patient, eroding my defenses with an ebb and flow of attention. This created an interesting sideshow. Leonard noticed all the at-

tention Wesley was paying me and told him to back off. "She's my wife, man." We had been divorced for more than three years, but I guess he thought he still had some hold on me because of Marcus and Chawn. He hadn't tried anything like that since right before our divorce was final, when I had just started seeing Bill. He had driven to Vegas to spy on me during a show, and Fanita saw him standing in the wings. "That's Leonard over there," she whispered between songs. After the show, he tried to pretend that he was there to "catch" me cheating, and I punted his butt all the way back to L.A.

Leonard's posturing with Wesley, I knew, would have about the same result. He'd roar a bit, then crawl back to his cage. But Bill still had part of my heart reserved long after we broke up, and it wasn't until I started dating Wesley that I finally began to think I was over Bill. We still saw each other from time to time. Bill went through a very tough period in the early seventies, when his solo career failed to flourish and he got so depressed that for several months he lost his voice. I would go over to see him and he'd say, "Pal, let's go around," and that's what we did, two old lovers who somehow managed to stay the best of friends.

Almost a year passed before Wesley and I became "involved." He continued to pursue me, but he was five years younger than I was and he was going to school. He didn't have much to offer beyond his good looks. The more I feigned indifference, the more determined he became. He took Marcus and Chawn out to the park or to ball games, and I got used to having a man around on a regular basis. I hadn't had any time to meet anyone on the road, and at home my only social network was at church—not exactly a great place to meet eligible young bachelors.

I think I just became addicted to the attention. Wesley had never gone to church regularly, but then all of a sudden he showed up at the house one Sunday. "Mind if I tag along?" he said. He basically just started following me all around—just as Daddy did with Mama. And, just like Mama, I finally gave in. Lord, how far the women in my family had come in forty years.

Once Wesley knew he had made some inroads, he started pulling back, almost like a pusher who withholds the goods after his junkie is hooked. When I wasn't looking for him—like at some Vegas shows, where he started showing up unannounced—he'd be around, and then when I needed him, he'd disappear.

Wesley wanted to move in, but I wouldn't let him do that with Marcus and Chawn in the next rooms. If he was going to spend the night, I made sure he didn't park the car in front of the house, and I didn't let him get out of bed until both boys had had their breakfast and were gone. I guess this was my way of throwing God a bone, of sending out a weak signal to my spiritual side. I mean, I hadn't exactly been a model of rectitude. As far as God was concerned, I might as well have been rolling up a message in a bottle, that's how remote and estranged we'd become. On the other hand, I could still count on one hand the number of men I'd been with, which I supposed for 1972 made me some kind of prude.

Sooner or later, though, Wesley and I started talking about getting married, and if I sound a little blasé about this, that's because I was. Funny how Bill and I had the great romance but no marriage. I wonder if we would have remembered our time—those magical nights in Palm Springs, the snow in Seattle—so fondly in the end if we hadn't been star-crossed. And Leonard

and I had at least had physical attraction and a practical issue involved. For me and Wesley, marriage was just something to do.

I should have known the marriage was doomed by the way he proposed. I was in the kitchen tossing a salad, and all of a sudden something landed plop in the middle of the lettuce from the other room. I thought one of the boys was fooling around with his toys, and I was right: the boy was Wesley, and the "toy" was an engagement ring. I slipped it on my finger, licking off the salad dressing. This made it the second engagement ring of mine that someone mistook for a baseball.

About the only thing I was feeling at that minute was dread. Now I'd have to face Daddy, who I knew wouldn't let me have a church wedding. (Even though I was estranged from the Lord, I still wanted to get married in church, especially because I hadn't been able to do that the first time around.) It was one thing to fool around, but to get married a second time? Catholics may think they have it tough, but the Pentecostals are just as strict about divorce and remarriage, and my own father was the enforcer. Wesley was grinning from ear to ear when he came into the kitchen and I pretended to be thrilled. The ring was beautiful, a carat and a half, a solitaire diamond. I didn't know what to say. I wanted to say no, because I knew I didn't really love him. But I hadn't had so much luck with true love. Bill was gone, and our baby was gone (Wesley knew about me and Bill but not about the abortion), and now I had two boys who needed a man around the house. *I* needed a man around the house. I think I said yes out of loneliness. I didn't even think about praying on it for a while. One more time, a decision that I made without the Lord turned out to be the wrong decision.

Valentine's Day 1973 wasn't too far off, and the Blossoms

had a gig—one of their last—in Lake Tahoe, so we set the date for then. I anticipated it with all the excitement of a trip to the orthodontist. Daddy never did give his blessing, so I felt like a teenager all over again, running away from my parents to elope. But there was no teenage excitement or giddiness. I was thirty-one years old, and not one member of my family was in that chapel to stand with me. As the time drew near, I filled my head with all kinds of amateur psychology: This is the start of something new. . . . A marriage is whatever you make of it. . . . Maybe you'll find a direction you like. . . . Just do it and let the chips fall where they may. . . . And so on. And when the minister said, "Do you take this man?" I replied with a confident "I don't know." There was silence in the room for about ten seconds. All I could really think was, What the hell am I doing? Then I said, "I do?" I suddenly looked up, lunch break was over, and I was married. And I went back to work.

Later Wesley asked me what was going through my mind. "Why did you say, 'I don't know'?"

"Oh, you know, I was nervous," I said. "I don't remember saying that." Here it was my wedding night and I was already lying to my husband!

Wesley finished college and became a security guard in the public schools, and history repeated itself. This time, instead of Leonard with his rippling muscles turning the head of every shopper at the market, it was Wesley with his pretty-boy face, winking at all the young teachers and administrative aides. I didn't need the sand on the car seat to open my eyes. One of Wesley's girlfriends called me out right at the school, in front of an assembly of students.

My sister, Edna, and her group, the Honey Cone, were

scheduled to play a concert there, and when one of the members, Carolyn Willis, got sick, Edna asked me to fill in. And right in the middle of the show Girlfriend started declaring her love for Wesley. She thought I was making fun of her, when in fact I didn't know a thing about her and Wesley. "He's mine, he's mine," this fool started screaming in front of her students. I had the microphone in my hand and was half tempted to send it flying at her, but finally I just said, "If you want him that bad, honey, you can have him. You both deserve each other."

Wesley dragged his sorry self back to our house that night with his tail between his legs, and, honey, did he put on a show. "Baby, she doesn't mean anything and she's a crazy nigger and you're my wife. . . ." Apologies and hosannas were pouring out of him like the sap from a spring maple. If I had really loved this man, I might have gotten truly upset, but instead I just thought it was pathetic.

Even so, I knew I couldn't leave him, at least not so soon after we were married. Besides, I still had a sweet tooth, and when Wesley poured it on, Log Cabin could have bottled him. I took him back, and we had a few pleasant months, during which I got pregnant. After that, whatever I was feeling, or wasn't feeling, about my new husband was quieted, for the time being, by my pregnancy. And my career, after a brief fallow period, was heating up again. There just might be life after the Blossoms, and after Bill. Suddenly there was a lot to be thankful for. And then, like a piece on a board game, I landed on the square that sent me back to the start.

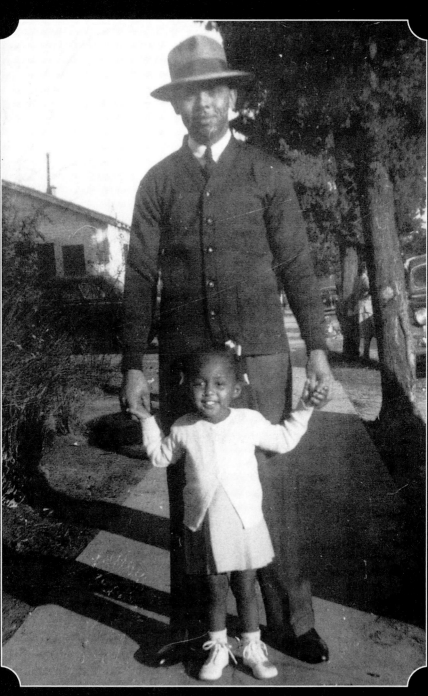

Central Avenue,
here we come. Daddy with "his Dolly," c. 1945.

Mama's reins were tight, especially when we were on our way to church, Los Angeles, 1951.

It's a good thing none of us snored: The five little Wrights, on the pullout bed we shared in the house on East Forty-second Street in Los Angeles, c. 1949.

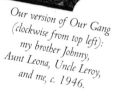

Our version of Our Gang (clockwise from top left): my brother Johnny, Aunt Leona, Uncle Leroy, and me, c. 1946.

The Reverend and Mrs. Wright, c. 1951.

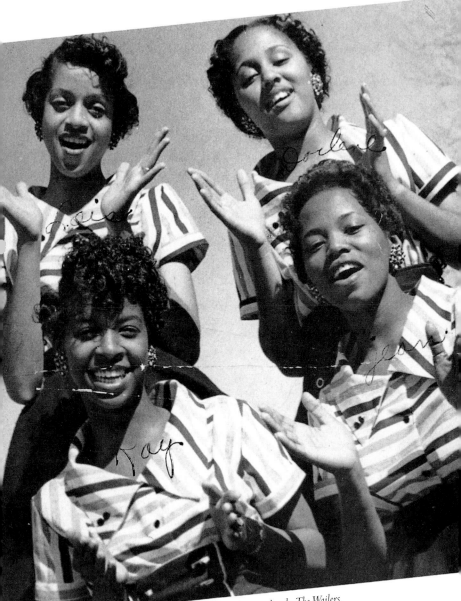

We had the whole world in our hands: The Wailers, a school group in San Antonio, Texas, 1955.

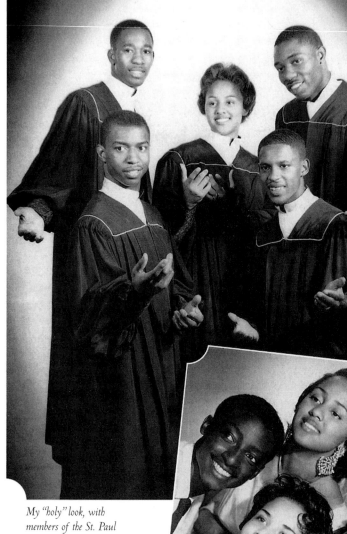

My "holy" look, with
members of the St. Paul
Baptist Church choir, 1958.
(Photograph courtesy of
Harry H. Abrams)

My "worldly" look, with
the Echoes, a pop group
I was in for about five
minutes, 1957.

*Phil Spector before he got too crazy, with me and Cherilyn
Sarkisian, who bloomed into Cher, at the Gold Star Studio, 1963.
(Photograph courtesy of Ray Avery/Michael Ochs Archives/
Venice, California)*

The Duke needed a maid.
Instead he got the business
from me and Edna,
Lake Tahoe, 1975.

The Righteous Sister, and
almost the Righteous Wife.
With Bill Medley and Mike
Patterson, our road manager,
at Bell Studios, 1968.

*Shindig brought the Blossoms a **Teen Screen** magazine award,*
but no new hit records. Jean King (left) and Fanita James (right), c. 1965.
(Photograph courtesy of Jack Schnitzer Photographs)

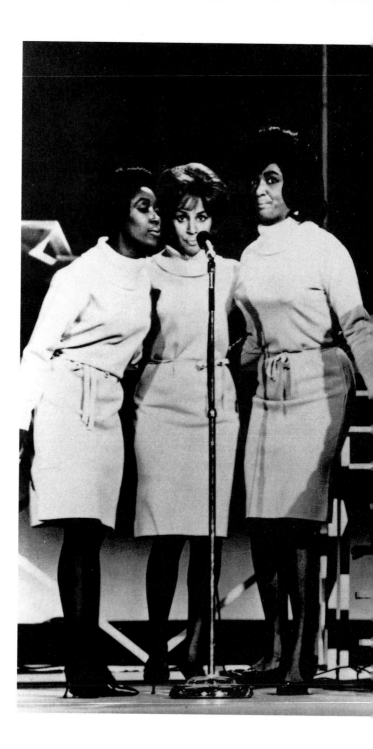

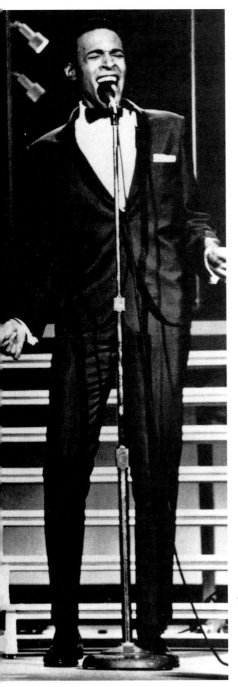

*Marvin Gaye was one of the Blossoms'
favorite "clients," much to the irrational
chagrin of my first husband. The* **T.A.M.I.
Show***, 1964. (Photograph courtesy of
Michael Ochs Archives/Venice,
California)*

On board
and in love:
Alton Allison, the
chief steward of my heart, 1983.

The preacher's daughter
finally got her church
wedding in 1990, when
Alton and I renewed
our vows.

Left: Goin' to the ...mayor's office. Alton and me, on our wedding day, June 28, 1984, Teaneck, New Jersey.

Jason's graduation day at Florida A&M University, 1996. My residuals from **Lethal Weapon** *paid the tuition.*

Three generations of Love: My sons and grandsons (from left) Chawn and his son, Daiquon, and (at far right) Marcus and his sons, Marcus Jr. (third from left) and Marcuez, 1997.

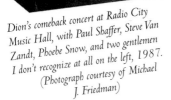

To Darlene
Thanks ... [signature]
Dion

Dion's comeback concert at Radio City Music Hall, with Paul Shaffer, Steve Van Zandt, Phoebe Snow, and two gentlemen I don't recognize at all on the left, 1987. (Photograph courtesy of Michael J. Friedman)

Backstage pass: MTV's Martha Quinn, Paul Shaffer, me, Eddie Van Halen, and Valerie Bertinelli after a performance of **Leader of the Pack**, 1985.

The best thing that happened during the run of **Leader**: my reunion with Cher, 1985.

With Kenny Laguna and my "good friend" Joan Jett on MTV, New Year's Eve, 1987.

I sang "Christmas (Baby Please Come Home)" in the Broadway production of **Leader of the Pack**, but the show never made it to the fall, 1985.

The sleigh bells were in tune but Sonny's voice still wasn't, at the twenty-fifth reunion of the Christmas album, with Ronnie Spector, at the Bottom Line, 1988. (Photograph courtesy of **The New York Times**/ Jim Estrin)

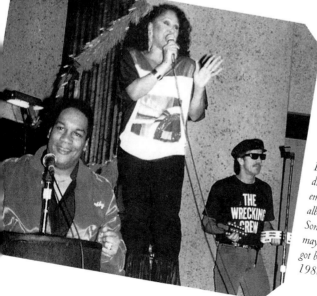

Bobby Jay, the New York disc jockey and singer, emceed the Christmas album reunion, while Sonny, recently elected mayor of Palm Springs, got back to his roots, 1988.

You go, girls: Pattie Darcy and my sister, Edna, flanked me and Cher during Cher's 1989 tour.

Medley's almost as skinny as he was twenty-five years ago, and Lord, could he still sing in 1993, when we recorded a new version of "Soul and Inspiration." (Photograph courtesy of Ebet Roberts)

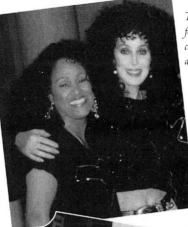

To think it all started
for Cher because I had
car trouble. We're still
as close as ever, 1989.

The grandes dames:
Marianne Faithfull,
me, Patricia Neal,
Merry Clayton, and
Liza Minnelli after
a performance of
"20th Century Pop"
at the Rainbow and
Stars, New York,
1996.

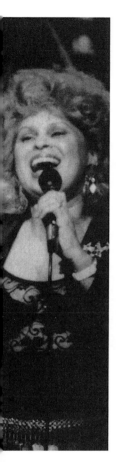

Lady Lena, one of
my heroes, graced my
presence at the Song-
writer's Hall of Fame
induction in 1992.

: With Whitney Houston
er bridal shower at the
ga Royal Hotel, New York,
92. By then she already had
re hits than her mother
me combined.

That's what friends are for:
Dionne and me at Whitney
Houston's wedding, 1992.
Dionne came to my rescue more
than once.

With Bonnie Raitt, another soul survivor,
at the Rhythm & Blues Foundation
Awards ceremony, 1995.

The surprise of my career:
Winning the R&B Pioneer Award
in 1995, and finding a check attached!
I guess it didn't matter that I don't
consider myself an R&B singer.

CHAPTER 19

The Blacker the Better

ou always hear about how the 1960s were
the golden age of pop music. Motown, Phil
Spector, the Beatles, soul, psychedelia—there
wasn't just something for everyone, there was
quality for everyone. Even the bubblegum
music was amazingly well crafted. I mean, if
Wilson Pickett can record "Sugar, Sugar," you
know there's got to be some substance there.

The conventional wisdom about the 1970s
is that it was a musical junk heap made up of
sixties decay—from sixties soul to seventies
disco, from sixties folk to seventies lame singer-
songwriters, from Jimi Hendrix to heavy-metal
blowhards. Even people who like seventies
music might readily fold into a full-body retch
on their way to the dance floor. But that's the

cheap and easy reaction. A lot of great music was made in the seventies, especially in the first half of the decade, even with the demise of the Beatles. Plenty of good new singers came along— Roberta Flack, Al Green, and Anne Murray, to name a few, and at least two classics, Michael Jackson and Karen Carpenter.

Michael, even when he was eleven years old, was such a little man-child, a whirling dervish onstage whose delivery and emotion dwarfed that of singers three times his age. I always thought he was James Brown, Jackie Wilson, and Chuck Berry all wrapped up in one. And he just kept getting better as he got older.

And Miss Karen, Lord, so smooth and deep at the same time, a true alto holding steady in a world of fluttery sopranos. (Take it from another alto.) Say what you will about how "white bread" she was, but let me tell you, all those millions of records the Carpenters were selling weren't being snapped up just by white people. The Honey Cone had a whole spot in their show devoted to the Carpenters' hits, and musicians, black and white, adored Karen's voice. My friend Larry Saltzman, a wonderful guitarist who played for me a few years ago, said recently that in the early seventies, he met the writers of the Main Ingredient's great hit, "Everybody Plays the Fool," and they told him they were modeling their sound on the Carpenters. Funny, I can easily hear Karen singing that song, or any of a handful of great early-seventies soul hits like "Betcha by Golly, Wow" or "Games People Play" or "Golden Lady." I never met her, but pop music has been poorer since she died in 1983.

The early seventies also brought an overall renaissance in black music. Aretha was having the best of both her R&B and pop leanings. Stevie Wonder, who was all grown up and exerting

creative control over his career, was releasing landmark albums like *Talking Book* and *Innervisions.* And Motown now had a rival for dominance on the black pop market: TSOP, the sound of Philadelphia, masterminded by producers and writers Kenny Gamble and Leon Huff. With equal parts grit and gloss, down-and-dirty bass lines, and strings and horns as sumptuous as white chocolate, Gamble and Huff and their artists—the O'Jays, Harold Melvin and the Blue Notes, the Three Degrees—were crossover dream merchants who helped make white America a little more funky and black America a little more affluent. In 1963, it seemed every singer in the business wanted to be on Philles Records; in 1973, every singer in the business wanted to be on Philadelphia International. That was where and when I landed next. No one knew better than I did that the only guarantee in show business is that there are no guarantees, but, Lord, when I signed with Gamble and Huff I thought I had landed the sure thing. Practically everything these boys put out was a hit.

I met them at a Muhammad Ali fight in 1973. Dionne Warwick took me along with her. Though it had been almost ten years since the last Darlene Love release, Gamble and Huff knew my music well and started talking about how they were looking to fill an empty slot on their roster for a female solo artist. I was free of Phil Spector and free of the Blossoms. I was available. I checked my shoes; what had I stepped in? I told Dionne to pinch me. Could it be that after all these years, God was finally giving me a second act?

Jimmy West, who was still my manager then, brokered the deal. It seemed as if overnight we were headed for Philadelphia, which had always been like a black utopia to me. I don't know what excited me more, Gamble and Huff's track record or

simply the fact that for the first time in my career I was going to be produced with a black sound. The only other black producers I had sung lead for had been Holland-Dozier-Holland, during our weekend-in-hell in Detroit a few years back. But to me Motown wasn't really a black sound; it didn't get down like "Back Stabbers," which to this day is one of my favorite records. Bill Medley once called me a "lily white" singer. I was looking forward to shoving those words down his throat with my first Philadelphia International album.

I still didn't know Gamble and Huff too well, and so for my first few nights in Philadelphia we just went to dinner and talked about the kind of songs I wanted to record: Did I prefer ballads or up-tempo? they asked. To their surprise, I told them I didn't want ballads. I wanted stuff like "Love Train" and "The Love I Lost," the blacker the better. I think they were a little surprised. "He's a Rebel" is up-tempo, they said, and sounded pretty black. But I thought that was a pop song. When I said black, I meant somebody getting the grittier parts of my voice. I didn't know if I could even find that place—so far no producer had even tried—but I knew that if anybody could make me sound gutty and soulful, it was Gamble and Huff.

After a couple of days Jimmy flew back to L.A., confident that I was comfortable, and soon Gamble and Huff started sending songs over to the hotel, demos that other singers had done. These were tough songs, the kind of porterhouse material you can sink your teeth into, and I did little else other than stay in my hotel room to learn them. Gamble and Huff called every day to find out what songs I liked and how I was doing learning them, promising that recording would start soon. There might have been one or two more dinners, too, before the fateful

phone call came. I knew something was wrong by the tone of Leon Huff's voice.

"Darlene, could you come to the office tomorrow?" When I got there, Kenny Gamble still hadn't arrived, and Leon Huff was shuffling his feet, his head crooked toward the window, then drooped down at the floor, spinning everywhere but in my direction. I mentioned the songs I had picked out and how I was looking forward to recording them, and he just uh-huhed me to death, until Kenny, Mr. Smooth, walked in. He didn't dress very loudly, but in the open-collared silk shirt and silk sport jacket and Italian shoes, he looked head to toe like money. When he walked, he sailed.

Kenny sat behind his desk and was all business: not arrogant, just strangely matter-of-fact. He didn't waste any time with the news he had to deliver.

"Darlene, there's been a slight complication with your contract," he said. "There's a clause that says we can sell your contract whenever we want, and there's a big producer out there who wants you, so that's what we've decided to do."

Suddenly there was a thud. It was the sound of my hopes dropping to the floor. Somewhere amid all the noise in my head I heard them say something about that being the bad news. And then that name came hurtling back, escaping from the Elba of my mind: Phil Spector. They had sold my contract to Phil Spector.

Lord, what was the good news?

My face must have been a big question mark. All I can remember saying is, "Phil? You know Phil Spector?"

"Yeah, we know Phil," Kenny said. The rest is a daze, a real *Twilight Zone* kind of thing for me. It was almost an out-of-body

experience, as if I had left the room and then come back after a
minute. They knew that I didn't want to be back with that man.
Why had they even bothered to go after me, to fly me first class
to Philadelphia, to send me songs? Had it all been just a ruse?

I didn't cuss them out, I didn't get mad, I didn't even want
to hear what they had to say. I just sort of floated back to my
room through a haze of cigarette smoke and crushed hopes. I
can't remember what my response was or even how I made it
back to the hotel. As far as I was concerned, my recording career
ended right then and there.

I do remember crying and screaming on the phone to Jimmy
West in L.A., who had barely had time to get off the plane be-
fore my call came. "I just left you a few days ago and everything
was fine," he said. "How could this happen?"

I took a flight to L.A. the next day, and Jimmy and I pored
over the contract. The clause was there, sure enough, but how
had Phil known about it? The agent provocateur in all of this
turned out to be Phil's lawyer, Marty Machette, who was also
Gamble and Huff's lawyer. What we didn't know was whether
he had tipped off Phil or whether the whole thing had been a
setup from the beginning. All the time Gamble and Huff were
plying me with fine wine and great songs, they must have been
talking to Phil. Maybe he wasn't offering enough, and they went
ahead with the illusion of producing me just to up the ante.

It's ironic that of all the contracts I had signed up to that
point, the deal with Gamble and Huff was the one time I had
all kinds of lawyers and show-business sharpies pick it over to
make sure I wasn't getting a raw deal. Jimmy West didn't even
remember that fateful clause a few paragraphs before the end,
and if I had read it, I must have figured that they would invoke

it only after they'd had a run of hit records with me and had nothing else for me to do. I never dreamed I'd never get to sing even one note. And now Phil had me again.

As I flew away from Philadelphia, my eyes watered over, and all I could see was that roster of acts hanging in the Philadelphia International office—Lord, there was not one artist that I didn't like—and I could envision the spot where my picture would have hung and how I would have made a good fit. Now it was just another dream trickling down my cheeks. Gamble and Huff never would have a successful female solo act. Instead, they made their money off me the easy way, from Phil's bankbook. I never found out what he paid to steal me away, but I hope it was a small fortune.

If Jimmy or I had been wiser, we could have taken them all to court and nailed them with conflict of interest. Even a legal illiterate like me knows that you can't have the same lawyer representing both sides of a deal. But, as usual, rather than fight, I decided to dress up the situation with as much brocade as possible. At least I would be recording again. And I had a new baby on the way. Dionne Warwick also rehired me to sing backup with her sister Dee Dee and her aunt Cissy Houston. The Lord was always generous with the silver linings; now if only he could take care of this one big cloud.

CHAPTER 20

Just Unlike Old Times

Phil Spector didn't call for months, and I was in no hurry to talk to him. Maybe I'd finally have another hit, but I was just getting too old for all the nonsense he imposed on everyone who got near him. Apparently Ronnie was, too, because they were getting divorced. I hadn't seen or talked to Ronnie much since she and Phil got married, but I had heard he'd become even crazier. There were rumors about guns and locking his adopted children in their rooms and having his employees followed. I didn't stand for his garbage in the sixties, and no matter how crazy he had become, I wasn't going to start now.

He finally contacted Jimmy West in mid-1974 and said he had a song he wanted me to

learn called "Lord, If You're a Woman," written by Barry Mann and Cynthia Weil. I love Barry and Cynthia. They're the best in the business—they wrote "You've Lost That Lovin' Feelin'" and "Soul and Inspiration." But, Lord have mercy, what were they thinking with this one? You always hear about songwriters and poets who write bizarre verse during or after a bad drug trip. This one must have been inspired by a bad case of promaine, because just the thought of it makes me sick. This was the era of women's lib, when Helen Reddy, while accepting her Grammy for "I Am Woman," thanked God, "because She makes everything possible." Now I was supposed to sing this tripe that went, "Lord, if you're a woman, listen to me, Sister." Give me a Peggy Lipton song any day.

Phil had signed a deal with Warner Brothers to start a new label called Warner Spector. Even though almost ten years had passed since his heyday, and though he had spent the early seventies as a kind of attaché to individual Beatles, they still shelled out millions. (He actually did do some nice work on the last Beatles album, *Let It Be*, which was salvaged from scattered and discarded tracks.) His first big signing for Warner Spector was Cher, and that made some sense, because she had remade herself from ragtag hippie to TV glamour queen. She had just had two No. 1 records, "Half-Breed" and "Dark Lady," and her divorce from Sonny practically guaranteed her a regular spot on the covers of supermarket tabloids. Somehow, that sixteen-year-old waif who wandered into Gold Star with her matted hair and tattered jeans had become, according to *People* magazine, the sexiest woman alive.

But when Phil signed Dion DiMucci and then bought my contract, the Warners bean counters must have cried foul. Phil

didn't care about new talent; I don't think he liked much of the pop music that came out after 1967. His other big project, for Apple Records, was a John Lennon album of oldies called *Rock and Roll.* It seemed Phil was bent on proving that time had stopped in 1963, and in a sense, for him, it had.

Phil's new assistant, Sandy Kalish, called me to book the session. I told her that I was seven months pregnant and did not intend to work till all hours of the night. Right away she put me at ease, telling me that Phil would just have to work around my schedule. I became good friends with Sandy; she was kind and smart, and I had no idea what she was doing working for a fool like Phil. I was still so angry over the whole business with Gamble and Huff that there was no way I could get excited about this session, especially with that turkey of a song. Phil knew I wasn't happy, and I think that fed his ego even more. It was as if he was saying, "I don't care if you don't like it, I know it's a hit." He was just as arrogant as ever. This time, though, his mouth wrote a check that bounced.

The session was at A&M and I didn't need anybody to direct me to the studio once I got there. I just had to follow the goose bumps on my arm, rising not because I was so excited to be working with Phil again but from the cold. I thought he was freezing us out in the sixties, but now it was really a meat locker. "Just like old times, right, doll?" Phil said. But if anything, Phil was even more remote now. He had his usual "cast of thousands" around him—Nino did the arrangement, and Larry Levine was one of the engineers—but the rest of the people fawning over Phil in the booth had nothing to do with the record. The tracks were already laid down before I got there to do my vocal—which was never the case in the old days—and

Phil seemed more concerned with showing off in front of Cher and John Lennon, who were his special guests, than with getting a good take from me. The song sounded like a bad James Bond movie theme, and the lyrics just kept tasting worse every time I sang them. "Lord, if you're a woman, listen to me, Sister, and help me stop loving that man." It was a real mess, almost like "River Deep-Mountain High" all over again.

What kept me with Phil so long in the sixties, aside from my contract, was my feeling that no matter what shenanigans he was pulling that day, he always respected my talent. But now he just kept his back to me while I was singing. I'd finish a take, and without turning around to look at me, he'd flip on the monitor and say, "I don't like it, do it again." A couple of times I couldn't even get a line out before he stopped and told me to start over. I looked up and saw them all laughing in the booth, and once, when Phil was turned toward me, I could read his lips: "Watch me make her do it again." I stood this abuse for about two hours, then I just put the headphones down, put on my coat, and walked out. It was bad enough that he had stolen my contract, but now he was treating me like his slave. I thought, Lord, if you're a woman or a man or a vegetable or a mineral or a time or a season, you can send Phil Spector right to hell. At that moment I didn't care if I ever recorded again. Phil didn't release "Lord, If You're a Woman" until years later, and it sold about three copies, probably to Phil, Nino, and Gloria Steinem.

CHAPTER 21

Another Boy to Love

I was thirty-three years old when I was pregnant with my third child, and Marcus and Chawn were already almost teenagers. My relationship with Wesley had simmered down while I was pregnant, but in my heart I knew that it was doomed, even if I couldn't actually verbalize or think it. I had made arrangements to have my tubes tied after the baby came, so I prayed that I would finally have the daughter I had longed for since I lost Rosalynn fifteen years before. But one more time the Lord had other plans, and on November 1, 1974, Jason Davion Mitchell arrived. He was three weeks overdue, and finally the doctors told me he was so big that they had to induce my labor. "Just please don't let

my baby be born on Halloween," I said. I had enough devils in my life already.

Jason barely made it, at five or six minutes after midnight, and I was such a happy camper that I forgot for a minute how much I'd wanted a girl. And when they brought him in to me, any residual disappointment flowed right out of me. He was beautiful, not too light, not too dark, with very keen features, and because he was so big he was fully formed; there were no wrinkles anywhere. I thought the angels had come down and kissed him. Not one of my babies was ever a lot of trouble, and Jason was maybe the happiest, most playful of the three boys.

The glow of Jason overwhelmed everything in my life for a while, especially the problems Wesley and I were having. He was still fooling around, and I knew it, and he knew I knew it, but for the first month or so that Jason was home I almost didn't care. Of course it was always my fault, too: I was gone too much, or Marcus and Chawn were acting up, or Leonard, who had bought a house just behind us to be close to the boys, was around too much. Nothing was ever Wesley's fault.

It was especially hard on Marcus and Chawn because Wesley turned into a real tyrant with them. "He was a real con man," Marcus says. "He would make you think he was the perfect dude, everything was beautiful, everything was just right. Once he was in, though, he turned the lights out. When I first met him, I thought, All right, this is cool. We're doing things together, hanging out, he's really fitting in. Once my mother married him, though, all that went to hell. I started staying with my father."

Wesley was a security guard in those days, and he seemed to think of the house as part of his rounds. I came home one day

to find him in uniform, with his gun in his holster and a ciga-
rette in one hand. He had Jason, who was about four months
old, on his hip. "I'm leaving," he said.

"What do you mean, you're leaving?" I thought this was just
more of his usual bluster, the latest extreme he'd go to to get my
attention.

"I'm taking Jason and leaving." And before I could scream or
call the police, he was gone. At that point I could not have cared
less about Wesley, but how was he going to take care of Jason?
I called my family and his family, and no one had heard about
this. Finally I called the police. "My husband just kidnapped
my child," I said.

"Is he the boy's father, ma'am?"

"Yes, but he kidnapped him. He doesn't know how to take
care of a child on his own. And he has a gun."

"Did he point the gun at you, ma'am?" He hadn't. "I'm
sorry, but if he's the boy's father, it's not a kidnapping, and
there's nothing we can do except fill out a missing persons re-
port. I suggest you wait until your husband contacts someone."

So that's what we did, wait. Four days and nights, until fi-
nally the fool called both his parents and my parents, to let us
know that Jason was all right and that they wouldn't be coming
back anytime soon. I knew it was time for the heavy artillery. I
called Nancy Sinatra.

We hadn't worked together in years. Nancy was in semi-
retirement, raising her own family, but I knew I could count on
her in an emergency. It didn't take long for me to get hysterical
on the phone. I didn't know how Wesley could manage it, unless
one of his bimbos was helping him, and that would make me
even madder. Nancy made me tell her the whole story a couple

of times to make sure she had it straight and that she wouldn't be calling the big boys to put out a brushfire. "Is he a violent person?" she asked. "Will he hurt the baby?" No, I said, but he's incapable of taking care of him on his own. Finally convinced of how desperate I was, she said she would do her best. She called Frank.

The next day I got a call from someone in "the Sinatra organization" who asked me for the license plate number on Wesley's car. Within hours two police officers were knocking on the door of an apartment across town. "Sir, this is an unofficial visit, but we suggest that you get that child back home to his mother." Wesley couldn't believe that they had found him, and to this day he still doesn't know how they did. He hightailed it back home that night, and kept ranting and raving about how I had "sent some people to kill him." I wanted to throw him out for good, but after letting him stew for a few weeks I took him back. After all that, I still had some feeling for him, and I certainly didn't want another divorce. As for Jason, he was fine, thank the Lord, except for a red behind, which probably came from the bleach Wesley was putting in his diapers. I'll always love Nancy and Frank Sinatra for bringing my child back to me, even if what happened was illegal. I'm sure I wasn't the first desperate mother to bend the rules a little.

CHAPTER 22

"Is This the Note You Want?"

What saved me was, of course, work, and with Wesley so unstable, I ended up taking Jason out on the road with me even before he could walk. The summer after he was born, Sonny Bono, now divorced from Cher, was touring, and he hired me and my sister, Edna, to put some notes in his act. And as soon as I could catch up with Dionne's tour, Jason came with me there, too. Dionne had forced me to go home when I was eight months pregnant. "Go home to your family," she said. "I won't have you delivering that child onstage." Dionne didn't realize, though, that I liked being with the family I had on the road more than the one I had at home. As soon as I brought Jason back out with me, Dionne practically adopted him.

She would let Jason stay with her on the plane, and as he got older she often put him onstage with us while we were performing, up near the orchestra. One night at Harrah's, when he was about three or four years old, he had been in Dionne's room a long time and then suddenly came running down the hall, right into Eunice Peterson, a great young singer who had joined us on the tour as another member of Dionne's backup group. "FUCK YOU!" he screamed, as innocently as "HI, MOMMY."

Eunice marched him in to me, where he repeated the cheer. "Who has he been with?" I said.

"Three guesses," Eunice said.

I confronted Dionne. "What are you teaching my child?" I said. "What if he says that in my father's church?"

She giggled away in that conspirational laugh children have when they know they're untouchable. "I thought he was so cute."

As mad as I was, I had to love Dionne for these "just plain folks" moments, which, no matter how big a star she became, were always plentiful. Sandy Kalish remembers a tour stop in New York, when Dionne took everyone to a local diner and chowed down and whooped it up. I was treated like another cousin and got to know all the Warricks and Drinkards (who included Cissy, later Houston, later mother to Whitney), who were East Coast gospel royalty. Dionne, though she was only a few months older than I was, was like the Queen Mother, reigning like a benevolent monarch.

But there were times when she was clearly on another level, filled with the helium of hits and acclaim she'd had since we first met on that cold day in December 1962.

I was only too happy to have a second family because my "first family" life was almost nonexistent. I stayed with Wesley

even after the craziness of the kidnapping because I just couldn't face the idea of another divorce, especially with Jason still a baby. I knew by then that I didn't love Wesley, but as long as I was away touring so much, I could mostly ignore the unhappiness at the core of our relationship. The downside of being on the road was that Marcus and Chawn were being raised by a tag team that included me, Leonard, their grandparents, and even themselves. And when I wasn't on the road, I was busy doing sessions. Phil Spector was calling again, finally, with a new project for me. Think of any cliché you can: Home was like a double-edged sword. . . . Like being between a rock and a hard place. . . . Like being between yesterday and nowhere. . . . Any way I looked at it, home was someplace I just didn't want to be.

During a break in Dionne's tour, Sandy called to tell me about sessions Phil had booked, and they all turned out to be background. This really was like the old days now, Phil forever putting my career on hold while he used my voice as, essentially, an expensive accessory to his other artists. I sang on Dion's album *Born to Be with You*, and Cher's song "A Woman's Story," and then I was summoned to Phil's house to work on songs for a movie called *The Idolmaker*. A couple of blocks before I got to the house, I noticed a car behind me a few lengths, and it stayed with me till I reached Phil's place in Bel Air. His house was located on a dark little street with speed bumps, and there was almost a block-long electrified fence and the usual BEWARE OF DOG signs and the concertina wire on top. If this was the prison Phil had locked Ronnie in, no wonder she had broken out.

I beeped at the gate, and when they let me in, I felt as if I were driving onto the set of a gothic horror movie. It was the

middle of summer in L.A., but it felt cold and creepy, leaves blowing, limbs hanging low and crooked as if they were going to snap. As I was driving up I saw the car behind me turn off its lights, but it still followed me right up to the circular driveway with the fountain in the middle. The fountain was dry, though, an apt metaphor for the man inside the mansion.

It was enormous. Phil had told me it was the old Kellogg estate, and I had to catch my breath just from the spectacle of the huge grounds and the front door as big and thick as a bank vault's. Before I could knock, I heard this commotion going on inside.

"C'mon, Phil, put away the guns. She's here."

"I'm not putting away my guns."

Against my better judgment, I knocked, and there was Phil, in a business suit, as usual, with a coal-black pompadour hairpiece like one of the Coasters and boots with four-inch heels, and around his waist a holster with a pistol hanging on either side. And I knew they didn't shoot caps.

"Darlene, my favorite singer," he said. "I just love you so much." Then he started twirling the guns on his index fingers, and that's when I stepped back out of the house.

"Just a minute," I said. "I'm not coming back in until you put those guns away."

"Don't worry, doll. I'm not going to shoot anyone."

"That's all well and good, but I'm still not coming in until you put them away." There was some commotion among Phil's latest pack of bodyguards, whose bloated muscles were in inverse proportion to their vocabularies. Then finally George, Phil's right-hand man, persuaded him to put the guns away, and I stepped back inside. It was still the same with Phil; he

just wanted to see how far he could push until somebody pushed back.

The foyer was more like a lobby, and Phil still had his Christmas tree up. "I keep it up until it dies," he said. I didn't bother to ask why he still had it decorated. There were pictures of Lenny Bruce all around it, and I didn't have to ask Phil about those, either. Lenny Bruce was Phil's hero, the Jewish rebel whose shocking humor and tragic end all fed into Phil's twisted-genius take on himself.

"Would you please turn some lights on?" I said. Of course everything was dark. The windows were covered with thick velvet curtains, all drawn, and you could barely see anything. Not that I really needed to; all I had to do was follow the smell of the musk Phil was wearing; Lord, I thought it was bad in the sixties, but he must have been bathing in the stuff. It was all part of Phil's idea of a funhouse thrill, I guess, the guns, the big hair, the darkness, the uncertainty he wanted to plant in everyone's mind. After all these years, though, I was still the only one who threw it back in his face.

I asked Phil why he had had me followed, and as he led me into the music room, he said it was because he had been working on some top-secret project.

"See those tapes over there?" he said, pointing to a pile of spools on the floor. "Those are the Watergate tapes. I worked on those for Mr. Nixon. Don't be surprised if you hear helicopters flying around." Apparently Phil was convinced that somebody was trying to kill him because of those tapes. That's why he had me followed when I was driving to his house.

I didn't put anything past Phil Spector, but this story was just too fantastic. Yes, Elvis had worked with Nixon, and it

wouldn't surprise me to hear that Phil took the same route from rebel to reactionary. But I still thought Phil must be joking; Nixon was already out of office. Why would he need Phil to doctor up the tapes now? Sandy was there, too, and she and I just gave each other one of those sliding-pupils looks; never a dull moment around Phil. The helicopters never came, except maybe in his head.

We worked on a few songs, which were really just rough thumbnails, but I could tell Phil didn't think much of them, and so we wrapped after only a few hours. Phil delayed so long on the project that he was finally pulled off it and Jeff Barry was called in to clean up his mess.

Warner Spector had to be the biggest tax write-off in the history of Warner Communications. The Cher single was a flop, and the Dion album turned out to be so dark and depressing that it was never released in America (though it came out in England, with little success). Phil produced one more album under his Warner contract, for the punk-rock group the Ramones, which came out in 1980, and as far as I know that was the last new music Phil ever released. Sandy called once or twice to say that Phil was working on something "really exciting" for me, but nothing ever happened. When I left his house that night and closed the door on the guns and "Watergate" tapes, I closed the door on my working relationship with Phil Spector, this time for good. But as he, and I, would find out later, only the singing was over.

As frustrating—and weird—as this latest round with Phil was, my time onstage with Dionne continued to be magical. The

sheer quality of the material, songs like "Walk On By" and "I Say a Little Prayer," was enough to humble the mightiest of singers. She had so many good songs, in fact, that she often crammed them into a medley as long as a mountain trail. It was beautiful, but endless. The other girls and I used to say that she should just sing four or five full versions and be done with it. But we never said it to her face.

That's because Miss Dionne had acquired, over the years, a bitchy reputation. I never experienced that side of her until we went back out on the road after Jason was born. By then many of the musicians who had come up with her had left or were being replaced. And soon it became clear that Dionne was not just our friend and peer but our *boss.* I remember one show when we decided to jam a little on one of our background parts. We weren't showing off or doing a run or anything, just stretching out a note here and there, testifying a little. After the show Dionne got us backstage and said, "All right, you girls stop wigglin' those notes," as if we were somehow taking the attention away from her.

When the tour hit Brazil one year, Eunice and I wore some fabulous dresses we had bought in Monte Carlo. Dionne always let us pick out our own clothes for the performances. They were white, backless, and low-cut. I mean, compared with what Toni Braxton wears these days, they were nuns' habits, but in 1975 they lit a few fires, and when Dionne introduced us to the crowd, the men went wild. We were very impressed with ourselves until we saw Dionne glaring at us. The next day she knocked on our door around noon and said, "C'mon, girls, we're going shopping." After that, she bought all our outfits.

The surest way to cross Dionne, though, was to mess up the

music. She didn't get to where she was without being exacting, but I never saw anyone call people out right onstage, in front of an audience. Our poor piano player, Joe, bumped into a wrong note one night, and Dionne stopped the show, marched over to him swinging her microphone, and started banging on the keys. "Is *this* the note you want?" she said. The poor guy never knew what hit him; he was just cowed, and he promised never to do it again, as did most of the musicians who piqued her wrath, because they knew she would fire them on the spot.

The most interesting tête-à-têtes happened between Dionne and her sister, Dee Dee. It would be difficult to call them rivals, because Dionne's success had far surpassed Dee Dee's. They both had voices that could pack a wallop, but Dee Dee just didn't get the material or the breaks Dionne did. She was a proud woman and wanted to be a star, and Dionne's success only made Dee Dee think she deserved it even more.

But there was no comparison between her and the magnificent Dionne. Dee Dee had one or two near hits, but nothing like the gold mine Dionne got from Burt Bacharach and Hal David. And while Dee Dee always had a meticulously maintained appearance, Dionne got all the shape in the family, the great legs, the big boobs. So Dee Dee spent most of her career in her sister's shadow.

When she was forced to work for Dionne, she often stormed off in the middle of rehearsal. And it wasn't just onstage; in a Vegas coffee shop a keno girl was rude to her, and Dee Dee whipped her to a fare-thee-well. Once when she was sick, she disappeared for a few days, and Cissy and I figured we'd be doing the shows without her. But on opening night she had a big surprise for all of us: She barreled down the aisle while

Dionne was in the middle of "Do You Know the Way to San Jose?" and bellowed, to no one in particular: "Where's my mike? Where's my stool?"

Dionne turned around and said, "What the HELL is that?"

"I'm doin' my show," Dee Dee said.

"Like hell you are. You ain't nothin' but fired."

And off Dee Dee went, in a cloud of smoke and fury. She'd be back again. She and Dionne would do this hiring/firing dance for almost as long as I worked with Dionne. Blood *is* thicker than water, even if some of it spills now and then.

Dionne was mostly the good witch with me, except for one night in Brazil. She caught me talking in the middle of a song; I had become distracted and wandered off my part—and into the deep end. I don't know if a band member caught my attention or I forgot a lyric or laughed at something in the audience, but whatever it was, Dionne had those cannons in her eyes trained on me. Her lips were curled and she was ready to fire. But I shot the evil eye right back at her and raised my arm, as if to say, "Talk to the hand, you don't want to go there." I had been in the business too long and been too good to let one wrong note or forgotten lyric drag me through the mud. I would have sacrificed the job and our friendship right then and there, because I can't think of anything worse than being embarrassed onstage in front of an audience. If Dionne had said anything to me then, there's no telling what I would have done. Lord, the sequins would have been flying. Luckily for both of us, she backed off.

Later on, backstage, she tried to act as if it was all in a day's work.

"I wasn't being malicious," she said.

"I don't care; just please do not ever call me out onstage," I

said. "Cuss me out later, dock my pay, fire me, but don't ever do that onstage ever again."

"I just want you to be paying attention, to do your job," she said, and walked off shaking her head. She was just like Phil; she went as far as she could go with people, wrung them out until they wrung back. She continued to correct, berate, and impale other musicians onstage, but never again did she try that stuff with me, because she knew if she had, security might have had to pull me off her.

It was because Dionne and I were so close that I insisted on the respect from her I deserved. Usually it works the other way around. When you're good friends with someone or in love, you let them get away with a lot more. But with me and Dionne, it was just the opposite. I gave her less rope. She knew how professional I was, and I would not have her using me to pump up her own ego. She knew I deserved better than that as a singer and a friend. She could trash-talk her own sister onstage if she wanted to, but I never let her do that to me.

Offstage, though, it was back to shopping and gossiping and boxing matches and family get-togethers. Family was always Dionne's number one priority. And in the seventies, Dionne needed to have close friends and family on the road. Though she was still one of the biggest stars in show business, she had hit a dry spell on the charts, precipitated, it seems, by advice she was given by an astrologer. For as long as I knew her, Dionne was always dabbling in this craziness. She used to hold séances out on the road (I never attended), and once I mistakenly took a tape of hers that contained a lot of mumbo-jumbo about the meaning of life and fulfilling your potential. It sounded like voodoo to me. When she got involved in the Psychic Friends Network

years later, the cynics all thought she was in it for the money. But I cut her some slack, because she was always a patsy for the tea-leaf readers of the world.

Sometime in the early seventies, an astrologer told Dionne that she had thirteen letters in her name, and should add an *e* to ward off bad fortune. And almost from the second she did that, her luck starting changing, for the worse. Burt Bacharach and Hal David, those two sugar-daddy songwriters, parted ways, leaving Dionne without her supply of material and forcing her to sue them for breach of contract, because they had signed to write and record several albums with her. And her marriage started faltering soon after that.

Dionne was married to a quiet man named Bill Elliott, an actor who was in the unenviable—for him—position of knowing that his wife was more successful than he was. He had some small parts here and there and was one of the stars of the sitcom *Bridget Loves Bernie*, which ran for a season on CBS in 1972–73. But once that show was canceled (not from poor ratings, but from the protests of religious groups who didn't smile on a Catholic-Jewish marriage on prime time), he found it harder and harder to get work.

He didn't hang around the tour much, except on the sacrosanct family occasions, like the birthdays of their two sons, David and Damon, and he was always perfectly nice to me, though we exchanged only a handful of words. But I'll never forget being in the kitchen of their house in Maplewood, New Jersey, having a cup of coffee and hearing Bill and Dionne going at it upstairs. I can't remember what the argument was about, I just remember it getting louder and louder, and I felt as if I were in the hot spot. Dee Dee was downstairs, too, doing an

interview for some local paper. Finally the racket got so loud that she went upstairs and said, "I don't care if you niggers kill one another, I'm doing an interview. Do you want all that in the press?"

I tried to stay out of their way, but it seemed that no matter what room I went into they weren't far behind, almost oblivious to me, their immediate surroundings blotted out by irrationality. Things were rumbling and shaking in their wake. Now, anyone who has seen Dionne Warwick's statuesque frame might not be in a hurry to mess with her, and I was expecting a bloody fifteen rounds to ensue, but all went quiet after a while. In about twenty minutes Dionne came downstairs, grim-faced but freshly made up, knowing, of course, that we'd heard everything and also knowing that the only consolation she wanted was silence on the matter. And we never did talk about it; there was only the tacit acknowledgment, the look exchanged between two women who had experienced troubled marriages and whose anger, in those difficult first minutes and hours and days after, couldn't get a foothold on the shame.

Dionne and Bill broke up shortly after that, and he died young, in his early forties, a few years later. Dionne's father died in 1977, and she moved her mother to Beverly Hills. I began to understand why holidays were so important to her. Like me, she had found her real family on the road.

CHAPTER 23

Truer Grit

ou never know whom you're going to bump into on the road, literally. Dionne was playing Lake Tahoe, and Edna was filling in on backup, and we were sharing a room at Harrah's. One morning when I was backing out of the door holding the room-service tray for housekeeping to pick up, I heard another door open and then a groggy, gravelly voice down the hall.

"Excuse me, miss, when you're finished, could you do my room next?" The man closed the door before I turned around, but he wasn't getting off that easily. I stuck my head in the door of our room and roused my sister. "Do you believe that sucker? He thought I was the maid. Brother, he's got something else coming."

I made a beeline to his door and pounded on it. "Excuse me, but I. . . ." My tongue was stilled by the vision in front of me. It was the Duke himself. "Oh, my God, Mr. Wayne. . . ." Then I remembered his presumption. "I am a big fan of yours, but I am *not* the maid. I know you thought so because I'm black, but my name is Darlene Love, and I work for Dionne Warwick, and we're singing in the main room tonight."

So much for all my "watch its" and "what fors." After seeing and meeting and working with so many stars, there were few left who could inspire this kind of starstruck awe in me, but John Wayne was one of them. To this day, there's nothing I like better than curling up on the couch on a rainy day and sitting through one of his old Westerns that I've already seen seventeen times. My husband always thought this was crazy. "Why are you looking at *that* again?" he'd say, coming upon me transfixed.

"Button it or take it elsewhere, I'm looking at the Duke," I'd say, and he'd hightail it out of my sight. And now this hero was staring straight into my high-noon eyes and knew he was overmatched.

"I'm so sorry, Miss Love," he said, turning a few shades of red that could never be duplicated by the makeup people in his movies. "I'm going to the Dionne Warwick show tonight and. . . ."

"Well, you look for me, honey, 'cause I'll be onstage," I said, and walked off in a mock huff of indignation and giggles. I told Dionne the story, and that night she told it to the audience, though she withheld the name of the "lunkheaded major-motion-picture star." Just as she was about to reveal the culprit, John Wayne stood up and said: "It was me! I'm the ignorant bastard she's talking about." The crowd roared and then gave him a round of applause for owning up to his mistake.

The Duke came backstage that night, and we must have partied for hours. He kept saying, "I just want one more for the road" (the road being the hallway to the elevator), and then one more and one more and one more. Lord, that man could hold his liquor. Finally he left around three in the morning, maybe a little wobbly but as ruddy and backslapping as ever. You always hear—and I always saw—how movie stars are fake and nothing like their screen personas, but John Wayne—Marion Morrison—was as much like his movie self as anyone in show business I knew, mostly in all the good ways. He was loud and tough but also funny and sweet, and I'm sure glad I decided to take my tray out when I did.

Moments like that were the biggest reward of the ten years I spent with Dionne on the road. There were always the brightest constellations circling her, and I think that had to do with the respect she commanded from cabaret *and* rock-and-roll audiences, even though she really didn't belong to either. The same could not be said of Nancy Wilson or, from the other end, of Diana Ross. The crowds at Dionne's shows were thinkers *and* rockers.

Speaking of Miss Ross, I'll always remember the night she came to see our show at the Riviera. I was backstage with Dionne, Cissy, and Dee Dee, and Gladys Knight and Leslie Uggams, who were visiting. Lady Diana was opening at Caesars the next week, and she came back to see us, cooing with all the sweetness and light that the Motown charm school had taught her. She was wearing a floppy red hat that could have fit Lyndon Johnson, a chiffon dress that didn't match, and a veil! Tacky, tacky, tacky. "Girl," I wanted to say, "you picked the wrong night to come to the show." When she saw all of us lined up on

the sofas, she knew she was a sitting duck and scurried out as if she'd just seen the ghost of Christmas future (which, in a way, she had. Cissy Houston's daughter, Whitney, would become Diana's successor as crossover queen). "Just wanted you to know how fabulous the show was," she said. "Gotta run, loves."

I didn't blame her for the quick retreat. There can be few things more unnerving than facing a roomful of your peers, especially if your peers are black women. Lord, those eyes lock on you like lasers and there's no escape. I'm not sure if black women have more jealousy genes, but, Lord, I never saw anything like this in the white female performers I worked with; this went beyond the fabled female cattiness. Etta James tells a story of how Dinah Washington came to see her and Etta made the mistake of singing "Unforgettable." Dinah, even though she wasn't the first to record the song, had just had a hit with it, and almost tore the place down beam by beam. Martha Reeves tells a story in her book of a similar experience with Aretha Franklin after the Vandellas added an Aretha medley to their show. And didn't Miss Martha's hackles rise up when she heard the Blossoms would be singing "Dancing in the Street" on a TV show. It was a tribute to her, but she didn't want to hear it. Was she really afraid I would sing it better than she would? Lord, I've never had a lot of self-confidence, but I never minded when I heard that someone else was going to sing my songs (not that it happened that much, anyway). U2 did "Christmas (Baby Please Come Home)" a few years ago on *A Very Special Christmas 2*, and I felt honored. But most of the black divas I knew protected their songs even more fiercely than they protected their husbands!

And now here was Diana, fresh meat for that roomful of sharks. I must admit I admired her attitude, that she could walk

around looking like that. But I don't think she was expecting such an open field with nowhere to run for cover.

There was silence for about ten seconds after she left, a brief pause before the flood, as we all looked around to see who would crack first. And then the cackling began: "What in the world was that on her head?" "Can you believe those shoes?" "And what was she thinking about that veil?" "That jewelry was fake." "She's put on weight." Lord, we must have gone on for half an hour. We dotted every *i* and crossed every *t*, almost in six-part harmony. I was laughing so hard that my eyelashes almost fell off.

Finally Gladys put a stop to it. "Don't even talk to me about Diana Ross," she said. There had been a lot of repressed tension between Gladys and Diana when they were both at Motown. Gladys and the Pips always thought they were offered the sloppy seconds off Diana's plate. Now we were the ones treating Diana like a dog. A lot of this was just plain jealousy. Diana, thanks to Berry Gordy, was bigger than we'd ever dreamed of being, the most successful black entertainer in white America, and you had to give the girl credit. She had something. There were better voices and more exciting performers and just more creative art- ists overall, but Diana had the whole package working.

But she wore her success too well. We all knew she came from the projects in Detroit, but the farther she got from them, the more she pretended they didn't exist. We had a big feast that day. And not one of us would get up to leave, fearing that we'd be the next course. Finally we left en masse and must have clung to one another all the way outside the hotel, until we were sure the claws were drawn back in.

Looking around that room in my mind now, I realize we

had something in common besides singing: divorce. All of us, except for Cissy, had been through the breakup of at least one marriage, even the exalted Miss Ross. A happy marriage and a successful singing career seemed mutually exclusive to me then, existing in different worlds, in different keys. I had one failed marriage and another one failing. So did Gladys. Now Dionne had joined our ranks, too. Dionne never talked about Bill after the divorce. She tried to be the same old Dionne. We'd go shopping and she would buy you whatever you wanted; many times I'd find myself picking up her purse, since she was so prone to leaving it everywhere she went. And we'd talk about the Bible a lot, sometimes having to call my father when we disagreed and needed him to set us straight on a particular passage. But we never talked much about Bill. Whatever pain she was feeling from the divorce, she suffered it silently.

It didn't take her long, though, to get back on the horse, as they say, and when Dionne set her sights on something, or someone, she aimed high, this time at Mr. Shaft himself, Isaac Hayes. Isaac had gained and lost a few paradises in just the first few years of the seventies: the indelible image, of course, is of the mean black mother draped in gold links (and little else) on the Academy Awards telecast, there to sing (sort of) his sizzling theme from the ruler of all blaxploitation movies and to pick up his own gold statuette. When I heard he was joining the tour, I said to Dionne, "What's he going to do with his chains? Is he going to bring his gang on the road with him?" I didn't know that Isaac had fallen on some hard times since *Shaft*. He got caught by the same snares that have grabbed most of us at one time or another. There was bad financial management, which left him bankrupt. Around the time he joined us, he was

up to his bald pate in debt and needed the quick cash a tour could give him.

So many men have an almost Siamese connection between their manhood and their livelihood, but not Isaac. When he came out with us, for what would be called the "A Man and a Woman" tour, he dripped with machismo. He always wore a fine suit (I guess the IRS didn't take his clothes), and for a man he had incredibly soft skin, and it was so black it almost looked purple. And he had a fine body, which he showed off one day in Sydney, Australia, when he decided he wanted to water-ski, even though he'd never done it before. He actually did stand up on the water for a millisecond. And then his legs went flying in opposite directions, like one of those karate scissor kicks. He must have walked around hunched over for a week after that. That little boat ride ended up being more of a threat to his manhood than bankruptcy ever was.

Dionne was smitten right away, and it didn't matter to her that Isaac clearly didn't return the affection—or that he was very much married. She wanted that man, and got even crazier when his wife was around. I was talking to Isaac in his dressing room one night when she started pounding and carrying on at the door. Isaac wouldn't let her in.

"Aren't you going to open the door?" I said.

"I'm not opening the door," Isaac snorted.

"She's not going to like the looks of this if you don't open the door. She'll be thinking there's something going on between us."

"I don't care what she thinks."

Dionne must have banged on that door for fifteen minutes, until Isaac finally couldn't stand it anymore and let her in.

Dionne had her hands-on-hips, bad-mama pose at the ready as soon as she saw me. "So what," she growled, "the *hell* is going on here?"

Before I could leap to my own defense, Isaac stuck his bald head into the middle. "Go ask Darlene," he said.

That was the end. It was one thing to have Dionne's eyes of fury trained on me, but now Isaac was asking me to take the fall for a sin we hadn't even committed. I leapt up, and as I was brushing by Dionne, I said, "Isaac is full of shit, and if you don't believe me, then you are, too. I told you before I don't want that man." And, in fact, I *had* told Dionne, when she first let on how fine she thought Isaac was, that I couldn't be less interested.

I never let Isaac forget the day he tried to get me fired, or worse. And I never asked what happened in the dressing room after I left. Isaac stayed with the tour for almost a year, and when Dionne recorded his song "Déjà Vu" on her big comeback album, *Dionne*, in 1979, she helped Isaac take a few more steps toward solvency. And they were always lovey-dovey onstage. Every night the audience lapped it up, but I would be thinking, If only they could see what I saw. I still had the best view. In fact, I was starting to think I'd had it for a little too long.

CHAPTER 24

Home Is Where
the Heartaches Are

y the late seventies, I had been in show
business for more than twenty years, and on
the road with Dionne for almost ten of them.
During that whole time, my family was always
something that took care of itself. If I couldn't
be home, there was always Leonard, or my
parents, or Wesley, or a housekeeper, to tend to
the daily business of raising the children while
I was away making a living. It was easy enough
when the boys were younger, but now that
they were young men, life started to get more
complicated for all of us.

The first crisis actually happened to Jason,
who was only three or four years old at the
time, and, thank God, I *was* at home when it
happened. Jason, though he was active and

mostly healthy, was prone to fevers, and one day while he was playing in the living room he suddenly dropped to the floor like a sack of potatoes. His eyes rolled up all the way in back of his head. He had a raging fever, about 105 degrees. At the hospital the doctors couldn't find anything wrong, and when the fever broke, they sent him home, advising us to keep him as cool as we could. So we left the windows open, kept a minimum of clothes on him, and even let him play with cold beer cans. But the fevers came back, and once even got up to 106. Finally my father came over and laid hands on him. After that he never had another fever. Another save for the Lord.

It wasn't so easy with Marcus and Chawn, though. On paper, they had most of what two young men could hope for, privileges that a lot of teenagers, especially black teenagers, didn't have. Leonard and I always worked, and they never wanted for any material thing. They had nice homes and clothes and money in their pockets and big birthday and Christmas celebrations. Leonard was always buying them dirt bikes and stereos and such. More important than the material goods, though, was the affection they got from their extended family, and the presence of the Lord in their lives. Church was my strictest rule; even if I was five thousand miles away, those boys knew where they had to be on Sunday. After all, their granddaddy was a bishop, so there wasn't much chance of them skipping out.

But the downside was that their mother wasn't home very much, and their parents were divorced, and they had a step-father who felt threatened by them. In the late seventies there were a lot of temptations for angry adolescents with time and money on their hands, and, I'm sad to say, Marcus and Chawn fell under that sway. It was Chawn, though he was younger, who

first walked down those roads of empty promises. At thirteen he started extorting money from other kids at school, mostly to buy marijuana, which led to some harder stuff and then to armed robbery. He did his first stint in reform school when he was fifteen and even finished high school there. I knew he was capable of better. At home, if he wasn't an angel, then he certainly wasn't a problem. He changed and fed Jason ("I practically raised that kid myself," Chawn likes to say now), and he was enough of a drummer to pursue a career in music. All the teachers he had at the reform school told us how smart and well behaved he was. But the streets of L.A. were tough, and Chawn has only recently been able to shake loose their grip. I prayed and prayed for Chawn's deliverance, and more than once or twice wondered if things would have been different if I had not been on the road so much. My father's "Don't you think she should be home more?" kept echoing like an ill wind.

"I never blamed Mom," Chawn says. "She had her career and had to do what she had to do. I liked having so much time to myself."

Maybe if I had been around, Chawn's life would have turned out pretty much the same: from one scrape with the law to another, stints in reform school and then prison, a common-law relationship. All the things that a privileged background and upbringing were supposed to insulate him from. I went from yelling to pleading to finally just praying. I knew he was a good, decent human being, and I could only ask God to let his true nature take over his life. Chawn's turnaround was, not surprisingly, accompanied by his return to church. All you nonbelievers out there might say this is just a coincidence, beyond the realm

of cause and effect, and maybe you're right. Only God knows for sure.

Marcus, though he was three years older than Chawn, didn't wade through quite as much troubled water. He, too, was talented, with a little of me—a good voice—and a little of Leonard—a talent for football, which he played in his sophomore year in high school. But Marcus was a brooder, and I didn't realize until this year just how much he had suffered from my absence. Because he was older, he felt it more, and so he got moody, and there were entire years when I don't think we communicated much beyond the day-to-day banalities.

I didn't know how my father would react to his grandsons' troubles; he was now a bishop, at King's Chapel, and I'm sure it couldn't have been easy for him in public to deal with this family turmoil. But he never closed his door to them or me, and Marcus and Chawn always had a good relationship with him. And that is what proved to be their salvation. As for me, between my problems with the boys and with Wesley, my father knew that home was no haven for me. So in the late seventies he just started showing up at my door, for no reason, just to see "how his little girl was." Once he caught me smoking, which I had never done in front of him. (I gave it up not long after that, and I'm thankful now that I did, because if I had smoked much longer, I might have caused irreparable damage to my voice. Almost every great singer I know smoked, which in hindsight strikes me as lunacy, like a surgeon juggling knives in a circus act on the weekends.)

Things weren't so rosy between me and my sister, Edna. There'd always been a little rub of jealousy between us, start-

ing when we were kids and with the fact that she succeeded in winning my mother's affection in ways I never could. And even though I never minded when she tagged along on my sessions or concert dates, we couldn't help feeling the competitive urge. But this was all small potatoes. We were still good friends when the John Wayne incident happened in Tahoe. And, sadly, that turned out to be the last time in years that she and I were really close.

Our relationship unraveled over, of all things, my car. I've never been one for trophy possessions. I knew I had a nice home and nice clothes and jewelry and occasionally liked them because I knew other people would like them. But for the most part I didn't need ostentation. The only perk from my years in show business that I really truly loved was my Mercedes, which I bought in 1975. It was a 380 SL, cranberry red with a white leather interior, a wood dashboard, and wood-lined doors. It had a Blaupunkt radio whose sound was so overwhelming that you thought you were in the living room listening to it. And, best of all, I bought the car for cash, $13,000, money I had saved in my AFTRA account through all the years of doing sessions. The previous owner was a little old lady who had put only 570 miles on it. I knew this car was going to be a classic, and I wanted to keep it as long as I could.

I took care of the car scrupulously, getting the oil changed and the points and plugs checked and having it washed and polished. In fact, after I got it back from the "pros," I always got in there and cleaned it again myself, because I was never satisfied with their work. I loved this car so much that my kids joked that it was like my fourth child. I guess they were right, because it came to symbolize the achievements I'd made in my career the way those phantom Grammys and recording contracts hadn't.

You can imagine my dismay when I returned to my car one day and found that my beloved radio had been stolen. I was fully insured, of course, but even so, this was my baby and I felt for the gun in my purse, the one I had carried ever since I started doing sessions late at night. I had never fired it outside a range, but if I had come across the thieves in the act, I might not have asked questions first.

I called Edna's husband, Greg Perry, who had produced her group, Honey Cone. Greg was the kind of guy who knew someone in every business, and he told me to go ahead and get quotes from three repair shops and then to send the highest one to the insurance company, which I did. And when the check came, I turned it over to Greg, who said he would take the car and get a good deal.

I knew Greg was full of himself and a real operator; you have to be, I think, to succeed in the music business. But I figured because he was family I could trust him. I didn't know that he was scavenging anywhere he could for money to get back into the studio. The Honey Cone, after a few years of hits like "Want Ads" and "Stick-Up," had faltered and lost their recording contract. I heard later that he had borrowed money from my parents for rent and food, and that it ended up being spent in the studio, all for naught.

After a week passed and I hadn't heard from Greg, I called my sister. "What's up?" I said. "Where's the car?"

Edna told me that Greg would have the car back in a day or two, and sure enough, the next night I heard someone pulling up. When I looked out the window, I saw Greg get out of the car and start to walk down the block. I guess he thought I wouldn't be home. When I saw that the radio was replaced with

some piece of tin junk they didn't even install but taped with duct tape, I got so angry that I ran into the apartment and got my gun. I could still see that fool down the street. I pointed the gun, but before I could fire it I saw a blinding light and ended up firing into the air. Greg darted down the next street, and as angry as I was, I went back in the house, knowing that the Lord had saved him—and me.

When I calmed down, I called Edna again. "Do you know what that nigger did?" I said. "He ripped me off."

There was no remorse or concern, only resignation in her voice. "Well, you shouldn't have given him the check." Now she tells me.

I ended up paying for a new radio myself, and I didn't speak to my sister for years after that. As for the gun, it came in handy once more in my life, but not before I got down on my knees and thanked the Lord for blinding my eyes and staying my hand.

By this time I was nearing forty and Daddy was almost sixty. He was graying, and his black robes in church covered a little potbelly, but whenever he came to visit me, the experience was transporting, like an old song. For a few blissful seconds it was Saturday afternoon all over again, and Daddy was walking me down Central Avenue and he was showing off his "Dolly" to all his friends. These were moments of grace, I came to realize. Forty years later my daddy and I still had our special time together.

As it turned out, however, they were not just precious moments, but stolen ones. One Sunday in March 1980 I got a call

from Dionne Warwick's mother, telling me she had to make it to my daddy's church that day. I could sense an urgency in her voice, though there's no way she could have known what would happen. It was getting close to Easter, and Daddy said he was going to give his Easter sermon about death and resurrection. Mrs. Warrick was there when I arrived, along with Dionne's secretary, Marie. Dionne herself would have been there, too, but she was out of the country. Daddy was at his drip-dry best, sweating and spitting the Word out for the packed house. Lord, no one worked the Word the way my daddy could, even at his age. But there was something even more intense about his preaching that day. He called a number of parishioners up individually to pray for their needs and kept saying, "Who knows when I'll get to do this again, heh, heh, heh."

Chawn was in a correctional facility at the time, and visiting hours were from two to four, so after services I went up to visit him, hoping to make it back for the evening program at church. When I got home I was tired and defeated. Even though my daddy's words of renewal and resurrection were still fresh in my ears, the reality of Chawn's life was drowning them out. I called the house to find out what time evening services started, and my sister-in-law Francine answered the phone.

"Hey, it's Dolly. What time are evening services?"

It sounded as if they were having services right there at the house, with all the racket going on. "You better come back right away," she said. "Your daddy died."

"What do you mean, he died? I just saw him not three hours ago at church. Would you please put somebody else on the phone?"

"He just died," Francine said, and then hung up. I called back, clinging to the idea that I had heard wrong or that Francine had the details wrong. This time I got Warren Campbell, a young minister in my father's church. "It's true," he said. "Your daddy died."

I had been through a divorce, seen my children in jail, and suffered the various indignities that twenty years in show business can bestow upon you, but never did I feel the shooting pain I felt when I heard this news. Strangely, the swiftness, the pure unexpectedness of it, helped me to deny reality as I tried to reassemble the details. After services, Daddy said he didn't feel well, and for one of maybe five times in his life, he didn't greet parishioners in the front but instead slipped out the back. He asked my mother to drive home. My mother had had a mild heart attack a few years before, and Daddy asked her about the shooting pain in his arm, wondering if that's what a heart attack felt like. They probably should have gone straight to the hospital, but Daddy wanted to go home and, continuing to buck the routines of a lifetime, told my mother to make him some tea. (Daddy never drank tea.) All the basketball games were on, so he watched them for a while, drank his tea, got into his pajamas, and went to bed. And while he was asleep, God called Daddy for the second time in his life. The first time—when he was saved and called to preach—he had been a little reluctant and didn't answer right away. This time there was no delay.

There must have been two thousand people at his funeral, which was held at Bethel (my father's first church). People came from Texas and from my daddy's other churches in Los Angeles.

We hadn't seen some of these people for years—that's how loved he was. My mother had so many people come up to the family pew that I wondered who was leaning on whom, the family on the congregation or the congregation on the family.

I'd always said how blessed I was that very few people who were close to me had died—and that's still true—but it also gave me no back catalog of reactions or coping mechanisms. As I sat in the pew, all I could think about was how people always said how it's better if someone goes fast, because there's less suffering all around. But death is a horrible thing in fast or in slow motion, and as sad as I was, I couldn't help looking at my father's coffin and getting mad at him—for dying. "I can't believe you left us down here with all this mess," I whispered under my breath. Of course, that lip I was giving Daddy was born of my faith. I believe I'm going to see him again, so I was upset that he couldn't stay on earth with us a little longer. He was only sixty; why'd he have to go to heaven so fast?

Wesley and I were still having our problems, but he sat with me at the funeral, and when the time came for the family to move toward the coffin, I felt this arm suddenly reach around my shoulder and lead me up. There were dark days behind us and, Lord knew, ahead, but on that day Wesley was the husband I needed him to be, the pillar for me to lean on.

When we got back to the house, it didn't take long for me to miss Daddy. He was always whistling, and now there was no sweet music floating through the rooms. Whenever there was a big gathering at the house after church, we'd always pick up food from Gadbury's barbecue joint down the road, almost always on Daddy's tab. Now those sweet smells were only a memory, too.

But it wasn't morose. There were no sad songs at the service. Everyone was laughing, remembering my daddy's jokes, talking about his golf game and living the legacy of his jocularity. I know he's up there laughing at us now.

"Hey, whatch'all doing down there?"

CHAPTER 25

Better Late Than Never?

My father's death and my imminent fortieth birthday shook me out of the plush languor of background singing once and for all. Quite simply, I was running out of time. If I was ever going to have a career of my own, a name that said more than just "the most overqualified backup singer in the business," I had to make my move. Dionne was between her rejuvenated success on the charts and her stint as host of *Solid Gold*, so there was plenty of work for us to do. But while she was already enjoying her first "comeback," I was still trying to get there for the first time. What I hadn't realized was that the door had been closing, crack by crack, ever since my last hit

all the way back in 1963. Now just a sliver of light was left. I had to move toward it.

My first big problem was that I didn't know anybody in the business anymore. Or rather, nobody knew who I was. So many of the people who gave me work in the sixties had either died or retired or gone into rehab, nursing their own wounds. I couldn't exactly call up Brian Wilson now and say, "Remember when you wanted to produce me all those years ago? I'm ready now." Gamble and Huff, I'd heard, were having money problems over at Philadelphia International. Phil Spector, after the Ramones album bombed, pulled up the drawbridge again (not that I'd want to go anywhere near him, anyway). And the scariest thing was that when I turned on the radio, I didn't recognize anything. The only stations that played my songs now were oldies stations. I was officially nostalgia.

So I called the two people I knew I could always count on: Bill Medley and Lou Adler. Bill, though he hadn't had a hit in years, either, continued to tour successfully with Bobby Hatfield and ran a club in Orange County called Medley's. Though we spoke infrequently, we'd lost none of our mutual affection and respect. With Bill, just as it had been with my father, years could be crossed in minutes. "Sure, Pal," Medley said. "Anything you want."

There were all kinds of logistics that had to be taken care of, like hiring a band and selecting material, the kinds of things that had always been taken care of for me. But now I couldn't depend on somebody else to do all the legwork. I still knew a lot of L.A.'s best musicians, whom I wouldn't normally be able to afford. But I had some credit built up with them, so I knew they would play a showcase or two for me gratis. Then there was

the matter of material. I didn't think I could sing "He's a Rebel" and "(Today I Met) The Boy I'm Gonna Marry," but Bill said, in that deep, blunt way he had, "You have hits, you should do them." We added a gospel medley of standards like "Down by the Riverside" and "Oh Happy Day." But I had resolved that this would not be an oldies show, and so I had to go to school and study what was on the charts. Bill came up with "Sometimes When We Touch," a great ballad written by Barry Mann and Cynthia Weil—after all those years they could still spin gold.

But I also wanted a rock-and-roll song, a *new* rock-and-roll song, because that was my one ace in the hole. I knew I could sing rock more convincingly than any of the big-time divas of the day. Dionne, as legendary as she was, wasn't really a rock singer. Tina and Aretha dabbled in it, but their signature songs were still mostly R&B. My calling card was "He's a Rebel," and if that's not rock and roll, I don't know what is. Bruce Springsteen was hot at the time, with his album *The River,* and I'd heard that he was a big Phil Spector fan. One critic said that his music was "a '57 Chevy fueled by melted Crystals records."

Once I heard "Hungry Heart," I knew what the man was saying. It was like vintage Phil, with the echoey, multilayered tracks, the overstated hooks, and a great song lying underneath it all. I knew in a minute I had to sing that song at the showcase, because it combined the best of both musical worlds, sixties soul with eighties wisdom. The set came together pretty fast, and in the summer of 1981 I made my debut at Medley's.

I was a wreck. I knew my voice would be okay, but I didn't know if anybody would remember or care who I was. Maybe at the end of the show I would still be just a backup singer

who not only never had her real shot at a solo career but who also didn't deserve it. Bill, of course, when he didn't have me in stitches, kept smoothing over my jagged sense of self-esteem. When it was time to go on, the thrill of hearing, "Ladies and gentlemen, a legend of today and tomorrow, Darlene Love," swept me up, and I tore into the show. There were no fifteen-minute limits, no playing to half-empty seats that wouldn't be filled until the headliner arrived. I was it, baby.

I was no fool, either. I had lots of friendly faces in the audience, and they seemed to like it. Medley was wisecracking the whole time, because he was taking in their drink money, but I couldn't have asked for more support. The same was true at Lou's club, the Roxy. What I didn't know was that not only did I have buddies in the audience like Dionne Warwick and Leslie Uggams, but that there were incognitos like Bette Midler, who came dressed in something like a hairnet and a burlap sack and sunglasses, and Robert Mitchum, Steve Van Zandt, and one of his friends, Bruce Springsteen himself, who got up on his chair during "Hungry Heart" and started moving and shaking, aping James Brown and channeling Elvis. It wasn't the first time a woman had sung one of his songs—the Pointer Sisters had had a huge hit with "Fire." But this was the gospel, and, Lord, I dug into that song as deeply as "Swing Low," and he loved it. It was a society columnist's dream, but for all the high-voltage celebs, I think the audience member who got to me the most was the man who said he came to the show thinking that some girl was going to be impersonating me. This man, like so many others in the audience, had known and loved and remembered the records in the sixties and thought it was impossible that I could still be

singing twenty years later. The two nights couldn't have gone better. All I had to do now was wait for the phone to ring. A record contract was so close I could see the ink on the dotted line.

You know what? The phone never rang.

Outside those two rooms, still nobody in the music business knew me. This was the first year of MTV, and the charts and the artists-and-repertoire departments of record companies, it seems, were filled with people closer to my sons' ages than mine. Rock and roll, the music that I had been a part of almost from its creation and had nurtured and helped flourish, had seemed to pass me by. And this was before the really big diva comebacks of the later eighties, like Tina Turner and Patti LaBelle. My voice was all tuned up, but I had no place to go.

"I think by that time Darlene was stuck with the stigma of being a backup singer," Lou Adler says. "Maybe her best shot was with those Phil Spector records; that would have been the time for her to really strike out on her own. Whatever held her back then ended up holding her back for more than ten years. That would seem to have been the springboard that wasn't taken advantage of. She still had it all working [at the Roxy showcase], voice, appearance, stage presence. It would be a lot easier to figure out if she failed in one of those areas. But she was a born entertainer. Maybe church gave her that kind of education. She had the personality, she had the looks, she was clean. I don't know, maybe she just wasn't aggressive enough. She's a nice person, very nice, and maybe that was what held her back."

My brother Johnny identified this part of my personality even before I started singing. "Dolly was always ready to step aside and let somebody else shine. She never minded being the

vice president and letting somebody else be the president. That's what might have kept her from peaking in her career to the extent that she deserved."

This major new career direction was not going over well with Wesley, not that much of anything between us was going well. But as long as I was bringing in a steady income, he would always come back around. A few years earlier I was going through our drawers and found a bunch of legal papers. That child was filing for divorce and didn't have the decency to tell me. He never served me with them, though, and for a few years we went through the same dance: He'd get some action on the side, come home, and accuse me of a litany of sins, and then we'd argue and come to a truce but never a true reconciliation. We must have each moved out half a dozen times. Then I would go on the road, which he complained about only because he thought it gave him the moral upper hand, but in reality I think he really liked it that way. We were always trying one more time to salvage the marriage for Jason's sake.

But between my being home all the time and not having much of an income, we reached critical mass after only a couple of months. Of course my income situation was supposed to be only temporary. Once I had a record contract and a few hits under my belt, we'd be back to where we were when I was with Dionne, if not better. But as the months dragged on, nobody was biting, except maybe Wesley and I. We were forced to live on his salary alone, which paid the note on our house and covered the basics, but not much else. Once Wesley started missing the "lovely incidentals" that my income paid for, he went looking outside for them, more and more.

But it wasn't just his cheating. He always tired of the action

on the side sooner or later and came back. Now our relationship had taken a particularly ugly turn. He was always accusing me of something. During my years with Dionne, I had her take money out of my paycheck for a savings plan. When I had $10,000, I told Wesley, and he said, "Oh, really? And what other money have you been hiding from me?" (Dionne's reaction was, "I told you that you shouldn't have told that nigger about the money.") The worst, though, was that he had taken my family Bible and defaced it, writing "Fuck the Wright family" all over the inside cover. By then I knew it was over. It finally got through my thick head that there were more bad times than good in this marriage. I asked him to leave our house in Pasadena. He did but said that he would be back for his clothes and if I didn't let him in, he would break down the door. He came over late one night after I had changed the locks and started pounding on the door so loud, I thought we were having another earthquake. I grabbed my gun.

Wesley was carrying on like a madman, and I didn't know what he was going to do. He had never hurt Jason, who was about seven years old at the time, but he had whipped Marcus and Chawn, so I hid with Jason in the closet and shouted for him to go away. He could get his clothes when I wasn't there. But he wouldn't budge, so finally I took my gun out and started shooting, again up in the air, until I heard my son sobbing, "Mama, please don't shoot my daddy." I put my gun down that night and never picked it up again.

Of course, all this was grist for Wesley when we went to court. He wanted a piece of everything—not just the house, which we ended up having to sell, but my jewels and furs and even my Mercedes. He had a company car that the school dis-

trict provided, but he still told the judge that he needed the Mercedes to get to work. While the settlement was pending, he got it, because he was the one with the steady job. For a while Jason was all I had left.

When everything was said and done, we sold the house and split the equity in it. Dionne Warwick, bless her soul, said she would testify that she had bought me all the furs and jewels I owned, but in the end Wesley dropped his claims on them. We eventually settled on joint custody of Jason, sparing him at least some acrimony. I never put his father down in front of him after we were divorced, though I can't say that the favor was returned by Wesley.

I wasn't sad the day the divorce papers were signed. In fact, the entire ten years I was with Wesley, from that first day we met on the football field, worked in reverse. The elation I should have felt, the mad rush of infatuation and the quieter elation of love, had never been there. But neither was the profound defeat when it was over. When the judge asked if we were sure this was what we wanted, in my heart I was singing a resounding "I do."

CHAPTER 26

Kicked Upstairs

Emotionally I was ready for the divorce, but financially it couldn't have come at a worse time. I was amazed to find just how tenuous my existence was, now that I wasn't working regularly and Wesley's weekly paycheck was gone. I knew that the Lord was telling me to go for my solo career, but I didn't how hard He was going to make me work for it.

After the showcases, I made the rounds at the record companies, only to be told how much everyone loved me but that they couldn't really do anything for me. I swore I wouldn't go back to backup singing, and there wasn't that much of it around anymore, anyway. In the new electronic age, most recording artists were doing without the heavy background vocals or

else they were doing the backup themselves. When a few months passed, I decided to stop waiting for someone to contact and got on the phone myself. My bright idea was to contact Bruce Springsteen.

After months of rejection, I must have still had some self-esteem left, otherwise I never would have had the nerve. I remembered that Bruce loved my version of "Hungry Heart," and I thought that maybe he'd like to be the savior of my career. The only trouble was that I had no idea where to find him, nor did anyone else I knew in the business. So I did what any unself-respecting fan would do: I got an album, found out where he recorded, and called him at the studio in New York.

I can just imagine what the receptionist who picked up the phone was thinking when I timorously asked if Bruce Springsteen was there. "Who's calling, please?" she said with the mild disdain that comes from being a professional fan swatter.

"It's Darlene Love."

There was no recognition in her voice, only a blasé "Just a minute," as she put me on hold. I figured I'd have to wait a few minutes or so and then I'd be told he wasn't there. The phone clicked, and I was all ready to say, "Thanks for nothing," when I heard that voice that was all rough and shy. "Hey, Darlene, it's Bruce."

And that's as far as my luck went, at least with the Boss. When I finally stuttered around to the reason I called—would he be interested in producing an album for me?—he said he didn't think he'd have the time, but then he passed me on to Steve Van Zandt, who had also been at the Roxy show. "Steve," I said point-blank, "I need work."

Steve didn't flinch. He said he'd make some calls, and a few weeks later he was on the phone, telling me to come to New York, where he got me some gigs at the Peppermint Lounge and the Bottom Line.

"I remember the first time I heard her do 'Hungry Heart,' I thought it was absolutely incredible," Steve says. "You never know through the years if they're still legitimate performers until you see them live, but she was so good."

Steve had enough pull that the managers at the Peppermint Lounge and the Bottom Line hired me sight unseen, and I was off to New York, where it was just like the Roxy and Medley's all over again: great shows, applause, and "I've been your fan since way back . . . ," but no record deal. At one point Chrysalis Records showed some interest, with the proviso that Steve produce me, but he was too busy, although that's not how he remembers it. Steve says, "I think if they had offered, I would have done it." Believe me, honey, I know I'm remembering it right, because it was the only offer I had.

The New York shows were great for making connections and friends, like Allan Pepper, the owner of the Bottom Line, who would be important in my career in the years to come, and Paul Shaffer. The Peppermint was where Paul told me that he thought "(Today I Met) The Boy I'm Gonna Marry" was one of rock's all-time great vocals. I still wasn't ready to think of myself as "history," but I loved this man for saying it, and we've been great friends ever since. These shows turned out to be just a nice holiday from the reality waiting for me back in L.A.: no work and steadily mounting bills.

More than a year had passed since I stopped working for

Dionne and my final split-up with Wesley. I had enough money for about a year to pay rent on my apartment and keep enough nice clothes for auditions and performances, but my reserves weren't nearly as deep as I had thought. By the time I finished paying the lawyers for my divorce and divvying up what was left with Wesley, I was down to my last thousand dollars or so. I knew that I'd have to ask friends for help to tide me over until some steady work started coming in. The first person I turned to was my mother. She was in the house all by herself, and I figured she'd like having the company of me and Jason for a while. But the Lord just kept the surprises coming.

"You can't live here," she said.

When I got over the shock of her response, I asked why. She said that at her age she didn't want to have a screaming child around the house, even though Jason was already seven years old and I had him only on weekends. Then she said she was on a tight budget and wouldn't be able to afford the "high electric bill y'all will run up." With these excuses, it was almost as if she had been rehearsing for this moment. Maybe she didn't know how serious my situation was, but I wasn't about to go into dollars and cents with her. I was her daughter, telling her I had no place to live, and she was closing the door, to her house and her heart. Those hinges hadn't rusted after all these years. A son's a son till he takes a wife, a daughter's a daughter for the rest of her life? Hah. Not to Mama. I might as well have been trash on the street. It took me years to forgive her.

"You should have just moved in," Edna said, but that wasn't me. Even with my own mother, I was too hesitant to impose myself. All I could do was think about how this couldn't be happening. I wasn't some naïve twenty-year-old trying to scrape by

and get on my feet. I was forty years old, and had worked for almost twenty-five years. But I was nothing but a naïve forty-year-old.

After Mama turned me down, I moved in with a friend named Jamie, a travel agent I met through Dionne. Jamie was fine at first, and I promised that I'd keep Jason out of his way, but after a few weeks I felt as if we were uninvited guests. He'd come home and not even say hello or say two words through dinner. He had told me I could stay as long as I wanted, and that was our first mistake. I learned a lesson about putting a time limit on favors; when people say they're down and out, they might be with you for three weeks or three years. Because I had no deadline, I probably didn't make finding my own place a priority, and though Jamie never told me I had to go, after a month or so he started getting snappy and condescending. The scarier part, though, was when he'd bring his tricks home in the middle of the night. I'd be on the couch when they'd stumble in, carrying on and usually drunk. These were the last days of Pompeii, before AIDS ravaged the gay population and when drugs and free sex were considered everyone's right. But even before AIDS I knew Jamie was playing with fire and I didn't want to be caught in the house when the blaze started. The next morning I told Jamie I was leaving; half of my things were in my car, anyway, and I stuffed it all into my brother Alan's place, where I ended up staying for a while. He had only a studio, but I had no other place to go.

As my funds dwindled, I started taking work anywhere I could. My friend Bea had a dry cleaners and offered to give me part-time work with a guarantee that I could take time off if an audition came along. Another friend told me of a pawnshop on

the corner of Hollywood and Vine where I could hock my jewels. It wouldn't sell them as long as I paid the interest, which was something like $15 a week. I took in the pearl necklace Leonard had given me, and the jeweler looked at me suspiciously, as if to say, "Who hocks a necklace like this? Where did you steal it?" But he took it, along with two diamond rings and a bracelet Dionne had given me. I got almost a thousand dollars. My friends all told me to sell the car, but I was steadfast. It was the last reminder of the life I had once lived, of the performer I once was and, I believed, would be again. Besides, it was paid for, and I needed a car to get around. I vowed that I'd clean houses before I'd give up the car, and, well, you know the rest. I was kicked upstairs—as the upstairs maid, that is.

I don't know what was more painful, hearing my songs on that car radio on my way home with my hands still smelling of disinfectant or two other collisions with my past. When I was working at the dry cleaners, Fanita came in with her beaded gowns, and I had just finished changing the solvent in one of the machines. I'm sure I look smudged and rumpled, but I was so happy to see Fanita, whom I hadn't really been in touch with.

"Hey, Neet," I said.

As usual, she was all sweetness and light, pretending to be supportive and friendly. I'd learned not to invest too much in Fanita's smiles. They were sure to break you sooner or later. She finally got around to asking me why I was working at Bea's cleaners. It was one of those moments when the need for God is so intense, it's more powerful than hunger. And, as usual, He filled me up just when I needed it. "What can I say, Neet? I needed the job, Jason and I gotta eat. As long as it's legal, there's no sin in it."

She wished me well, turned her proud self around in a hurry, and stuck her nose up in the air. She must have thought that if she looked upon my misfortune any longer, some of it might rub off on her. I found out later that she was on the phone to Gloria in a hot minute, telling her how pitiful I looked. I tried to find some good—or at least neutral—intentions in her cruelty, but my own worst suspicions were confirmed a few weeks later, when my car broke down on the road and I had to walk several blocks to a garage. I looked up and there was Fanita driving by. She didn't bother to stop. She just slowed down long enough for me to catch the "Serves you right, bitch" that flashed across her face. As she did with the incident at the cleaners, she denied this ever happened, but again, I know it did, because Gloria asked me about it later, which meant Fanita must have told her it happened. Was Fanita still holding a grudge over my leaving the Blossoms, or did it go back even further than that, to my joining the Blossoms and denying her the glory she thought she deserved? Whatever it was, it had hardened in her soul, and as I trudged along I felt another part of my treasured past, my friendship with Fanita and all the wonderful things we had shared, swallowed up by the blighted landscape of the present.

I had Jason on the weekends, but we barely had time to say hello before Wesley was taking him back on Sunday. I think if any one of those situations had been different—if I had been able to get some singing work, or if I'd had the time I needed with my son, or if I'd had my own place to live—I might have been able to go on. But now it seemed God was absent from all the sectors of my life.

My first inclination was to retreat, to look for salvation in the past. I called Dionne Warwick. We had been out of touch

for several months, and I wasn't exactly advertising my station in life at the time. Dionne was shocked to hear how far I had fallen and how fast. "I can't hire you back," she said. "I've already hired another girl. But I'll send you something."

I felt like a beggar, and Dionne's response, to me, was like the typical "I'll send a donation and be done with it." But, Lord, was I surprised to find $5,000 delivered by messenger a few days later. It was the first small column of light I had seen since before my father had died.

I got my own place, a pretty little loft in Culver City, across from MGM Studios. I kept doing day work and the occasional sessions, if I could get them. Thank God for Luther Vandross, that girl-group historian and then about the hottest R&B singer in the business. He was producing Aretha Franklin's *Jump to It*, and he called me and Cissy Houston to work on a track. Lord, there we all were again, where we belonged, in the studio. Luther was a great comfort in those days. He made me feel that maybe it wasn't all over for me yet. Luther recently said about that session, "Darlene was a real team player. She didn't mind giving a healthy amount of credit to another diva, and she was blown away by what Cissy was doing on that track. A lot of insecure singers might allow something impressive that another singer has done to go unnoticed. Not Darlene. She just kept saying, 'Oooh, just wait till Miss Cissy comes in here. We all have to move back from the microphone.' Darlene was always so lively, sometimes so much that she got on my nerves."

Luther told me to keep following my dream. The brick walls I was hitting, he told me, had nothing to do with me. He said, "You can sing any style of music. It's just that the dots haven't been connected through no fault of your own. It's all based on

an intangible combination of crosswinds. Look at all the people who can't sing for shit and sell millions. It's unfortunate, but it happens."

After this session, one of the few that I did in those days, I vowed to myself that by the time I saw the end of that $5,000 Dionne had sent me, I would be singing full time again. But, Lord, getting my career afloat turned out to be, literally, just that.

CHAPTER 27

All Aboard

*I*t was time to be creative. None of the usual avenues for work—record company showcases, auditions, demo tapes, called-in favors—were working, so one night I sat with a friend named Marian, another travel agent I had met through Jamie, and we tried to dream up ways I could get a singing job. She had just come back from a cruise and off the cuff said, "You know, the entertainment on those ships is terrible." Lightbulbs all over the room. In a minute we were combing the Yellow Pages for every cruise line out of Los Angeles.

It wasn't exactly the same thing as calling Bruce Springsteen and asking for work, but ever since I'd stared at my own reflection in a toilet bowl and in Fanita's angry eyes that day on the

road, I wasn't thinking about my pride. Marian actually had an album of music from her last cruise, a lot of "One Note Samba" stuff (barely one note), and there was a number on the back for the operations department. Turns out they didn't book the entertainment, but the waiters and maids and such. I wasn't looking for that kind of work and got ready to hang up, but the man, George Suarez, had actually heard of me—or at least the person I was claiming to be. He wanted me to come down just to see if it really *was* me. Even when I showed him my pictures and bio and sang a few notes for him, he shook his head as if he were hallucinating. But finally he convinced himself he wasn't seeing things, and he said he would call the vice president of the cruise line, a Mr. Zonis, to see if he could arrange an audition. This man was probably used to hearing all manner of one-man bands pass through his office, so I wasn't nervous. If anything, I was worried about being too good.

I sent Mr. Zonis a video, and he offered me a job over the phone, but not before asking me that same question I'd been asked at the Roxy, a question I would hear time and again over the next decade: "Are you the real Darlene Love?" Finally my mystery singer status was paying off a little. I was an invisible legend, and it was adding now to my marquee appeal. When we got around to talking about money, he said, "Well, we usually pay the disc jockey $125 a week." $125 a week! I hadn't made that little money since I started in this business more than twenty years before. I would rather have gone back to cleaning bathrooms.

"Okay," he said, "maybe I could pay $500 a week. Just one question: You are Darlene Love. Why on earth do you want to sing on a cruise ship?"

"No disrespect intended, but that's easy for you to say. If you can find me a singing job on land, honey, you're some kind of miracle worker."

Within a few weeks I was on board, headed for the Mexican Riviera, San Lucas, and the Cayman Islands. I took one last look at L.A. behind me. Lord, I thought, if I get seasick or lonely, it's gonna be a long swim home. I certainly can't drink all this water. But I didn't linger there long. Los Angeles was no longer the city of my childhood, my early recording success, or the birthplace of my children. Now it was the place where my father had died, where my two oldest children were in and out of trouble with the law, and where my career was in tatters. I had to get away and find my voice again.

The ship, to my great surprise, had its own orchestra, so all I had to do was bring my charts and we were cooking. The passengers all seemed a little shocked themselves that the floor show wasn't just the usual lounge lizard with the schmaltzy electric keyboard. I was a hit, all on my own, somewhere in the Pacific.

The hard part was all the down time I had. I missed Jason, who was eight years old. Would my absences have the same effect on him as they had on his brothers?

My loneliness was tempered a bit by the crew members, who were all very friendly and appreciative of my talent. I found myself spending a lot of time with the chief steward, a man named Alva. The last thing I was looking for on this cruise was a love affair—but I was lonely, and he was sweet and had a beautiful cabin, where I started spending more and more time. My own room was like a cubbyhole with a water spout; Alva had a

beautiful tub, which became my refuge, and within a few weeks I think there was more of my stuff in the bathroom than his. Always hovering somewhere near was a quiet, shy man named Alton, who was Alva's assistant.

Alva and I ended up having a "don't ask, don't tell" affair. I didn't want to know about his life and kept the deepest parts of my life separate from him. This seemed to suit him just fine because he did the same, and as a result almost got me in big trouble. We docked in San Francisco, and he got off to find a big surprise waiting for him, and an even bigger one for me: his wife, who had flown in with Mr. Zonis. And she was coming on board!

I was the last to know again. Alva didn't wear a wedding band, and never said anything about his wife, but it just goes to show you how you can't hide from misfortune, even way out on the high seas. Some of my friends tried to get a message to me, but I was off the ship for the day, and came back and headed for the room as I normally would. Before anyone could stop me, I walked in and saw the whole commotion going on; I had to think fast. "Can I borrow the keys to the gym?" I said, and ran out of there. Luckily somebody had gotten all my stuff—a robe, my toiletries, a picture of me that Alva had—out and into Alton's room.

After his wife—who I heard suspected there was something going on—left, Alva kept trying to come on to me, bringing me coffee in the morning and saying he wanted to talk to me. But I was having none of it. I could have killed that little man. What was he trying to do, get *me* killed? I wasn't interested in being the other woman, and besides, I didn't like him that much, anyway. There would be other tubs.

As angry as I was with Alva, my two-week stand with him did have a payoff, in that I got to be great friends with Alton. He was a dark Jamaican man, with a kind of stealth kindness about him. Suddenly I'd look away for a second and my bag would be in my room, or he'd be opening a door for me or escorting me from deck to deck. But all he would say in those first weeks was that he couldn't "believe that I was the lady who made those records," which he had heard and loved back home in Jamaica. His father owned a bar there, and "He's a Rebel" was on the jukebox. Alton told me how impressed he was that a black woman was out making a living by herself on the cruise ships. I had made an even stronger impression on Alton though I didn't know it right away.

"I had just gone through a difficult breakup," Alton says, "and was having a hard time with my commitment to my faith, and then one night I sat down and listened to this gospel song Darlene was singing on the ship, and it was like finding my way back to the Lord. Besides, Darlene was the only one to tell Mr. Zonis she wouldn't do any staff work: you know, greeting passengers, setting up bingo cards, that kind of thing. Everybody did staff work, even Mr. Zonis. But not Darlene. I think I respected her for having the nerve to tell the director of the cruise line himself."

At first I wasn't attracted to Alton, at least not until after we had become the best of friends and had come to depend on each other's companionship. Alton worked nights as I did, and so we spent our days just walking on deck and talking for hours about nothing in particular. I told him all about Leonard and Bill and Wesley, trusting him with a lifetime of secrets and

hidden feelings. I felt I had nothing to lose when I was talking to Alton, because I knew he would protect and preserve them. When I was off the ship I wrote to him, and when I didn't hear from him after the third letter, I told him that if he didn't write back I would take that as a sign that he wasn't interested.

But Alton responded then. It was only his shyness that had been holding him back, plus one or two girlfriends he had hidden away down the Pacific Coast. His shyness was actually what got me, I think. Even after we had spent days and days together, he came out and said, "Do you like me?" with that heartbreaking schoolboy's reticence at the prospect of his first kiss. And with Alton I learned a lesson about a deeper love, or brushed up on it. For the first time since Bill, I was with a man who respected me as an equal and who depended on me as much as I depended on him, not just for sex (which came much later), but for laughter and the language that is mostly incomprehensible outside of that population of two. One of my fondest memories is of a leave Alton had from the ship and how we both got so drunk—on three bottles of wine, but mostly on each other—that we fell asleep and woke up half an hour before his ship was leaving. The dock was twenty minutes away in Long Beach, and by the time we got there, the ship had pulled up anchor and was moving out toward the sea. Alton had to jump, and thank God, he made it without breaking any bones. Lord, I was thinking amid the guffaws I couldn't stifle, that man must really love me.

Alton was my first miracle in a long time, and I knew that things were going to turn around from there. I also got a raise from the paltry $500 a week the line was paying.

But the troubles of recent years reared their ugly head one more time while I was on board, in Juneau, Alaska: a message came from the captain that I had to get back to Los Angeles as soon as I could. Marcus had been shot and was near death.

Alton, the captain, and even Alva did everything they could to comfort me, making all my travel arrangements and packing for me. "Call when you can," Alton said as I got off in Juneau, and I hated to leave him. Marcus needed me, I knew, but I wondered if I needed Alton more.

I got to the hospital and found Marcus still unconscious, with tubes and wires stuck all over his body. I'd never felt more powerless in my life. Here was my child, lying there somewhere between life and death, and I couldn't do a thing to help him.

Lord, please, I begged, don't take another child from me. In times like these I knew I could always depend on my father for a direct line to God, but now he was gone and I found myself praying to him, too. I must have had a good connection, because after a few harrowing days, a miracle occurred and Marcus lived.

Marcus had been shot because he had refused to give over his watch. "I didn't think the guy had a gun," he said when he recovered. "And I said, 'C'mon, you have no weapon and you're trying to rob me?'"

But there was a weapon. Lord, to think I almost lost my son over a stupid watch. If I ever had any doubts about putting my own gun down for good, they were banished that day.

As soon as he was out of the woods, and safe in the care of his father and stepmother, I hurried to get back on board and to Alton. I was still prone to doubts, but during one cruise we were separated—Mr. Zonis sent me to Miami to work an

Eastern Seaboard cruise—and I was sick without him. I called Mr. Zonis and told him I had to get back to a ship with Alton. He was the stability and the joy in my life now. The career would work itself out, or not. For the third (and, so far, last) time in my life, I was in love.

CHAPTER 28

The Big Thaw

*I*t had been a long time between miracles, and now, all of a sudden, there was Alton, and a healed Marcus. Except for getting on my knees hourly in praise, I could have left the Lord alone for years after that. But He still had one more to send my way, and it was waiting for me on a crowded, sweaty tabletop stage in New York.

One day in the fall of 1983, when we were at sea, I got a call from Allan Pepper, co-founder and owner of the Bottom Line. Allan had that coffeehouse look: messy silver hair, open-collared shirt, rumpled jeans, and sneakers, like a raggedy beat poet only slightly combed out by a wife and kids and a house in New Jersey. And the Bottom Line, where I had

played some gigs a couple of years before, was right in the heart of Greenwich Village, the hub of folk music in the early sixties, the musical birthplace of Bob Dylan. Allan was always a kindred spirit with those guitar slingers, and the bookings at the club were often neo-folkies and pop poets. But Allan also had a sweet tooth for another kind of New York music: girl-group pop and soul, and in 1983 he and a writer named Melanie Mintz came up with the idea to stage a musical revue based on the songs of Ellie Greenwich, one-half of one of the big three Brill Building songwriting teams in the early and mid-sixties, and the woman who had put so many words and notes in my mouth.

Allan was a shrewd businessman (he was also one of the cheapest men I knew; more on that later) and he felt that baby boomers, who now had deep pockets, were becoming disenchanted and suspicious of the new music on the radio, which at the time was Brit pop like Culture Club and Human League. Sure, there was also Michael Jackson and Prince and the Police, but more and more boomers were tilting their ears backward. I think the music from *The Big Chill*—a dozen or so Motown and soul classics—was as responsible for the movie's success as anything that happened on the screen.

Allan wanted me to sing many of the hits that Ellie had written, my own and a few others, and I would even have a few lines of dialogue, playing . . . myself. I don't think I've taken less time to make a decision.

The show was set to run for only a weekend, and the first rehearsals were held in Ellie's apartment near Lincoln Center. As glad as I was to be in this show, I approached her carefully, and I think she did the same with me. We were still basically strangers. She wrote the songs in New York and Phil Spector recorded

them in Los Angeles, and if we met at all, it was only briefly. I knew more about how those records were put together than she did. So now we were circling each other like the birth mother and the adoptive mother of this music, which was all grown up and thriving, it seemed, independently of both of us.

Our appreciation and mutual respect was cut by a squirt or two of jealousy, because Ellie had always wanted to succeed as a performer. But unlike Carole King, she was never able to make the transition from songwriter to singer. The seventies had been a lost decade for her. She wasn't even able to write much of anything new that had an impact, unlike, say, Barry Mann and Cynthia Weil, who never had trouble finding artists or a market for their songs. After a couple of failed albums, she had her own breakdown, and there were years when she didn't even leave her apartment.

And my jealousy of her could start with that apartment. Even after years of not working, she still had the grand piano and the antique furniture and the great view and more square footage than some of the houses I'd lived in had. I was still scraping by, paycheck to paycheck, doing "rent" gigs. That's one of the inherent injustices of the music business: the songwriters get paid every time a song is played on the radio; the artists don't. When "Da Doo Ron Ron" hit No. 1 again in the seventies, in a remake by Shaun Cassidy, it probably gave Ellie enough income for a few penthouse apartments and probably a few more breakdowns. The eighties had been a little kinder. Nona Hendryx recorded one of Ellie's new songs, "Keep It Confidential," and Ellie was also working with the ascendant Cyndi Lauper.

But we were both so excited about doing the show that we

could put away all the should-have-beens and I-got-robbeds. That first day at her apartment, she was the effusive Jewish mother, plying us all with food and praise.

"I was in the kitchen holding a tray of drinks when I heard Darlene singing," Ellie says, "and I thought, Oh, my God, that voice, is it really possible she can still sing like that? I almost dropped the tray."

For me, the thrill came in meeting so many great young singers who would end up being some of my closest friends: Karla DeVito, who did Ronnie Spector almost better than Ronnie Spector did, and Ula Hedwig, formerly one of Bette Midler's Harlettes and a singer with more soul than any of the nouveaux divas on the radio then. And I wasn't just "the legend," there for the credibility my name would lend. I was a contemporary, and sitting in that circle around Ellie's piano, I realized that God had pulled another fast one on me.

Just when I was beginning to give up on the idea of ever making more of my career than singing on cruise ships and playing "rent" gigs, He had sent me *Leader of the Pack.* And even if I hadn't been a major player in the music business in almost twenty years, he gave me a voice that had mostly been immune to the passing of time, and an appearance, that was, well, aging slowly. If I didn't look quite the way I did in 1962, then I certainly didn't look like a grandmother, either.

By the time we moved to the Bottom Line, it barely felt like work. I met a lot of the musicians whom I still work with today, incredible talents like Jimmy Vivino and Leo Adamian, whose love for these songs shone through every note. The music was loosely woven around Ellie's life story, her growing up in Levittown, Long Island, learning to write songs, breaking into the

music business as a young college graduate. Perhaps the most brilliant stroke of casting, beyond the songs themselves, was Paul Shaffer, David Letterman's gnomish bandleader, as Phil Spector. Paul nailed him, with his cape and his snickering whine. We all got the joke. In one sense, it was almost like, Let's get all our friends together and put on a show in the barn, except the barn was a smoky boîte in Greenwich Village, where we couldn't help but trip over all the good feelings spilling over that fabulously cramped stage.

The real stars, of course, were the songs themselves; they were nostalgia for a lot of people, true, but on another level it was as if they all had a transfusion, the fresh blood flowing straight from the hearts of all these fabulous young singers. As for me, here I was in my forties singing "Wait Til My Bobby Gets Home." Somehow it made more sense now than it did twenty years before. Even Ellie seemed to be getting reacquainted with her own work. She sat in a corner during the rehearsals, puffing away on a cigarette and singing along. The writer of the show, Melanie Mintz, caught her one day sitting in the shadows and belting out "Look of Love." Melanie had been trying to get Ellie to be in the show, but Ellie recoiled every time. But you know how it goes; "Methinks she doth protest too much. . . ." Everyone in the room knew, even if Ellie didn't admit it, that she wanted to be onstage with the rest of us. But the fibers of her recently restitched ego were still a little thin and tenuous; it was only after constant cajoling and nurturing from Melanie that Ellie finally agreed to be in the show.

I have to admit that this bothered me at first. Ellie was a good singer, but she was already the star of the show, in the

sense that it was a celebration of her life and work. Why did she need to be onstage, too? Wasn't it enough that she got paid all those years for the songs? Why did she need to steal from the real performers' time to shine? But I got over that fast. Melanie wrote her into the second act, when the up-to-date Ellie suddenly emerged from the audience and took the story into the present. The show became such a runaway train of joyful noise that no one had room to wallow in negativity very long. And aside from attaching my name and face to a lot of these classics, it even redressed an old wound: the walloping finale would be "River Deep-Mountain High," and I finally got my chance to sing it.

The first weekend was set for late in 1983, and it sold out instantly. Seven of us sang all the leads and backgrounds for about thirty songs, and from the opening thunder cracks of "Be My Baby" to the final tsunami of "River Deep," we were a smash! After the last performance, we were all exhausted, and Allan Pepper came and begged us to do one more show. He had paid us only $800 each for the entire weekend; this was less money than I had made on the Chitlin Circuit. All I could remember when Allan was putting on his best sad-sack face was that he had sent me a bill for tea and cheesecake I'd had in my dressing room! The others waffled, but I straight out said forget it and went back to the cruise ship. It was fun, but I wasn't interested in slave labor.

Besides, as great as *Leader of the Pack* was, it was only pretty background music compared with the symphony Alton and I were writing. We had talked about getting married, but he was having trouble getting off the ship. Somebody had to sign him

off, and because he was so good at his job, no one was willing to do it. He kept saying, the next port, the next port, but then he'd call and say they'd essentially shanghaied him for another tour.

Eventually Allan booked *Leader of the Pack* for a month in early 1984, and I decided then that the new start I'd been praying for was waiting for me in New York, and that I would move there for good. Jason was the only reason for me to look back, and if he had been younger, I might not have gone. But he was almost ten years old, and in school, and I knew I'd have him in the summer. He was about the only sacrifice, though, I'd have to make. This time, coming to New York, which had been so forbidding when I first visited, in the early sixties, was now almost like going home, home to the songs that were mine. The only downside was that Alton *still* had trouble getting there. It was almost like God's final test of our love, but the more I had to wait, the more I missed him.

Allan Pepper let me stay at his house in New Jersey, and I got to be great friends with him and his wife and kids. He might have been cheap, but he was always honest, and I never felt as if he was trying to cheat me. When I agreed to come back for *Leader of the Pack,* I told him I wouldn't do it for less than $1,000 a week, which was still a ridiculously low amount of money for seven or eight shows a week. He still laid the "you're taking food out of my children's mouths" line on me, and we both had a good laugh.

The show had two separate monthlong runs and got fabulous reviews. *The New York Times* said, "In its performances and in songs that capture the essence of teenage joy and longing, it's a powerhouse." We had a wonderful choreographer named Ed Love, who made sure the dances were authentically sixties,

without being too cheesy. And the songs were absolutely true to the originals. The show was recorded for a soundtrack, and there was even talk of a move to Broadway.

Alton finally got off the ship in April 1984 and we moved into an apartment on Twenty-seventh Street, one of those railroad flats that cost about $700 a month. Alton got a job at Tower Records in the reggae department; or, should I say, he created the reggae department at Tower, because before he got there, nobody knew a thing about the music. Finally in June we got around to getting married. This would be my last chance at a church wedding, and one more time it was not to be. I didn't yet belong to a church in New York, and even if I had, it wouldn't have been easy—this was my third time around. We got married at the mayor's office in Teaneck, New Jersey, with a little help from the mailman.

It turned out the judge wouldn't perform the ceremony until he saw my divorce papers. I hadn't even thought to bring them with me from California, so I had to have Gloria Jones send them. The day of the wedding, we kept looking for the Federal Express truck, because that's what Gloria told us she had used. A few times a truck would turn the corner and we'd practically throw ourselves down in front of it. But Gloria had sent them by Express Mail, and they came with the regular mail delivery, very late in the day, and in just enough time for us to go to City Hall and get married. Allan Pepper's kids sang "Chapel of Love." Lord, nothing is easy, even the happiest days of your life.

The next hurdle was getting Alton's green card. We went down to the immigration office, where we were herded into separate rooms and subjected to all manner of personal questions: Which side of the bed do you sleep on, which is the house key,

and so on. Then they asked us what we had done last weekend, last Fourth of July, last Christmas. We couldn't really remember, so when they finished, the smart-mouthed young woman leading the "investigation" declared the marriage a fraud and said she could charge me with perjury. I took one look at her and said at the top of my lungs, "You go ahead and charge me with perjury, and I'll sue your butt and everybody else's here."

I think that was all the testimony she needed to hear. They took me and Alton back into the separate rooms and asked some more questions, about our laundry habits! We did our laundry together, at a coin-op around the corner from our apartment, though Alton was very particular about washing his own underwear. When we both said this independently, they were convinced the marriage was real. I always tell everyone that Alton got his green card because of his drawers!

After the Bottom Line version of *Leader of the Pack* wound down, Allan, Melanie, and Ellie began negotiating to take it to Broadway. That's where all the trouble started. In fact, even before we closed at the Bottom Line, I could see the clouds gathering. I looked out into the audience one night and saw Michael Peters, the Broadway choreographer, and said to Ula, "Uh-oh, something's up, Michael Peters is checking us out." I couldn't understand why another choreographer was interested in this show; we already had great dances. From the get-go, Allan and Melanie were fighting with backers, who wanted to make the show something it wasn't—a standard Broadway musical. This would have meant cutting songs into medleys, adding Vegas-like dances, and putting a story in the second act. I was caught in the middle of all this, and suddenly Allan Pepper wasn't returning my calls. I didn't know whom to trust.

Little did we know that when Ellie became a performer in the Bottom Line show, we were creating a monster. Now the Broadway producers were wooing her, making her out to be the star of the show and trying to get her to do things their way. It wasn't long before Allan and Melanie were bought out, Michael Peters was in as director, and the show was subtitled *The Ellie Greenwich Musical.* I was wooed into the show by promises that my part would be preserved and even beefed up, and that my name would be "above the marquee," Broadway talk for shared top billing. It wasn't the first promise that would be broken.

I knew the show was doomed from the first pronouncement that came from Michael Peters's lips: We all had to audition again. I couldn't believe the stupidity of it. We had a smash at the Bottom Line with really great talent. But Michael Peters said this was *his* show, and when the smoke cleared, only Annie Golden, Pattie Darcy, and I made the cut; Peter Neptune, who was fabulous as Ellie's ex-husband, Jeff Barry, at the Bottom Line, was relegated to the chorus. And Ula, wonderful Ula, was turned away. Peters said he didn't want anyone "ugly" on the stage. Ula may not have been your standard beauty queen, but she is a striking woman with very pronounced features and has a terrific stage presence. And a real voice. Apparently, that didn't matter.

Peters announced he was hiring "real actors" to play the young Jeff and Ellie. And then who came along? Patrick Cassidy and Dinah Manoff. Not exactly superstars in my book. At least Patrick could sing; Dinah had to go out and take voice lessons. And it just went downhill from there. The dances were ridiculous; they looked nothing like the sixties, but like some manic eighties video. (Peters's claim to fame at the time was that

he had directed Michael Jackson's "Beat It" video.) The sound system was terrible. And the songs, those incredible songs, were cut and pasted together like some musical scrapbook, or rather, scrap heap. The whole point of the show as it was originally conceived by Melanie and Allan was to preserve the integrity of the songs as they sounded on records. Now it was all just a big loud mess. Unbelievable how something so good could be turned into something so bad.

Every time I tried to open my mouth they told me, essentially, to speak when spoken to, or rather, to sing when spoken to. They were the Broadway pros, they said, they knew what they were doing. Then my part kept getting smaller, and my name was lost in the jumble under the title of the show on the marquee. They kept trying to keep me out of interviews and press for the show; they all went to Ellie. Finally my manager, Kenny Laguna, pulled me out of rehearsals. I had known Kenny for years, since he played in bubblegum bands in the late sixties. In fact, one of his bands was responsible for getting the Blossoms dropped from a gig, because they were supposed to play for us and couldn't read our charts!

Now Kenny was a medium-time producer and manager whose greatest success was with Joan Jett. I had signed on with him to take some of the stress off me. "I was only too happy to bring Darlene into the family," Kenny says. "Since I was fifteen I had been hearing about this goddess of rock and roll." As for *Leader of the Pack*, Kenny believed that they were playing divide and conquer. "Darlene was stealing the show, but Ellie was taking the biggest cut," Kenny says. "And they beat up Bob Crewe, too, who was producing the cast album. It wasn't the right kind of record for those songs."

The eight producers of the show tried to work around me, and Bob Krasnow of Elektra Records, which was releasing the cast album, told Ellie to just go ahead and find someone else. But guess what? They couldn't. After Ellie, I was the last link to any authenticity this show had, and all of a sudden Ellie was calling me herself. But her tone was not very conciliatory or friendly; it was more like "This is a bad career move for you, Darlene. Out of sight, out of mind. If you don't do the show, your career could grind to a halt."

"So it might, Ellie," I said. "But, tell me, who are you more concerned with, me, or you, or the show?"

In the end I went back, grinning and bearing it. Ellie's words about being out of sight, out of mind stayed with me, so I put aside my differences for my own sake. I hadn't quite put my stamp on New York yet, and I wanted people to know I wasn't dead. But it wasn't for Ellie or for the show; it really was for me. And that might have come from some overdue self-recognition that no one was going to watch out for me. I had to do it myself.

Even after I went back, the insulting behavior continued. There was an appearance on the Phil Donahue show for which I was told only my singing was needed.

"What's the matter, can't I talk?" I asked Ellie.

"Well, I fought for you, but I lost," she said.

That was Ellie, always standing up for you and losing, while keeping enough of the spotlight for herself. I wasn't even invited to a *Today* show appearance, until the producers of the show said they weren't interested in the spot unless I was in it. Annie Golden had the best line. She and I shared a dressing room one floor up from the "stars," Patrick and Ellie and Dinah, and

one night right before we opened she said, "Now I understand a little better what black people go through."

We all got a laugh when the reviews came out, because we could have written them ourselves. *The New York Times* was among the more brutal and accurate: "This show does lead the pack in such key areas as incoherence (total), vulgarity (boundless), and decibel level (stratospheric, with piercing electronic feedback)," and then later, "One can only wonder at the ingenuity and strenuous effort required to stamp the life out of nearly all" the songs. I got some nice notices—the good reviews within the bad reviews, as it were. But poor Ellie took the brunt of it, as almost every critic put down her appearance in the show. At the Bottom Line, the downtown crowd along with a contingent of Ellie Greenwich fans had validated her appearance onstage. But the uptown theatergoers had no idea who she was (imagine some of the blue-haired matinee ladies looking in the program and saying, "Is 'Da Doo Ron Ron' some kind of a disease?"), and many of them walked out at intermission.

Amazingly, *Leader of the Pack* did get a Tony nomination as best musical, mostly because only one other musical opened that season, *Big River*, and there must be at least two nominees for the category to be viable. We were all set to do "River Deep–Mountain High" on the broadcast, but then at the last minute they decided on one of those wretched medleys. Apparently the bad reviews did nothing to cloud the bad judgment.

The show opened in April 1985 and closed before the end of the summer. Ellie and I have been estranged almost ever since. She recently said that she had no idea that I had suffered as much as I did. I wonder what she thought I was doing those

two weeks I was out of the show. Going on vacation? "I was as much of a victim as anyone else," she says. "I had no idea what I was doing. How do you think I liked saying no to all the friends who wanted to be in the show?"

I can't really be angry at Ellie anymore, because I know she paid dearly for her moment in the sun, as it turned out. The real tragedy was what might have been, if the show had been left alone, or left at the Bottom Line (where it would probably still be running). A decade later, *Smokey Joe's Cafe*, essentially one long concert of the songs of Jerry Leiber and Mike Stoller, was a smash. That's what *Leader of the Pack* could have been.

Ellie and I still don't talk very often, and we see each other only on the rarest of industry occasions. Alton has her pegged the best: "You could ask for no finer friend. Just don't go into business with her."

Ellie's feelings are just as complicated. "Oh, Darlene, I love her," she says. "I could rip her eyes out." I once felt the same about her, but now I can be philosophical about *Leader of the Pack* and the good things it brought me. It made me move to New York, where people discovered me all over again. And the show ran long enough to bring two very special people into my life, one old friend and one very important new one.

I hadn't seen Cher for more than ten years, not since the days when she was still married to Sonny, and everybody knew how many skins she had shed since then. Now she was an Oscar-nominated actress, but when she came to see the show, she still seemed like the same tough, giggly, beautiful teenager she had

been back in 1963. Nothing had changed between us; it was as if we were in the studio again with Phil, waiting for a break to get a burger from Brother Julius.

"It was almost like we had seen each other yesterday," Cher says. "We talked about Phil and what an idiot Sonny was, not really being mean, just talking the way we always talked. We became friends when we were both really young, and in show business you get used to making friendships, then being able to pick them up three or five years later in the same place. It's rare in life, but not in our business. And our friendship has not changed one iota in thirty-five years."

Cher and I saw each other more often after that. In the late eighties she revived her recording career and took me out on the road with her—as a backup singer! Everything had come full circle. She got her start singing backup for me, and now here I was singing behind her, and happy to do it. "It just goes to show you how strange show business is," Cher says. "I'm always thrilled to have her on the show with me, and happy to throw her a solo. I always sounded so much better when Darlene was around." Well, I may make her comfortable, but after thirty years of having hits, she doesn't need anyone to make her sound better. Her last album, *It's a Man's World*, released in 1996, may have been the best of her career. The material was very strong, but beyond that I'd never heard her sounding so relaxed.

I also made an important new friend during *Leader of the Pack* named Glenn Daniels, a Hollywood casting director and, as it turned out, a big fan of mine. He came backstage and told me he was working with the director Richard Donner, who was busy in preproduction for a "buddy" movie starring Mel Gibson, a new Hollywood heartthrob, and Danny Glover, one

of the great black actors of this generation. He wanted me to read for a small part in the movie, to be called *Lethal Weapon*. There were a few things I'd rather do, like have another No. 1 record, win a Grammy, win Lotto, but reading for a role opposite Danny Glover wasn't very far behind.

But the paint was still wet on the latest broken promises of my career, so I steadied myself, took the man's card, and tried to rein in my enthusiasm and my hopes. Movie deals fall through all the time. Maybe I wouldn't even get the part. Maybe I'd end up on the cutting-room floor, as I had with my "big scene" with Elvis in *Change of Habit*. I held on to that for about as long as it took for me to get from my dressing room to the street. I looked back at that marquee and, for the first time, wanted to shout praise to the Lord for putting me in that show. Mysterious ways, indeed.

CHAPTER 29

A Picture Out of Focus

lton and I settled into married life like a couple of twenty-year-old newlyweds. It was a little bit like O. Henry meets *Mad About You.* We were living in our cramped apartment on Twenty-seventh Street, getting by on Alton's salary from Tower Records plus my rent gigs, and I even started singing at weddings and bar mitzvahs and the like. Hard to believe that at that point in my career I was playing those kinds of jobs, but even more bizarre was that a lot of great musicians came along with me, people like Paul Shaffer and Jimmy Vivino, even though I ended up paying them only about $100 a night.

This was the kind of life I imagined was lived by couples fifteen years younger than we were (Alton, in fact, *is* almost ten years

younger than I am), but I didn't mind. We were in love, and in a sense I was having the life I didn't have when I was first married and started having babies immediately. Thanksgiving was really the first time I had been away from California for the holidays, and I decided I would cook up a storm, even though it would just be Alton and I. I went crazy: a huge turkey, corn bread stuffing, candied yams, greens, a regular banquet. The only problem was that Tower Records was open twenty-four hours on Thanksgiving, and Alton didn't get home from work until almost midnight. We could have waited until the next day, but we were so determined to eat while it was still our first married Thanksgiving that we stuffed ourselves and then went to bed! Lord, the two of us moaned for days.

My "five-year" plan in those days was basically twofold: to land a big Broadway part and to sign a recording deal. Broadway had already come through, sooner than I expected, though it didn't quite pan out the way I had imagined. As for the record deal, I was heartened by the comebacks of Tina Turner and Aretha Franklin. Tina was riding "What's Love Got to Do with It" into the hearts and minds of a new generation of listeners, and she was a few years older than I was! No. I at age forty-five! An inspiration for us all. We had been friends in the sixties. There was, of course, the now legendary session for "River Deep-Mountain High," and we would bump into each other on the road often. During one engagement in Vegas with Bill Medley, I went to visit her in her hotel room and found her just after Ike had done a number on her face. We weren't best friends, but I knew she was happy to see me, if only to take her mind off what had just happened, what had been happening for the better part of ten years. I can't remember much of what was

said, but I do remember that she talked about wanting to leave Ike even then, though she didn't think she could make it on her own. I suppose I could have gone on about how she should leave that fool, how she *was* good enough to make it, but I also knew that one day she would realize it on her own. Thank God, she did. There were some lean years when she was doing the dives in Vegas, but when she made it all the way back, she gave hope to battered women and entertainers everywhere.

Tina's "Private Dancer" tour hit Jones Beach on Long Island in 1985, and Kenny Laguna, my manager, got us tickets. It was a wonderful show; Tina's voice, all raw and raucous in the sixties, had acquired deep shadings over the years, and she could now sing a greater range of material. Of course, she could still kick it into high "Proud Mary" gear, too, and Lord, those legs. They were still the envy of every would-be chorus girl and hoofer. We went backstage to visit Glenn Frey, her opening act, and I excused myself to go say hell to Tina. There was a barricade near her room, and I ran into a piano player I knew from church. We kissed and hugged, and he said he would tell Tina I was there, at which point she appeared maybe twenty feet from me, but still on the other side of her barricade. The piano player, whose name was Robby, went over and spoke to her, but then she suddenly turned her back to me and walked away.

"I'm sorry, Darlene," Robby said when he came back. "Tina says she's busy and can't see you now." I could tell from the long face he was wearing that he was giving me the polite version. I couldn't imagine what I had done to offend her. A friend told me that maybe she was upset about my singing "River Deep" in *Leader of the Pack* and going on about how I wished I could have recorded the song. But that didn't seem justification for this cold

shoulder, especially because she had been lucky enough to overcome all her troubles. I hope she realizes just *how* lucky she was.

Aretha had made it back under the tutelage of Clive Davis, impresario of Arista Records. After a few modest successes in the early eighties, she scored big with "Freeway of Love" in the summer of 1985. She's another of my old friends who have proved all the teencentric A&R men in the business wrong. I saw Clive Davis one day on the street, when I had just gotten out of the gym and probably looked as sweaty and grungy as if I'd just come from a mosh pit. I tried to pass unnoticed, but he saw me and said, "Darlene, I know that's you underneath that baseball cap. Don't try to hide from me." Clive actually told me how beautiful I was, and my reply was "Give me a contract," but he had Aretha, Dionne, and Whitney Houston, so his roster of divas was already full.

Leader of the Pack did get my voice, and face, in front of practically every record executive in New York, and so Kenny didn't find as many closed doors as I had a few years earlier when I made the rounds of companies in L.A. Seymour Stein of Sire was interested, and so was Elektra, who had done the cast album, but Al Teller of Columbia expressed the most interest. He told Kenny that he learned how to kiss while listening to my records. At long last I had my record deal. Even with all the potholes and speed bumps, my five-year plan was still almost on schedule.

Alton was the first to smell something rotten in my deal with Kenny, but I believed in him to the bitter end. So far he was the only manager who had actually done something for my solo career. Little did I know that the deal with Columbia involved Kenny's other big client, Joan Jett. He used to call us his "No. 1

club" because we had both sung on No. 1 records. But I would soon find out who was No. 1 within Kenny's No. 1 club.

From the way Kenny tells it now, Al Teller was big on me but cool on Joan, while Tommy Mottola, one of the big three at CBS, was big on Joan but cool to me. Kenny played both sides and got us both deals, but before work on my album started, I found myself singing backup for Joan gratis. According to Kenny, "Darlene always had that rock-and-roll thing, Jagger and Joan, too, where they weren't sounding like any color." Maybe that's true, but I had no connection to Joan's music at all. Kenny made us out to be best buddies, but what he was getting essentially was free backup vocals.

Kenny was so set on this rock-and-roll direction for my album that he turned down the song "So Emotional," which was later a big pop and R&B hit for Whitney Houston. Instead he had Tom Petty write and produce a song called "We Stand a Chance." By the time we were finished it ended up costing almost $75,000. We recorded it in L.A. at A&M Studios, where everyone had to be pampered and first-classed for a song that wasn't even that good. Kenny called in Flo and Eddie—formerly the lead singers of the Turtles—to sing backup vocals with me, and they couldn't hold their parts. I think I would have preferred Sonny Bono.

All this was money coming out of my pocket. There was a signing bonus for my album, not a penny of which I saw. I think Kenny spent it all on the Tom Petty track. There was also a $10,000 producer's fee for each song. Since I basically produced the version of "You'll Never Walk Alone" on the album, which would be called *Paint Another Picture*, I should have seen that money too. But every time I went to Kenny for cash, he

said there wasn't any, because it had been spent. Another time he told Joan that she should thank me because I made her album possible. So it seems that backup vocals weren't the only things I was investing in her. The only way I could ever get any money out of Kenny was to tell him I couldn't pay my rent. Then he'd hand over $900 or so. But that hardly made me feel like a prized client. Instead I felt like a beggar.

In the end, *Paint Another Picture* was an album lacking a strong vision. I hadn't been as lucky as Tina or Aretha, who had fallen into the hands of sympathetic and inspired producers who cared as much about making a good record as about making money. I also had myself to blame, for not imposing *my own* vision more on the album. By the time we finished, there had been a corporate shake-up at Columbia and the album was ignored, which didn't surprise me, because it was a mess. I think the final insult came from a few of the reviews, which said, "Can she ever make a good record without Phil Spector?" I knew I could, and would.

In the meantime, millions were already hearing my voice and seeing my face, but it had nothing to do with singing and everything to do with not being able to cook.

CHAPTER 30

I'm Gettin' Too Old
for This . . . Not

*F*unny how expectations cause dreams to expand. *Leader of the Pack* and *Paint Another Picture* were so disappointing to me because I had imagined, not entirely unrealistically, the big happy ending. I'd had hit records once, and saw my contemporaries having the greatest successes of their careers, so I had also imagined myself with the platinum record and the Grammy. As for Broadway, maybe the notices for *Leader of the Pack* at the Bottom Line had gone to my head, but I imagined a similar result. And even though I survived the rubble of the Broadway reviews well enough, it still wasn't quite what I was hoping for. Who would have thought that I'd be involved with

another No. 1 before the end of the eighties and that I wouldn't have to sing a note?

Shortly after *Leader of the Pack* closed on Broadway, I had gone to see Dick Donner, who was directing *Lethal Weapon*. I had no idea what this movie was all about, but I was determined to get the part no matter what, unless it was something demeaning. I didn't want to go from playing a nun, as I had in *Change of Habit*, to a drug addict or a hooker, for example. But I was generally keeping an open mind. Since there was no script, I decided the best way to go into this screen test, or interview, was to wipe all the disappointment of *Leader of the Pack* off my face. For all I knew, Glenn Daniels, the casting director, could have been an overzealous fan who wouldn't be able to deliver on his good intentions. I prayed on this like everything else. God told me to go.

I was more nervous than I had ever been in my career, only because I wouldn't be singing. My voice had always been my sure thing, the unimpeachable force that righted me even when the jobs didn't come through or the promises were broken. But now I didn't have that to fall back on. Glenn Daniels had told Kenny that they were looking for a new face, not the usual suspects among black actresses. Well, I hadn't been in a movie in almost twenty years. I certainly wasn't your run-of-the-mill black actress.

I walked into the room where Dick Donner, all six feet five of him, towered over me, and within five minutes I was asking for a script, something I could focus on. But Dick didn't want to hear me read, he just wanted to chat and get to know me. Great, I thought, fat chance I have at this job.

Dick and I had a mutual friend, Francine Lefrak, the good seed among the *Leader of the Pack* producers, and after we chatted

for a while, he said, "So, Darlene, Francine tells me that if you had had a bigger part, that show would have been a hit." It was all over after that. I let loose a howl, and within fifteen minutes I felt as if I had known this man for years. Dick said as far as he was concerned, I had the job. "I wanted to see how you could improvise," he said. Lord, that had to have been the easiest audition of my entire career.

You'd think I'd have learned my lesson after all those years, but I was positively radiating. And then I lost a little juice every day I didn't hear from the producers. Finally a month went by and I said to Kenny, "See, I didn't get that part."

"They'll call, they'll call," he said, and they did, to ask if I would come in for a screen test.

"I knew it," I said. "They were lying all the time. I never had this part."

But I did. The screen test was just to match me with the young actors and actresses they were considering for the roles of my kids. *Lethal Weapon*, in fact, all four of the *Lethal Weapon* movies, turned out to be the only occasions in my career when every promise made to me was kept, including the ones I had made to myself. They were big hits, excuses to print money. And I even got paid.

The woman I was playing, Trish, didn't have many lines, but the camera was on me a lot, and it smiled on me. I think Mel and Danny talked more about me, and my bad cooking in the film, than I talked myself. Dick told me explicitly not to act; he just wanted me to be myself. I was so green, I didn't have time to really think about being nervous. The first day I was completely fascinated with a scene in which Gary Busey drove a car backward down a highway. It was as intricately choreographed as a Jerome Robbins routine. The car always ended up in the same place

every time. I had forgotten from *Change of Habit* that being in the movies is like waiting all day on a subway platform for a train to come, and then when your moment comes it whooshes by. I did have one big scene that required me to "act": when I found out that my daughter had been kidnapped. Dick told me to think of any sad or emotional song I had ever sung. We did it in just a few takes; if only Phil Spector had been that easy to work for!

Mel and Danny were both the same good-natured, prankster screwballs they were in the movies. Mel was always eyes-spinning-in-his-head wired, and Danny was always looking for time to nap. We'd be out to dinner, and Mel would be trying to sneak mashed potatoes in your shoes, stuff like that. But we were all like family. The craziest one of all was Joe Pesci, the sidekick from *Lethal Weapon 2* and *3*. He had that neurotic snicker, that verbal nervous tic—"Okay, okay"—that reminded me of Phil. He always came to the set with his dog, singing my songs! He used to be a disc jockey, and, honey, he knew every word. Imagine how I squealed when I saw this man who had brutalized his way to an Academy Award in *GoodFellas* walking around with a little white poodle singing "(Today I Met) The Boy I'm Gonna Marry."

I think what I loved most about *Lethal Weapon* was that it let me just enjoy my job without having to watch my back every second or worry about getting paid or getting credit. These movies were great fun, and the royalties I kept getting put my son Jason through college. And after all the years I had been singing, who would have thought it would be this bit part that struck the most resonant chord in the average fan. "Sang 'He's a Rebel'? Nope, don't know her. . . . Appeared with Elvis in the '68 special? . . . Sorry. Played Danny Glover's wife in *Lethal Weapon?* Oh, sure, I know her. . . ."

CHAPTER 31

Back to Mono

After about five years New York started to feel like my backyard. Alton and I, even though we had to scrape by a few months when I wasn't working and his limousine business was just getting off the ground, were growing closer as the years went by. I never got tired of this man's kindness, his humility, his deep reserves of faith in me and in us. There was a strength in Alton that had nothing to do with being macho; he was never afraid to tell anybody when I was bringing home more money than he was, for example. And he never cared about the spotlight. He would always be there, waiting in the wings or at the stage door, but that's as far as he wanted to venture into it. "My job was to watch Darlene's back," he says. "Whatever it

took so that she could worry about performing without being distracted by the rest of the stress that goes with it."

I was still working toward the same goals: Broadway and *Bill-board*. I did get in one more show, *Carrie*, about which I'll say only this: I got to go to London and take Debbie Allen's dance class, which worked me into the best shape of my life. There were sore muscles that had been asleep for forty years! When Alton came to London he couldn't believe how toned I was. "Damn, Love," he said, "is that you in the bed with me?" Theater scholars know that the show itself was one of the unmitigated disasters in Broadway history. At least it closed on the first night, and we could all laugh about it before too long, unlike *Leader of the Pack*, which was like a six-month hangnail. And *Carrie* gave me some-thing I had been longing for most of my life: a daughter.

Around the time we all arrived in London, Debbie Allen, who was directing the show, started telling us about a young dancer who was on her way to join the cast. Debbie raved about her, so we knew she had to be good, if Debbie was taking the time to single her out. I was expecting some prima ballerina, but instead there was this little girl, Rose Jackson, barely twenty years old, looking like some vagabond out of a thirties movie, doing pliés over and over across the stage. What a silly child. We formed a bond immediately. She had made her way from New Orleans to New York, where she, like thousands of other hope-ful Broadway babies, lived hand-to-mouth while she waited for her first big break. She got into a few choruses and caught Deb-bie's eye at the audition with not just the professionalism that comes from years of dance class but also the hunger that turns that professionalism into magic. Lord, that child could dance.

I think I hit it off with Rose right away because I felt she

needed to be protected. I wasn't worried about how she'd deal with the sharks of show business; she had enough street smarts to navigate her way around them. I was more concerned with practical things. In London, I had to lend her one of my coats because she didn't have one. And back in New York I think Alton and I must have helped her move about six times. Even though she was getting work after *Carrie*, in shows like *Ain't Misbehavin'*, she had to pay almost half her income to agents and managers, and so she couldn't always make her rent. (At one point I found out she was sleeping in the theater!) A few nights she'd sleep on our couch, or call late at night after a performance just for some connection back to the real world. Or she'd call and ask Alton, "Can Mom come out and play?" and even though neither one of us had a lot of money we'd get on the bus and take in the town. I sometimes felt closer to her in those days than I did to my own boys. Her work got steadier and she got on her feet financially, then went out to California and met a writer on the set of *Married . . . with Children* named Michael G. Moye, whom she married. Now they're back east, and we're as close as ever. Rose was another answered prayer in my life. Answered on God's timetable, certainly not mine, but answered nevertheless.

Even though *Carrie* closed on the first night, I was making a name in New York, thanks to Allan Pepper and the shows he gave me, plus a regular stint every Christmas on David Letterman's show singing "Christmas (Baby Please Come Home)." Every year he asked Paul Shaffer, "When are you going to get your friend Darlene to come on and sing that song?" It got to the point where he was introducing it as "the only Christmas

song that matters." Well, not really, but fifteen years running I've been singing that song on his show, so I won't argue with him.

The Phil Spector Christmas album seemed only to grow in prestige as the years went on, and Allan Pepper essentially decided to re-create the album onstage at the Bottom Line. For one show he got me and Ronnie and Sonny Bono together with a lot of great local talent like Pattie Darcy and Ula Hedwig and Vivian Cherry. Ronnie looked as tarty as ever, but her voice sounded pretty good after all those years, though she still acted like a sheltered princess, even at forty-five years old. One night I went over to her dressing room, where her husband, Jonathan Greenfield, was standing guard, and I asked her what she was doing all by herself. "Oh, just feeling lonely," she said.

"Well, why don't y'all come over with the rest of us and stop sitting here in this cage?" She did, and we had a blast, probably talking about Phil and how crazy he was.

To be fair, though, the records we made with Phil had some legs. Almost thirty years later we were still singing these songs to packed houses, all the more amazing because you really couldn't find Phil Spector records in stores. The Christmas album was available on CD, but he kept the rest off the market, waiting for a label or the money that he thought was worthy of the "genius" that went into making them. Rhino Records, the expert reissue label in Los Angeles, at one point announced it had acquired the rights and then months went by without any release.

It was around this time that Phil got himself elected to the Rock and Roll Hall of Fame. I was at peace with this. Phil belonged in the Hall of Fame, even if he had taken the low road.

But Ronnie and the Righteous Brothers and I also belonged there, and to put him in without us was like repeating the sins of the sixties. At least Phil invited us to the dinner, along with Larry Levine and Ellie Greenwich and Gerry Goffin. I hadn't seen Phil since that strange day at his house, and not many other people had, either. One of the reasons I went was to see what he looked like. I wouldn't have been surprised if he came out like the Elephant Man.

Kenny Laguna and I went, and at our table there was maybe half the contingent Phil had invited: Ellie, Gerry, Larry, Ike Turner, Allen Klein (Phil's partner), but no Phil. Allen later told us that Phil wouldn't come out of his room until it was time for his induction. Same old Phil—casting a giant shadow and then hiding in it. Allen Klein was there to issue surrogate insults. "So, Darlene," said Allen, another smart-mouthed little man, "Phil tells me you're just a background singer now." I could have left the table right then and there.

Phil looked surprisingly the same; maybe a little puffier and paler, but in the sixties he always looked older than he was. I guess now everyone else had caught up to him a bit. His speech was also the same old Phil, rambling in and out of the fog, impressed with himself and disdainful of everyone else. The really interesting stuff came later, at the post-ceremony party in Phil's suite. He had all his goons around him and felt a rush of the old invincibility, meaning he could piss on anyone he wanted, starting with Ellie. She had recently lost some weight and looked fabulous, but Phil started calling her a dog and berating her about *Leader of the Pack*. "Who do you think you are, going on Broadway?" he said. "You didn't write those songs by yourself."

Ellie was reduced to tears; Phil always knew what wounds to open, or reopen.

Kenny was in the corner, figuring he'd have to take on some of Phil's boys. Then Phil got in his face and started singing in that mock whine of his, "I Hate Myself for Loving You," making fun of one of the Joan Jett hits Kenny had produced. I'd had enough and got up and told Phil to get back in his chair. "Okay, doll, okay, no problem." The only way to get that child to behave was to treat him like a child. Lord, why after all these years was I the only one who stood up to Phil?

Phil didn't dare insult me that night. He had done that a few weeks earlier, when Kenny got a call to have lunch with Allen Klein. Allen was one of the most feared men in the music business, the New York version of Colonel Tom Parker, having managed (commandeered, really) the careers of the Rolling Stones and the Beatles. Now he and Phil were in partnership—talk about your unholy alliances—and they were finally ready to release Phil's catalog on CD. Allen brought a piece of paper he wanted me to sign. It said that Phil would pay me $25,000 to give up all my claim to royalties for the songs we recorded. And it came with a not-so-veiled threat. "Don't go stirring up Darlene," Allen Klein told Kenny. Allen was the type of man who'd schmooze you and make you feel as if he were the most honest man on earth, that he was always looking to give you the best deal, like a car salesman.

I'll say this for Kenny: He knew how to smell a rat. We didn't know exactly how many songs I'd have on the eventual collection, but we knew that $25,000 was chump change. Instead of taking Phil's offer, Kenny put me in touch with an organization

called Artists' Rights, to start compiling information to use in a suit to claim back royalties from Phil. The boxed set hadn't even come out yet, but these lawsuits took years. Phil would have already made and pressed a few more million before we ever got to court.

The four-CD box, *Back to Mono,* finally came out in the fall of 1991, and my recordings were all over it: eleven of my solo tracks, plus another half-dozen or so as the Crystals or Bob B. Soxx and the Blue Jeans, not to mention all the songs I sang and arranged backup vocals for. Some of those songs I didn't even own copies of, like "Chapel of Love." It cost almost $100, and it was a smash. It was officially certified gold, a level that only a handful of multi-CD sets have attained.

And what did Phil send me? A gold record! With nothing negotiable attached. But this time I checked my outrage. I knew I would be seeing him again, and that I would be the one requesting the command performance.

CHAPTER 32

Who's Darlene Wright?

eep on. As the eighties turned into the nineties, and I closed in on my fiftieth year, I kept hearing the same message from friends like Cher: "Be true to yourself, Darlene. Keep singing, no matter what." I heard it from Alton, too, who on a daily basis let me know that he was in for the long haul. As long as I wanted to pursue my dreams, he'd always be there, usually in the shadows, the quiet strength that carried me. And I heard it too from God, who, also on a daily basis, gave me the reason and the faith to go on.

Even if I wasn't getting any royalties from *Back to Mono*, there were some trickle-down benefits. Shanachie Records, a small folk and R&B label, signed me for an album, or should

I say, half an album, with the singer Lani Groves, and the songs were all oldies, like "Let It Be" and "Rescue Me." It wasn't quite what I had in mind, but it was only the beginning, because by the end of the year I had a vision that hadn't come around for twenty-nine years: my name on the charts.

The movie *Home Alone 2* was set for a Christmas release in 1992, and the producers asked if I wanted to sing "Christmas (Baby Please Come Home)" for the soundtrack. The last thing I wanted to do was make Phil Spector richer, though, which is what would have happened if that song had gone in the movie. So I did the next best thing; I called Steve Van Zandt and got him to write a new song that had the same feeling as "Christmas (Baby Please Come Home)." He came up with "All Alone at Christmas," and thanks to the huge box office of the movie, it got enough radio airplay to enter the pop charts in November 1992. Steve thought this would be the song that really got my recording career going again full steam. It was released by Arista, and he starting bugging Clive Davis to sign me. "The only problem was they were putting all the irons into *The Body- guard,*" Steve says. "I wish I could have started my own label, for all these great artists who can still really sing but who have no record deals."

But for once I wasn't disappointed. I knew the shelf life of this song was limited, because it was seasonal, and besides, Clive Davis was still on diva overload. The important thing was seeing my name again in *Billboard.* Whether the song got to No. 3 or No. 83 (where it eventually peaked), the music business knew that I was still out there, and still singing.

This little bountiful swing in my career continued when I got a call from Allan Pepper, who once again opened up his club

and his heart, if not quite his purse strings. He wanted to stage another musical on the scale of *Leader of the Pack,* and this time the subject would be me! The idea was to answer the question "Who's Darlene Love?" The Bottom Line wasn't exactly Broadway, but something in those cavernlike, beer-scented walls felt like home, plus it was steady work only a short commute away. Allan Pepper and Melanie Mintz, who would write the show, called *Portrait of a Singer,* wanted it to be the kind of production that could eventually move to a bigger theater in New York or go to Europe, and they were giving me a percentage ownership, essentially, in my own life, for which, after all I'd been through, I was pretty grateful.

I wasn't prepared, though, for the amount of work involved, which was more than any show, concert, album, or any other undertaking I'd been involved in. There were hours spent with Melanie, going over autobiographical information; hundreds of demos to listen to for the "new" portion; a band to rehearse. Even with all the people working on it, it felt like a one-woman show.

The basic idea of *Portrait of a Singer* was to reintroduce me and my voice to fans who had known me for years but didn't know they knew me, to shake off the anonymity that had followed me around for my entire career, to end my detour from center stage. A medley of songs that I had sung backup on, things like "Goodbye Cruel World" and "Monster Mash," opened the show. Then one of the background singers explained that what these songs all had in common was Darlene Wright. "Who's Darlene Wright?" another asked, and off we went, from preacher's daughter to Blossom to Phil Spector's bread and butter to backup for kings and queens like Elvis and Dionne

Warwick to, finally, a soloist again on a half-dozen new songs by old friends like Jackie DeShannon and Barry Mann and Cynthia Weil. It was exhausting, and I wondered how many other singers my age were working that hard.

I wished I could have been more involved than I was in the creative decisions of the show; sometimes I felt as if it were Melanie's show, not mine, and I was just a performer. One night we put on a free performance for our friends, and I gave Allan and Melanie a list of twenty-five or thirty people I had invited.

"You can't have that many people coming," they said.

"Excuse me, isn't this show about me? And I'm the star, right?"

"Well, yes, but you just can't have that many people."

"Okay, y'all, if that's the way things are." Amazing.

There was a chorus of praise from the reviewers, but what made it all worthwhile was, as always, the people I was working with, including the pistol pianist/musical director Bette Sussmann, and great musicians like Jerry Vivino, Leo Adamian, Dave Keyes, and Larry Saltzman. And the singers were my old buddies Ula Hedwig and Vivian Cherry and a smoothie named Dennis Ray, who I swore was channeling the voice of Sam Cooke. Some nights we were full to the rafters, the crowd dotted with celebs like Paul Simon and Jackie DeShannon and Phoebe Snow, and other nights we played to twelve or fifteen diehards, usually at the late show. These fans were people like Art Cohen, a cosmetics clerk from Philadelphia who took Amtrak up from Philadelphia every week and stayed for both shows. And every night the moment of recognition in the crowd was palpable, though it occurred at different times. They'd hear a song that helped finally place me in their lives, or maybe they'd realize

they'd seen me in *Lethal Weapon*, and someone would whisper, "Oh, *that's* her."

But no matter how many people we played for, we always started every show with our prayer circle backstage. It didn't matter what faith you were, even if you were no faith; this was our version of the "team prayer," a way of affirming one another and recognizing the spirit that was bigger than any of us. Larry Saltzman, my guitar player, remembers that the spirit was with us both on the nights when the place was jammed and on the nights when it was hardly worthwhile for Allan to keep the show running. "Everybody just played their guts out," he says. "I thought it was important to invite as many people as I could to this show, whether their initial response was, 'Oh, I grew up with Darlene Love' or 'Who's Darlene Love?' because I knew they'd walk out with a bit of history and with this incredible otherworldly feeling, which can only have come from Darlene's religious background, because she always sang from some very deep place."

Portrait ran, on and off, for almost two years. During that time, Allan and Melanie, who were acting as my managers, told me they were fielding all kinds of offers, for record deals, for productions of the show in London, or for a move to a bigger theater in New York. Melanie and I started work on an autobiography, but after two years, there was no book, no record deal, no offers to move the show. I did get a stint on the soap opera *Another World* for a few months, playing an Alcoholics Anonymous sponsor, and though I really liked the work, it started to conflict with the rehearsal and performance schedules of *Portrait*, and finally the producers of *Another World* told me I'd have to choose. I liked acting, and loved the people on the show,

including Linda Dano (I was playing her counselor), but I knew that singing was my first priority, so I had to leave. They got another woman to replace me for a while, but she didn't work out, and they wrote the character out of the show.

As *Portrait* started limping a little into its second year, Allan and Melanie told me there were some deals being proposed but that they were so insulting that they didn't want to bother me with them. Later Allan said he didn't know he was supposed to be looking for other work for me. As friends, Allan and Melanie were wonderful, but once more, business ended up not mixing, and so I had to move on.

There was a pleasant coda to my years with Allan, even though he didn't have a direct role in making it happen. In 1995 I got a call from the Rhythm and Blues Foundation telling me that I had won their pioneer's award. I had never heard of this organization, and beyond that, I still did not consider myself an R&B singer. I thought for sure the woman was pulling my leg. But it turned out to be legitimate. Not only would I be honored at a ceremony with Junior Walker, Fats Domino, and the great jazz singer Arthur Prysock, I'd also get a check for $15,000. The whole idea of this group was to honor legends while they were still alive, and give them some financial reward, because so many R&B greats were cheated out of their proper royalties. Lord, my acceptance speech went on and on—I didn't know if I'd ever have the chance to make one again, so I felt as if I had to get it all in.

But that was about the only positive thing that happened in my last year with Allan Pepper. Alton, as always, had the most sanguine outlook. Some time after *Portrait* closed, he spoke to Allan and told him that he truly believed whatever else hap-

pened in my career would be an offshoot of *Portrait*. And when I was able to wipe that film of disappointment from my eyes, I saw that it was true. *Portrait* did remind New York audiences of who I was even more than *Leader of the Pack* had, and showed them I wasn't just some creaky nostalgia act. It introduced me to more wonderful musicians like Bette Sussman and renewed my ties with others. And in the final days of the show, another man came into my life as a fan and became the manager who would pick up the ball from Allan and Melanie and make one more run with me for the goal line. But first he had to find me, because after *Portrait* closed, we still had to pay the rent, and I had headed back to the cruise ship.

CHAPTER 33

My Day in Court

few years earlier Alton and I moved from the city to Rockland County, about thirty minutes north. We loved New York, but five years was enough. We rented the bottom of a house, and my biggest problem became keeping my identity a secret from the neighbors. Once *Portrait of a Singer* came along, I started getting a lot of press coverage, and then people started linking me not just to the show but also to *Lethal Weapon*. The next thing I knew there was a stream of people at my door, all with "daughters who wanted to be singers" and "sons who would make fine actors," and what advice did I have for them? It got to the point where we had to escape these future stars and their parents, who were attaching themselves to me like barnacles.

We decided we had to move again, late in 1994. We found a house about ten miles away on a quiet, hidden block. There was just one problem, though: I wasn't working full time, and Alton was busy changing careers from the livery business to pest control. So we didn't exactly have a regular income, which led to some trouble securing a mortgage for the new house. But as I always say, Leave it to the Lord. Alton and I prayed and prayed. With only a couple of days left before our contract ran out, we got our mortgage.

With our income so dependably uncertain, I found myself doing spot duty on cruise ships again and taking as many corporate gigs as I could. These jobs involved performing at some convention or junket that companies sponsored for their executives. That's where I might still be if it hadn't been for that fan who came to see *Portrait of a Singer.* Jonathan Pillot was a lawyer who had some clients in the music business, and he was a big fan of rock and roll, still a few years shy of his fortieth birthday. He had come to see *Portrait* and soon the fan in him kicked his inner entrepreneur into gear. He had a friend who knew me, and he asked for a meeting just to see what was going on in my career. By the time he got to me, though, I had already left for the cruise ship, an event that in itself made him decide he was going to manage my career; like everyone else, he couldn't believe I was taking a job there.

When he finally caught up to me, I knew after our first meeting that if anything was going to happen in my career—at least before I became eligible for Social Security—Jonathan was going to help me achieve it. There was a fire and a hustle (in the sense of alacrity) in his eyes that I had never seen. Within a year after I signed with him, I had a show with Merry Clayton

and Marianne Faithful, a deal for this book, and sessions with a New York record producer. Lord, I thought, what if after all these years I had just needed the right manager? How could it have taken me so long to figure it out? I haven't gone back to the cruise ship since.

Jonathan was also one of the important people in my corner when my lawsuit against Phil Spector finally went to trial. I had filed the suit in 1993, after we watched Phil reap the profits from not just his *Back to Mono* set but also from several of my songs that were used in blockbuster movies like *GoodFellas* and *Gremlins*. We didn't know how long it would take to get to court. The Ronettes, whose "Be My Baby" made a small fortune when the song was used in *Dirty Dancing*, finally got there in June 1998, and they filed their suit before I did. But my day had finally come, and it was set for February 1997. Phil was finally going to have to account for himself.

As I walked up the steps of the Rockland County Courthouse on the first day of the trial, the words "moment of truth" took on a whole new meaning. I knew that I had the truth on my side, but I also knew that Phil's lawyers would try to distort it any way they could and try to make the jury believe that I was lying. The building itself had an oddly soothing effect on me, though. It was about a hundred years old, only two stories with two marble staircases leading up to the courtroom. It was older than Phil Spector or me or even rock and roll. When I walked into the courtroom and saw old-fashioned wooden benches for spectators and breathed in the cool mustiness of the place, I thought that the truth had a chance.

The statute of limitations had run out on any claim I had on

the original sales of my records. My suit covered royalties from the box set and various other compilations, plus the use of my recordings in films. Whenever I approached Phil about this, he argued that I never had a contract with him, that I was always free to record for someone else, and, most important, that the singers were just interchangeable parts in his records, no more important than the saxophone player or the second engineer.

Phil of course had Allen Klein in his corner, and a team of attorneys, and I had Ira Greenberg, the lawyer for Artists' Rights. Straight off I knew we were going to have a case. When Phil's lawyers made the point about the singers being insignificant cogs in his machine, Ira countered with "But Mr. Spector did not put out an album called 'The Best of the Saxophone Player.' He did, however, put out an album called 'The Best of Darlene Love.' "

It was an important opening salvo, but we still had a long way to go, simply because we didn't have the contract with us. Our biggest hurdle was proving to the jury that the contract had existed. And that help would come from an unlikely source: Fanita. She had a royalty statement from Phil that said, "Dear Fanita, I love you, maybe there will be something left next time." This would be the pivotal piece of evidence in the trial, and a way for Fanita and me to put all our differences behind us. And it was because of this lone piece of paper that the judge, George Bergerman, had allowed the case to go to trial.

The jury was made up of five women and three men, two blacks and six whites, people who knew very little about the music business, and who were probably bored by the days of testimony from lawyers and accountants. I figured this was

working to my advantage. These were just regular people who wouldn't be impressed by any city slickers. But in the end the case would come down to whom they believed, me or Phil.

My testimony was pretty simple. I testified that I remembered signing a contract, in the office of Lester Sill, who was Phil's partner, and gave them the amounts: 3 percent for my solo record, one-third of that for Bob B. Soxx and the Blue Jeans. Phil's lawyers tried to confuse me with details like who was there at the contract signing, how much it was for, when it was. But I knew the truth. I had signed. Why else would I have stayed with Phil for so long? Phil's lawyers raised that very question, not realizing that it was working to my advantage.

The big spectacle, of course, was Phil's appearance at the trial. He was as reclusive as ever in the late nineties. The only work we'd heard he'd done was an album with Celine Dion, the big French Canadian ballad singer. Of course, no one ever heard any of it, except for Phil's innermost circle, which still included Nino Tempo. Nino recently told me, "There's one song that's the best song I've ever heard him do, better than any Ronettes, Righteous Brothers, Darlene Love song. I think he wrote it himself. He doesn't have to put it out. He knows in his head it would be a No. 1 song. That's enough. He doesn't have anything to prove to anyone." But later even Nino would say, "He abused Celine more than I'd ever seen him abuse anyone, even Ronnie. I think he was trying to get between her and her husband. I took him aside and told him he was going to scare her away. I wanted to tell her to get as far away as she could from him. But she didn't need me to do that. She was a smart woman. She got out of there." Phil really must have thought it was still 1963.

One thing Phil certainly didn't set out to prove at the trial

was his sanity. First he was deposed on video, for six hours, and did a real Michael Jackson trip, in a white mask and surgical gloves. He rambled on about how he didn't know why I hadn't just left and recorded for somebody else. He claimed that he never got his hands messy with the business part of the label, and that he was just a record producer. He said that nobody had contracts. He said that he had paid me a flat fee for each song and that, as far as he was concerned, was that.

Things got even more interesting when he came to testify in person the next day, arriving with his usual motorcade like some head of state, escorted by his usual goon squad. He looked pale and wraithlike. I guess he still wasn't getting out much. By the time he was called there were only forty-five minutes left in the session, so the jurors got to hear only the questioning from Phil's lawyers. And for the first time in more than thirty years, I saw the normal Phil. He was funny and charming, spelling out letter by letter the names of the people he was talking about. He had jurors laughing at almost every turn, and I thought, Lord, what am I doing here, if he's gonna get all friendly with the jury? He was practically bonding with them. And the hardest part was when Phil called me a liar, and I just had to sit there and smile politely. Lord, did I want to explode.

But the next day crazy Phil came out when Ira started his questioning. It didn't take Phil long to get irate, even though he was being asked all the same questions, like why it made sense for me to stay with him if I didn't have a contract. He started addressing the judge, asking him if he had to answer these "stupid" questions. When Ira showed him the royalty statement and asked him to examine it, he got squeamish and said, "Oooh, that's nasty, I don't want to touch that." He said that it wasn't

his signature and that his mother would "never let him have anything that messy." So much for not knowing anything about the business end. Then Ira got him to admit that the Righteous Brothers and Ike & Tina Turner had contracts. That was when Phil became unhinged, like the Jack Nicholson character in *A Few Good Men.* The judge kept admonishing him, and the jury saw that he wasn't the laughing, joking eccentric old chap of the day before. After he was dismissed from the stand, court was adjourned for the day, and I walked past their huddle on the way out. All I could hear was Allen Klein telling Phil he had to calm down or he would blow the case.

Ten days after the trial started, it went to the jury, right before a lunch break. We hung around the courthouse, my group at one end of the hall and Phil's at the other (minus Phil; I guess he was so sure he was going to win that he didn't stick around to hear the verdict). I told Ira it was in God's hands, and felt confident. Ira told me God didn't always answer his subpoena. We were subdued, almost funereal. Phil's contingent, though, was pretty boisterous on the other end, so sure that Phil would win. It wasn't even forty-five minutes later when the bailiff appeared to say the jury needed a calculator! It was almost as if the sun had broken on our end of the hall and a cloud burst down on Phil's end. His crew looked dumbfounded.

An hour or two later the jury came back, and the judge said to the foreman, "How do you find?"

"We find for the plaintiff, Your Honor."

Hallelujah! I had won.

I almost didn't hear the figure—in excess of $263,000— because in some ways it didn't matter. Somebody had finally, publicly, said that Phil Spector owed me something. "Nobody

had ever beaten him," Kenny Laguna says. The press took the same attitude: surprise that a woman no one had really heard much from in thirty years had beaten one of the toughest, most powerful men in the music business. As for the money, I knew it would be years before I'd see it, because they would appeal (even though they had to put up the money and pay 9 percent interest on it as long as the appeal dragged out), and anyway, I'd have to give almost half of it to my lawyers. But with that victory I won something for every singer and musician who had given themselves to music their entire lives and seen other people get rich from it. We had a quiet celebration at a local steakhouse. If I had been younger, maybe I would have been more exuberant, but it was more of an inner peace that descended on me on that day, March 7, 1997. I felt as if this was the day I had reclaimed some of my jewels, and a big part of my soul.

My first public appearance after the trial was at an outdoor promotion to announce that I would be joining the cast of *Grease*, the screeching sock hop of a musical that was running on Broadway again. Though I was playing Teen Angel, the go-go-booted guidance counselor from above, there was one scene in which I would appear as a member of the class of 1959, the very year I really graduated from high school! Here I was, singing vintage rock and roll and playing a high school student from the fifties. Lord, I was thinking, how far I have come.

But when I walked out on the makeshift stage that had been erected outside the Eugene O'Neill Theater, I knew something was different. I saw people stuffed into Forty-ninth Street on either end, winding down an alley to Forty-eighth and spilling

out west onto Eighth Avenue. It was a gray Wednesday after-noon, about half an hour before the matinee, and I couldn't believe the river of people. Granted, New Yorkers have never let a hard drizzle scare them off a free concert, even one that was going to last only five minutes. But as I panned around I saw a mini-melting pot: young, old, male, female, black, white, and beyond. Then the emcee said, "Here she is, our newest cast member, the legendary Darlene Love, to sing her big hit, 'He's a Rebel.'" I thought the roar would topple the model pink Cadil-lac on top of the marquee. My usual reaction would be, "Who is causing these people to make such a fuss? It couldn't be me." Even after forty years in show business, I still wasn't used to such a response; I couldn't be getting it at age fifty-five because I never got it when I was twenty-five. But now, with my victory in court over Phil Spector so fresh in my mind, I somehow didn't feel compelled to look over my shoulder. I knew the song, and the applause, belonged to me.

EPILOGUE

ixty was the deadline. I promised myself long
ago that by the time I reached that age, I would
have achieved all my goals. Another hit record.
A Grammy award. A long run in a Broadway
show. Whatever it took to detach, permanently,
the word "unsung" from the words "Darlene
Love." By the time I was sixty, I figured, I would
have been in show business almost forty-five
years. I knew that the Lord had blessed me
with stamina and with a voice that was aging
gracefully, but even I had to slow down at some
point. How many more times could I sing
"He's a Rebel"?

Now the day of reckoning is less than three
years away, and I'm still out there trying to
make a name for myself. There's been no

new hit record yet. No Grammy. Only small parts here and there onstage and in the movies. I'm *still* singing "He's a Rebel." And I'm still learning that even at this point in my life, God has other plans.

I received this insight (practically) straight from God's mouth to my ears. My brother Alan and his wife, Marvene, are co-pastors at the Word Center Church of Los Angeles, and in February 1998 I attended services there while I was in town filming *Lethal Weapon 4*. Marvene was preaching to the congregation and called me down to the sanctuary, where she delivered this message to me from the Holy Spirit:

"Darlene, it's not over. Fifty-seven ain't nothing and sixty is even less. Your latter end is going to be greater than your first. And you should let go of the past. Let go of the wrong that has been done to you. Let go of the injustices in the industry. Just let go. . . .

"If you think you're busy now, you think you're working now, the end is going to be better than the first. You've not going to retire. You plan on retiring? [I answered yes.] *Was that on your mind?* [I laughed and answered yes.] *At what age?* [I said sixty.] *Sixty, okay. It's okay if that's your desire, but the next three years are going to be more plentiful than your first fifty-seven years. I mean, regular, regular, regular. Regular appearances, regular work, regular money, continuous income. And God is going to teach you to open your mouth and ask for what you want. And when you open your mouth and say what you want, without hesitation, you're going to get it. . . . No, don't cheat yourself. Don't be afraid. Open your mouth and receive it, says the Lord."*

All I have to do is open my mouth and ask. Lord, I laughed when I heard that. My mouth is *always* going. If I'm not singing, then I'm in somebody's face, laughing or yammering on or giving them what for. I was the one—practically the only one—

who told off Phil Spector. I was the one Bill Medley dubbed "Motormouth." I was the one Luther Vandross would shush in the studio all the time for chitchatting so much.

Yet when I thought about it, I realized that at some moments of truth, I probably should have spoken up and didn't. Part of me would always be the dutiful preacher's daughter who learned in church that you kept your head down and your mouth shut. My brother Johnny was right; too often in my life, I did settle for being the vice president. And I learned the hard way that sometimes you can have too *much* faith. It's impossible to have too much faith in the Lord, but you can have too much faith in people. Like Mama. I took what she had to dish out because I believed she had my best interests at heart, until I finally had to leave the house. Like my first two husbands. Like Phil Spector. And while I was overspending so much of my faith on them, I was being stingy with someone else. For too long, I didn't believe in myself.

But I have to let go of all that, says the Lord. Forgiveness is probably the toughest of his commands. Who doesn't like to hold on to the insults, slights, injustices done to them? To savor revenge, or at least fantasize about it? I've had so much hard luck that I could make a life of tallying up all the debts owed to me. But it's an empty pursuit. Only God can judge. Forgiveness is the only way past all the hurts. When you hold on to them, you just make them happen over and over again. I never thought I'd say this, but someday I might see Phil Spector in heaven. As my daddy always said, a lot of people you think you're going to see there will be unexpectedly delayed, while some others you never thought you'd see will be on the express elevator.

This was all thrown into high relief recently when I had

my own elevator ride skyward, up to a heaven-on-earth called Rainbow and Stars, a soigné cabaret at the top of the Manhattan skyline. I was there to perform in *Love for the Holidays*, a revue of my music and career. This *was* the kind of place where I was hoping to be at this point in my life: a four-star club with sold-out audiences for a month. I was truly dazzled, but not just by the splendor of the view over my shoulder, a testament to the majesty of Con Edison. I was overwhelmed by the panorama of my own life, right there in front of me. I sang "Swing Down Chariot," a gospel standard, and was instantly transported back to my daddy's church. Before I was a singer or an actress or a wife or a mother, I was a preacher's daughter whose father always brought his work home with him. Daddy taught us early that we'd never have to look far to find the Lord, who was always reaching up, down, to the side, there to steady me or throw me a line, the piton suddenly emerging from the face of the mountain.

And Lord, on that mountain there were some magnificent peaks. As I sang Phil Spector songs like "He's Sure the Boy I Love" and "(Today I Met) The Boy I'm Gonna Marry," I relived all the blood-rushing ascents and dips of our time together. When I sang "Christmas (Baby Please Come Home)" and realized that I had become, with all the Christmas songs I'd introduced over the years, an official voice of the day of the Lord's birth, I thanked Him for that opportunity. I sang "Soul and Inspiration" and thought of Bill Medley and the near-perfect, unwavering love we had. And yes, I sang "He's a Rebel," this time with my three sons in mind. I used to say to each of them, "You ain't nothin' but a rebel," whenever they were following some path or plan that wasn't mine and that didn't seem to be

the Lord's. But whatever their route, they've all found their way to God. Marcus is the father of two sons, working in a security business and getting acquainted, for the first time really, with inner peace. Chawn is also the father of two boys and now married to his childhood sweetheart, a doctor. And Jason made me the proud mother of a college graduate in 1996.

There was one more song that resonated deeply within me, a new one cowritten by the show's musical director, Bette Sussman: "The Age of Miracles." As I was singing these lyrics—"All that I have/begins with you/My love, my life, my truest call/ Here in the age of miracles"—I knew that these words were the gospel truth, because I was staring at so many of the miracles in my life, right out in the audience. There were friends like Barbara Armstrong, whom I met almost thirty-five years ago and who has been like a sister, standing by me through many trials and whoops and hollers. And there was Ellie Greenwich, with whom I shed a tear during "Christmas (Baby Please Come Home)," not just because of the song but because of the knowledge that the hatchets have been long buried.

Seeing Ellie brought to mind some of the people who had sung these songs with me through the years: Fanita James, for example. Our friendship, too, is newly healed. Jean King, gone for almost fifteen years now, but not before we had mended our fences and forgiven each other for the pain we'd stupidly caused. Sonny Bono, who was soon to leave us but who, till the day he died, never let himself get beat by anyone else's opinion of him. And Cher, who didn't make that particular show but with whom, as she said, I could renew my friendship in a blink. We really had come full circle since those days at Gold Star. I thanked the Lord for her and all the multitudes of friends, past

and present, who have given their ears and their hearts to my voice and my life.

And of course, there is the greatest miracle, my husband, Alton. As the love songs new and old flowed, I saw this man cloaking himself in the anonymity of the wings every night but really shining as bright a light in the shadows as any in the sky. Lord, I love being married. Everyone should be blessed with the kind of sustained, and sustaining, faith and love that Alton brings me every day, onstage and off. (For good measure, we finally did get our church wedding, a few years ago at the Redeeming Love Christian Center in Rockland County, not far from where we live. Our union has always been blessed by God, but we finally got to say our vows in His house. Maybe that's why we're still going strong.)

The view, of course, isn't always so glorious. After all those years of broken promises and pulled-out rugs, I've gotten used to expecting an ambush around every corner. This is still the entertainment business, after all. The faces change but the nature of the beast doesn't. On some days those long, hard rides I took to the houses I was cleaning don't seem so far away.

But in my fifty-seventh year, I realize that you have to be patient, even when that means being patient with God. His way may not be your way, but as a saying I heard recently goes, "The will of God will never lead you/Where the grace of God cannot sustain you." Now I feel closer to the Lord than ever, and at peace with his plan for me. The proof of this is the way I react now whenever I bump into the typical "Who's Darlene Love?" conversation, which, despite all the nice notices and jobs I've been getting lately, still happens from time to time. I'll be on line at the supermarket or the post office, or walk-

ing on the ·beach with my husband, or even incognito before a show in some club where I'm performing, and I'll overhear someone say, "Darlene Love, wasn't she one of the Shirelles?" "No, she was one of the Chiffons," and so on. Every now and then someone really out of the loop still says, "Isn't she that rock singer who was married to Kurt Cobain?" I used to want to tee off on these people, to tell them that I was never a Shirelle or a Chiffon or a Supreme or a Marvelette, and that I was old enough to have been Kurt Cobain's mama. These encounters used to make me feel as if my life were one of those late-night TV commercials, the ones that come on between *Odd Couple* reruns and the psychic network. A stentorian voice announces, "This singer has sung on more hits than Elvis and the Beatles combined," and then, as a scroll of songs unrolls on the screen, the artist turns out to be someone you've never heard of. Well, I did sing on a whole lot of hits, and a lot of people still don't know my name.

Now when I run into these conversations, I just chuckle quietly to myself, as if I'm sharing a joke with the Lord. I remember my good friend Luther Vandross's sage words: There are people in the backwoods of Alabama who can out-sing anyone on the *Billboard* charts but who will never be heard outside their own homes and churches—and like it that way. And there are people who are household names who are barely more musical than the sound of steel wool rubbing against dirty pots and pans. It all depends on a series of crosswinds that have very little to do with talent.

And everything to do with God, and where he wants you to be. There's not a day when I don't thank him for his direction, for my voice and for taking it to the people he wants to hear it. I

may never be a household name like Tina Turner or Diana Ross. To so many people, in fact, I'm still the anonymous legend, the voice without a name, the singer on the side. But whenever I hear the question "Who's Darlene Love?" what's important now is that *I* know the answer. And so does God.

DISCOGRAPHY

Compilation assistance by Rudy Calvo and Art Cohen

The story of Darlene Love's life could also be told in the legacy of her recordings, hundreds of them beginning in 1957 and continuing to the present. For an artist who recorded so much, a good many of these records didn't have her name on them—she was more likely the lead singer of the Blossoms (who themselves had several pseudonyms) or the mystery lead singer on legendary sessions for the producer Phil Spector. For diehard musical gumshoes, a separate section of recordings she sang backup on is included, though it is far from comprehensive. To list every song she has sung lead or backup on would require an entire volume of its own. All citations are for singles or individual tracks unless otherwise noted.

The Echoes

Aye Senorita/My Little Honey	Combo 128	1957

The Blossoms
Singles

Move On/He Promised Me	Capitol 3822	1957
Little Louie/Have Faith in Me	Capitol 3878	1958
Baby Daddy-O/No Other Love	Capitol 4072	1958
Son-in-Law/I'll Wait	Challenge 9109	1961
Hard to Get/Write Me a Letter	Challenge 9122	1962
Big Talking Jim/The Search Is Over	Challenge 9138	1962
I Gotta Tell It	Challenge	

(Unreleased until 1995, issued on *Playing Hard to Get*, Ace 5591, UK only)

I'm in Love/What Makes Love	OKeh 7162	1963
Things Are Changing*	E.O.E.O.C.T 4LM-8172	1965

(Basic track produced by Phil Spector; commercial for Equal Opportunity Employment. Also recorded by the Supremes and Jay and the Americans; originally planned as a Ronettes track, with Brian Wilson playing piano. Jerry Riopelle produced the Blossoms' vocals.)

Good, Good Lovin'/That's When the Tears Start	Reprise 0436	1966
My Love, Come Home/Lover Boy	Reprise 0475	1966
Deep into My Heart/Let Your Love Shine on Me	Reprise 0522	1966
Good, Good Lovin'/Deep into My Heart	Reprise 0639	1967

Stoney End/Wonderful	Ode 101	1967
Wonderful/Cry Like a Baby	Ode 106	1967
Tweedlee Dee/You Got Me Hummin'	MGM 13964	1968
You've Lost That Lovin' Feelin'/ Something So Wrong	Bell 780	1968
Soul and Inspiration/Stand By	Bell 797	1969
Stoney End/Wonderful	Ode 125	1969
I Ain't Got to Love Nobody Else/ Don't Take Your Love	Bell 857	1970
One Step Away/Break Your Promise	Bell 937	1970
It's All Up to You/Touchdown	Lion 108	1972
Cherish What Is Dear to You/ Grandma's Hands	Lion 125	1972

Albums

Shock Wave	Lion 1007	1972

Touchdown; It's All Up to You; Cherish What Is Dear to You; Moody; Fire and Rain; Last Call for Love; Shock Wave; Grandma's Hands; Heartbreak; Just Remember

A.K.A.

(Records that featured Darlene Love's voice but not necessarily her name or that of the Blossoms)

Playgirls (A pseudonym for the Blossoms)

Gee, But I'm Lonesome	RCA Victor 47-7719	1960

Duane Eddy and the Rebelettes

(Dance with the) Guitar Man	RCA Victor 47-8087	1962

Crystals

He's a Rebel	Philles 106	1962
He's Sure the Boy I Love	Philles 109	1962

(Alternate take from this session released in England
in 1979)

Bob B. Soxx and the Blue Jeans/Singles

Zip-a-Dee-Doo-Dah	Philles 107	1962
Why Do Lovers Break Each Other's Hearts?	Philles 110	1963
Not Too Young to Get Married	Philles 113	1963
The Bells of St. Mary's	Philles 119	1963
Here Comes Santa Claus		

(Above two from *A Christmas Gift for You*)

Albums

Bob B. Soxx and the Blue Jeans	Philles 4002	1963

Zip-a-Dee-Doo-Dah; Why Do Lovers Break Each Other's
Hearts?; Let the Good Times Roll; My Heart Beat a Little
Faster; Jimmy Baby; Baby I Love You; White Cliffs of
Dover; This Land Is Your Land; Dear (Here Comes My
Baby); I Shook the World; Everything's Gonna Be All Right;
Dr. Kaplan's Office

("Jimmy Baby" is considered one of the great "lost" Darlene Love lead vocals by aficionados; "Dr. Kaplan's Office" is an instrumental, named for Phil Spector's psychiatrist.)

Hale and the Hushabyes

Yes, Sir, That's My Baby Apogee 104 1964
(Featuring the Blossoms, Brian Wilson, Jackie DeShannon, Sonny and Cher, and Edna Wright; also issued on Reprise 0299)

Al Casey and the K-Cettes

Surfin' Hootenany Stacy 962 1963

Wild Cats (A pseudonym for the Blossoms)

What Are We Gonna Do/3625 Reprise 0253 1964
Groovy Street
(Issued on *Pixie Girls* CD, Japan WB 3540, 1990)

Herb Alpert and the Tijuana Brass

Mexican Drummer Man A&M 732 1964
(Featuring vocals by the Blossoms)

Moose and the Pelicans (The Blossoms with Kenny Laguna and friends)

He's a Rebel	Vanguard VRS 35129	1969
We Rockin'/The Ballad of Davy Crockett	Vanguard VRS 35110	1969

The Glass House

Touch Me, Jesus (From the album *Inside the Glass House*)	Invictus	1970

Original Cast of *Leader of the Pack*

River Deep-Mountain High	Elektra 69647	1985

Darlene Love
Singles and Individual Tracks

Chapel of Love		1963
(Today I Met) The Boy I'm Gonna Marry/My Heart Beat a Little Bit Faster	Philles 111	1963
Wait Til My Bobby Gets Home/ Take It from Me	Philles 114	1963
A Fine, Fine Boy	Philles 117	1963
Christmas (Baby Please Come Home)	Philles 119	1963

(Rereleased in 1964 as Philles 125X, backed with "Winter Wonderland," and in 1974 as Warner/Spector 0401, backed with "Wait Til My Bobby Gets Home")

White Christmas
(It's a) Marshmallow World
Winter Wonderland
 (Above four from *A Christmas Gift for You*, released
 November 1963)

(He's a) Quiet Guy/Stumble and Fall	Philles 123	1964
Strange Love		1964
Long Way to Be Happy		1965

 (Above two unreleased until 1991, when they appeared
 on Phil Spector's *Back to Mono*)

Too Late to Say You're Sorry/If	Reprise 534	1966
Lord, If You're a Woman/Stumble and Fall	Warner/ Spector 0410	1977
Ooo Wee Baby (From *The Idolmaker* soundtrack)	A&M SP 4840 (LP)	1980
Alley Oop (From the *Bachelor Party* soundtrack)	IRS 70047 (LP)	1984
He's Sure the Boy I Love/ Everybody Needs	Columbia 07984 (LP)	1988
Mr. Fix-It (1930s version)	Sire/WB 9 26236-2 (LP)	1990
Mr. Fix-It (alternate version)		1990

 (Above two from the *Dick Tracy* soundtrack)

All Alone at Christmas (From the *Home Alone 2* soundtrack)	Fox 10003 (cassette)	1992
Rockin' Around the Christmas Tree	A&M (LP)	1992

 (Duet with Ronnie Spector from
 A Very Special Christmas 2)

Soul and Inspiration	SBK 28336	1994

 (Duet with Bill Medley)

I Listen to the Bells Epic 1995
 (Duet with Luther Vandross, 57795 (LP)
 from his album *This Is Christmas*)
Sleigh Ride TVT 8070-2 1996
Deep in the Heart of Xmas 1996
 (Above two with the Brian Setzer Orchestra,
 produced by Phil Ramone, from the *Jingle All the Way*
 soundtrack)
Summer Nights Rhino R27575 1998
 (Duet with Lou Christie)
Hopelessly Devoted to You
You're the One That I Want
 (Duet with Lou Christie)
We Go Together (Ensemble)
 (Above four from *Grease Is the Word: Boppin' Tunes from the
 Hit Movie*)

Albums

Darlene Love Masters PSI 2335-236 1981
 (UK only)
 Run, Run, Run, Runaway; (He's a) Quiet Guy; Stumble
 and Fall; Strange Love; Take It from Me; Long Way to Be
 Happy; Playing It for Keeps; Johnny (Baby Please Come
 Home); (Today I Met) The Boy I'm Gonna Marry; A Fine,
 Fine Boy; Wait Til My Bobby Gets Home; Lord, If You're a
 Woman; I Love Him Like I Love My Very Life
Whole Hearted Love 01 1983
 We Can Work It Out; Da Doo Ron Ron; I'm So Excited;
 (Today I Met) The Boy I'm Gonna Marry; Sometimes

When We Touch; I'll Never Love This Way Again; Up
Where We Belong; Gospel Medley

Darlene Love Live Rhino 885 1985
(Reissued on CD in 1992 in Japan/Century Recorders
00385) Da Doo Ron Ron; Wait Til My Bobby Gets Home;
(Today I Met) The Boy I'm Gonna Marry; Sometimes
When We Touch; Why Do Lovers Break Each Other's
Hearts?; Goodbye, So Long; He's Sure the Boy I Love; Not
Too Young to Get Married; Gospel Medley; He's a Rebel

Paint Another Picture Columbia FC 1988
 40605
He's Sure the Boy I Love; Paint Another Picture; I've Never
Been the Same; Desperate Lover; Everybody Needs; Gypsy
Lover; Love Must Be Love; We Stand a Chance; You'll
Never Walk Alone

Bringing It Home Shanachie 9003 1992
(With Lani Groves; Darlene Love solos and duets listed)
It's All Right (duet with Lani Groves); Let It Be; Use Me;
I'll Be There; Bring It On Home; Too Many Fish in the Sea
(duet with Lani Groves)

The Best of Darlene Love ABKCO 72132 1992
(Taken mostly from the Phil Spector *Back to Mono* box set
released in 1991)
He's a Rebel; Zip-a-Dee-Doo-Dah; My Heart Beat a Little
Faster; He's Sure the Boy I Love; Why Do Lovers Break
Each Other's Hearts?; (Today I Met) The Boy I'm Gonna
Marry; Chapel of Love; Not Too Young to Get Married;
Wait Til My Bobby Gets Home; Run Run Runaway; A
Fine, Fine Boy; Stumble and Fall; (He's a) Quiet Guy;
Long Way to Be Happy; Lord, If You're a Woman

Darlene Love (EP) 1996

> Da Doo Ron Ron; He's Sure the Boy I Love; He's a
> Rebel

The Best of Darlene Love Marginal 074 1997
 (Belgium)

> (29 tracks including Darlene Love, the Blossoms, the
> Crystals, and Bob B. Soxx and the Blue Jeans songs with
> Darlene Love singing lead) He's a Rebel; Zip-a-Dee-Doo-
> Dah; He's Sure the Boy I Love; Johnny (Baby Please Come
> Home); Why Do Lovers Break Each Other's Heart?; (Today
> I Met) The Boy I'm Gonna Marry; Chapel of Love; Not
> Too Young to Get Married; Wait Til My Bobby Gets
> Home; Run Run Runaway; A Fine, Fine Boy; Stumble and
> Fall; (He's a) Quiet Guy; Long Way to Be Happy; Lord,
> If You're a Woman; Strange Love; My Heart Beat a Little
> Faster; Too Late to Say You're Sorry; White Christmas;
> Marshmallow World; Winter Wonderland; Christmas (Baby
> Please Come Home); That's When the Tears Start; Hard
> to Get; I Gotta Tell It; Big Talking Jim; Son-in-Law; Good,
> Good Lovin'; What Makes Love

Darlene Love Live 1998

> (Live recording of appearance at Rainbow and Stars,
> December 1997) Marshmallow World; Winter Wonderland;
> The Age of Miracles; He's a Rebel; Medley: He's Sure the
> Boy I Love/(Today I Met) The Boy I'm Gonna Marry;
> Hey Phil (Hey Jude); A Change Is Gonna Come; Medley:
> Where Is the Love?/Killing Me Softly; Soul and Inspiration
> (duet with Dennis Ray); Who Is Gonna Carry You?; If
> You Believe; Swing Down Chariot; Silent Night; Christmas
> (Baby Please Come Home)

Backup Vocals

The following is a selective sample:

Singles

Rockin' Robin	Bobby Day	1958
Everybody Likes to Cha Cha Cha	Sam Cooke	1959
Santa's Comin' in a Whirlybird	Gene Autry	1959
Chain Gang	Sam Cooke	1959
Alley Oop	Dante and the Evergreens	1960
Goodbye Cruel World	James Darren	1961
Johnny Angel	Shelley Fabares	1962
Seeing Is Believing	Eddie Hodges	1962
Monster Mash	Bobby "Boris" Pickett and the Crypt Kickers	1962
Move Over Darling	Doris Day	1962
Surfer Street	Allisons	1963
Da Doo Ron Ron	Crystals	1963
Be My Baby	Ronettes	1963
Baby I Love You	Ronettes	1963
In My Room	Beach Boys	1963
The Shoop Shoop Song (It's in His Kiss)	Betty Everett	1964
Do I Love You?	Ronettes	1964
Walking in the Rain	Ronettes	1964
You've Lost That Lovin' Feelin'	Righteous Brothers	1964

Just Once in My Life	Righteous Brothers	1965
Unchained Melody	Righteous Brothers	1965
(You're My) Soul and Inspiration	Righteous Brothers	1966
River Deep-Mountain High	Ike and Tina Turner	1966
The Poor Side of Town	Johnny Rivers	1966
Baby I Need Your Lovin'	Johnny Rivers	1967
The Tracks of My Tears	Johnny Rivers	1967
Sweet Ride	Dusty Springfield	1968
I Can't Make It Alone	Bill Medley	1968
Brown-Eyed Woman	Bill Medley	1968
If I Can Dream	Elvis Presley	1968
Rubberneckin'	Elvis Presley	1969
Let Us Pray	Elvis Presley	1969
Someone Is Standing Outside	Bill Medley	1970
Rock and Roll Lullaby	B. J. Thomas	1972
Basketball Jones	Cheech & Chong	1973
Get It Right	Luther Vandross	1997

Albums

Bobby Darin Sings Ray Charles	Bobby Darin	1962
Phil Spector / A Christmas Gift for You		1963
(Featuring Darlene Love, the Ronettes, Bob B. Soxx and the Blue Jeans, and the Crystals)		
Johnny Rivers at the Whisky à Go-Go	Johnny Rivers	1967

One for the Road	Righteous Brothers	1968
100%	Bill Medley	1968
1968 TV Special	Elvis Presley	1968
Off the Wall	Smokestack Lightnin'	1969
Now	Charity	1969
Wolf King of L.A.	John Phillips	1969
Peggy Lipton	Peggy Lipton	1969
Brethren	Brethren	1971
6680 Lexington	Six Six Eight Zero Lexington	1971
Billy Joe Thomas	B. J. Thomas	1972
Los Cochinos	Cheech & Chong	1973
Al's Big Deal	Al Kooper	1975
Love at First Sight	Dionne Warwick	1977
Robert John	Robert John	1979
Live and Learn	Elkie Brooks	1979
Sweet Thunder	Bill Medley	1980
Go Nutz	Herman Brood	1980
Romance Dance	Kim Carnes	1980
Hot, Live and Otherwise	Dionne Warwick	1981
Let Me Know You	Stanley Clarke	1982
Jump to It	Aretha Franklin	1982
Get It Right	Aretha Franklin	1983
Busy Body	Luther Vandross	1983
The Night I Fell in Love	Luther Vandross	1985
A Very Special Christmas	Various Artists	1987
Cher	Cher	1987
Power of Love	Luther Vandross	1991

*T*he story continues. . . .

This year marks the sixteenth anniversary of my journey titled *My Name Is Love.* Thank you to all of my fans and my "network," who demanded and helped me make the reprint of this book finally become a reality.

There are no words to adequately express my deep gratitude for all that has happened over the last few years: three years on Broadway in *Hairspray*, a multicity tour with *Fame* in Australia, the 25th Anniversary Concert for the Rock and Roll Hall of Fame at Madison Square Garden (with Bruce Springsteen and friends), and my greatest career highlight; being ushered into the Rock and Roll Hall of

Fame as one of the 2011 inductees! My peers called, and I came running.

This year will be my twenty-seventh consecutive appearance on David Letterman's Christmas show . . . as he says, Christmas begins when he hears me sing "Christmas, Baby Please Come Home."

God has truly been my source on this sometimes tough but amazing journey. I love every opportunity to use my gift and share it with the world. Recently, my life has been impacted by two most outstanding human beings: the late Gil Friesen and the wonderful Morgan Neville. Gil left the world a piece of his heart and all of his passion in conceiving and producing the film *Twenty Feet from Stardom*, which tells the story of the benefits of patience and perseverance through the experiences of the finest, most triumphant background singers in the history of the music industry. Directed by the incomparable Morgan Neville, *Twenty Feet from Stardom* not only tells the story of my life, but its relevance is true for everyone on this earth who uses and perseveres in the gift that God gives. Thank you to both of them from the bottom of my heart. Keep the faith!

Love y'all,
Darlene
June 2013

ACKNOWLEDGMENTS

DARLENE LOVE would like to acknowledge:

—My Lord and Savior Jesus Christ, for bringing me through all the times of my life, good and otherwise. I give you all credit for my continued growth and for the peace and self-confidence I have found in the awesome power of love.

—My wonderful sons, Marcus, Chawn, and Jason. You are truly blessed to have survived the difficult times when my career kept me away constantly. I hope this book helps you understand me better and gives you a clearer perspective of the people, places, and events that keep me in pursuit of my career goals.

—Mom, Thanks for having me. God knows best.

—Aunt Melissa, Thanks for filling in the "blank spots" for Mom when events and people tried to evade her memory.

—Gloria Jones, I'm glad we're still friends, through it all.

—Cher, Thanks for coming through for an old girlfriend. No matter how big a star you became, you always found time for our friendship. Your voice and your spirit are as beautiful as ever.

—From the department of We Go Way Back: Jimmy and Cheryl West, Angie Hanf, Peggy Boyd Henderson, Wanda Dabbs, Shirley Weathers, Nino Tempo, Lou Adler, Barbara Armstrong (my New York sister, always there), Kenny Laguna, Karol Kamin, Mike Patterson, Sandy and Harris Kalish (no-holds-barred friendship), Fanita James, and Sue Simmons.

—Chuck Rubin, Thanks for being a friend in deed. The office space and coffee helped make this project a lot easier.

—Allan Pepper, Thanks for adopting me into your family and making the Bottom Line stage my launching pad.

—Ellie Greenwich, Aunt Dorothy Heath, Bette Midler, Rudy Calvo, Art Cohen, Luther Vandross (more than friends), Eunice Peterson.

—My sister, Edna, and my brothers, Johnny, Joseph, and Alan, I love you.

—Rose Jackson, the best "play daughter" a mother could ever want, and the multitalented Michael G. Moye, thanks for your "eye."

—My pastors, Clinton and Sara Utterbach, It is through your ministering of the pure Scriptures that my spiritual growth has soared by leaps and bounds.

—Steve Van Zandt, Merry Clayton, Marc Shaiman, Paul Shaffer, Thanks for making this business one of true friendships.

—Bill Medley, Our love for each other evolved into a wonderful friendship. You convinced me that I'm capable of a successful solo act and backed it up with the necessary prodding, encouragement, and putting-it-all-together! I'm eternally grateful.

—Rob Hoerburger, I thought you "outdid" yourself in the *New York Times* article. But on this project, you drew from the depths of your soul. Thanks for all the laughter. Now you know more about me than any human being. We'll be laughing for years at the stories we excluded. Keep those notes in a safe, retrievable place.

—Jonathan Pillot, Every wife, child, parent, relative, friend, and entertainer *needs* someone like you in their corner. Thanks for all the phone calls during my first year as your client. Your resilience has breathed new life into my career. You have turned all the stripes and strikes into home runs. You are a man of men!

—My husband, Alton, Our love knows no bounds. Thanks, honey, for adding ours to the list of solid marriages, strong enough to beat the turmoils ever so prevalent in show business. "The heart of her husband doth safely trust in her, so that he shall have no need of spoil" (Proverbs 31:11). Fifteen years ago I asked you to take care of my heart, and you have. I love you, honey.

Rob Hoerburger would like to acknowledge:

—My family, Virginia, Mary, Peggy, and Maggie, You are the original girl group of my life.

—Peggy Scully, After Darlene, no one sings "He's a Rebel" like you. Thanks for everything.

—M. E. Hoerburger, Thanks for your support, and for letting me steal your chair.

—Robert Vare, Linda F. Magyar, Liana MacKinnon, and Sarah Harbutt, the original team. Thanks for The Power of Love.

—Jaimie Epstein, Kit Combes, Meg Holt, Jack Rosenthal, Adam Moss, and the rest of the crew at *The New York Times Magazine*, Thanks for the weekly sustenance.

—J. D. Biersdorfer, Thanks for helping to get the Book of Love on line.

—Alton Allison, Lou Adler, Bill Medley, Ellie Greenwich, Cher, Paul Shaffer, Luther Vandross, and all the other people quoted in this book, Thanks for being so generous and patient with your time and memories. Special thanks to Ellie for the pastrami.

—Jonathan Pillot and Henry Ferris, The Knicks could use a couple of go-to guys like you.

—Larry Saltzman, Dave Keyes, and Allan Pepper, Thanks for showing me a little corner of Eden at West Fourth and Mercer.

—Nora Bardak, Chuck Romano, Michele McKenna, Daniel Rushefsky, Paul Grein, and Ed Thompson, Your continual over-estimation of me is a big reason this book exists.

—Carolyn and Brian Waldron, Thanks for the book writer's wardrobe.

—Wm. Ferguson, Your two cents gave us a title—Voilà! We always have time to be funny. Keep playing hockey on the moon.

—JoAnn Jackanich, Jane St. John, and Mary Lou Flemming, the early teachers.

—Dad and Eileen Benjamin, Thanks for giving me plenty of listening time. See you in the great record store in the sky.

—M. P. Hanrahan, Thanks for the boxes from Rocco's, the box of olives, the M.I.B.W.N.S., a cup of No. 9, a dash of No. 5, and all the other secret ingredients.

—Darlene Love, You "changed my life." Thanks for all the good fortune, music, and faith you've given me. Now, there are just a few more questions. . . .

—J.C., You're the Man, the Savior, the Reason.

In addition, the authors would like to acknowledge the following books and writings, which were invaluable sources of information and inspiration: *The Amplified Bible; The New American Bible; The Heart of Rock and Soul,* by Dave Marsh; *He's a Rebel,* by Mark Ribowsky; *A Commotion in the Blood,* by Stephen S. Hall; *Last Train to Memphis,* by Peter Guralnick; *Angela's Ashes,* by Frank McCourt; and the letters of A. J. Nowick.

INDEX